How the
Light Gets In

How the
Light Gets In

A memoir by
Keira Shae

For information contact
By Common Consent Press
4062 S. Evelyn Dr.
Salt Lake City, UT 84124-2250

Cover design: Aubrey Bateman and D Christian Harrison
Book design: Andrew Heiss

www.bccpress.org
ISBN-13: 978-1-948218-07-8
ISBN-10: 1-948218-07-0

10 9 8 7 6 5 4 3 2 1

This book is dedicated to my Nicholas.

All of us have "special ones that loved us into being," and I certainly do, too.

Ring your bells that still can ring,
Forget your perfect offering.
There is a crack—a crack in everything;
That's how the light gets in.

—Leonard Cohen, "Anthem"

To love another person is to see the face of God.

—Victor Hugo, *Les Misérables*

Acknowledgments

Nicholas has taken the brunt of this work—the countless hours of me crying, sorting, and healing. Then, the writing and the fall-out from writing it. He was my first editor and the sole person who believed in this book for many years. Nick believes that stories change people. Instead of telling me the story of a victim lost to insanity, he told me the story of a brave girl who fought through terrifying things and then returned to help others. The stories we tell ourselves and each other make all the difference. I am evidence of that. Thank you, Nick, for telling me a story to save my life.

My foster family is presented in my story briefly because they are private people. They do all of their service in very quiet, unassuming ways, which is why they have been my lifelong heroes. They are generous and kind no matter the cost, and they certainly never expect to get any praise for it. This is one of my rare chances to appreciate their Christ-like love and selfless natures. It's safe to say I might not have survived, or fared so well, without their help.

I had many teachers and school administrators who gathered around me like hens. While I owe my life to many helpers along the way, this book was directly influenced

and improved by two of my Utah Valley University instructors: Dr. Matthew Draper and Professor Julie Nelson.

It seems like I wrote a very polished book, but what I actually wrote was the equivalent of emotional vomit. My BCC Press editors Michael Austin and Lori Forsyth made it intelligible and cohesive. They didn't do it for riches and glory, either. They gave up their weekends and free time simply because they believed in my story. The whole BCC family rallied behind me, and only because they love telling impactful stories. I'm forever thankful that they took a chance on me.

All of us have special ones that loved us into being.

I have so many.

Thank you.

Foreword

Perhaps the most horrifying and long-lasting effect of any abuse is the idea that someone you love and trust—most often someone who controls whether you live or die—derives great pleasure from seeing you suffer. Seeing the ecstasy on their face, hearing their laughter, witnessing their brightest smile while you writhe, fight, beg, plead, run, cower, and scream is a powerful lesson. You not only learn that your discomfort or pain is to be ignored, but that you bring happiness to others if you suffer. It is the most human desire of all to want an end to your own pain. Yet, if you learn from your infancy that your caretakers want you to suffer, then pursuing your happiness, freedom and joy—even experiencing them for a moment—can feel like impending death as you break away from tribal rules.

This was reflected in my relationship with God, in my marriage, my own motherhood, and my relationship with my mother. The more pain and suffering I endured, the more I loved them. Pursuing anything that made me happy felt like an unending panic attack. I learned not to have any desires at all, as they were a threat to belonging to the tribe.

This is why those you see who endured great childhood abuse or rape seem to only suffer and intentionally

self-harm. They learned they will get love—or even simply attention—if they are broken and screaming.

When people encounter those who derive pleasure from others' pain they recoil, they know it's not human. For others . . . it's Mother. Father. Brother.

Then, the bravest first action an abused and suffering person can take is to pursue what makes them happy.

Introduction:
Hello, My Name Is . . .

Keira Shae Sullivan
Keira Shae Miller
Keira Shae Martin
Kashae
Shae
Keira Shae Cox
Keira Shae (hopefully) Nelsen
Keira Shae (depressingly) Sullivan forever
Keira Shae Scholz
Keira Shae Sullivan-Scholz?
Keira Shae Scholz, formerly Sullivan.

Can you hear me sigh? My life is exhausting.

I don't really know who I am.

I'm more like my prostitute mother than you might think; I have let a very intimate, creative part of me out into the world. I'm in your life, like a lover, for a brief moment. But it is not the whole me. I am still a mystery, a disappointment; we are not married. You will not know me fully.

I have built you stairs that descend into my subconscious. For a few brief moments you will smell the fetid smell of substance abuse; you might swirl in the darkness of depression; you can feel the heaviness of despair viscerally, as a victim does. We will connect.

Memories are strange treasures. They are not a newspaper that you throw in an old box and later discover under your bed and revisit with the same clarity they once had. They are the letters that make up the words of the story you tell yourself. You piece together the sensations and try to create a narrative out of the most valuable parts. The story is a little different every time.

Had I written these memories years ago while very young, in the middle of great anguish, the story would have been vastly different. I am absolutely certain that my memoir would have a different tone if I were writing this with gray hair. C'est la vie.

I do not write as a reporter. I write as a victim, a daughter, a suffering soul, a wounded hater, a recovering rager, a pious nun, a vapid skank, a gaping black hole, and a passionate lover of personal tales. We all have them. I believe we are healed by telling them—by telling our truth.

There are many unpublished chapters; they drown in the depths of my heart. This is everything that anyone needs to know now about my festering, ailing spirit, and the healing I burn, weep, and ache to find.

Initially, I wrote this story for myself. I spent years in cycles of certainty and doubt, tears and triumphs, processing the pain.

I have learned how much we love control and how little of it we have.

I have been homeless enough to know that the only home I really have is my body.

I have been in a family, then have been rejected by it. I have been accepted into a tribe—a church, a neighborhood,

a school—and then rejected by it. I have rejected others out of a sense of tribal loyalty, too. I have rejected myself through self-harm and harsh criticism; I have obsessed over the love that I thought I would deserve when I attained a certain kind of excellence. This has taught me that I belong to myself. I am safe with myself, so long as I am gentle.

In my own struggle of accepting all my light and my shadows, I find a stillness in myself and a radical love for others with all their glitter and gold. Yes, even the prostitutes. The drug addicts. The abusers who are hurting inside. There is a crack in everyone. That's how the light gets in.

I hope these lessons I paid dearly for, then took the time to write down, will enrich your souls and infuse your bones like a concentrated broth.

I wish you peace in all your pain.

Selah.

Part One

My Daddy Gave Me a Name, Then He Walked Away

As with most stories about women, mine begins with my mother. Sierra.

Her shape was made up of circles: innocent, bright brown eyes, a child-like button nose, tight, bouncy curls that fell around a very round set of cheeks, large breasts, a tiny waist that met hips to rival her chest. Even her fingernail beds matched. Warm, brown freckles dotted her fair skin.

But best of all, my mother had the most brilliant, shiny red hair. It was as if God Himself decided He wanted more color in our lives and daubed the paintbrush once with her lively shade. Her name was unique; my grandmother read the name in a newspaper advertisement while smoking a cigarette. She lived in the poorest section of Kansas, and the newspaper was her way of unwinding after long days at the Canning Company. She tucked it away for that special day when she named her last child.

Sierra: her daughter, became my mother; she was eighteen the day that happened.

I remember when I was eighteen. I was terribly confused and cocky. My facade was thin. I struggled against the waves

of life beating rhythmically against my swimming strokes. It was a scary and exciting time for me. I cannot even imagine what passed through her mind when, at the same age, she discovered that she was pregnant with me and that my military father wanted nothing to do with an unplanned child.

I know that she was afraid, but only from two stories that my grandmother told me.

The first was that my father, wherever he was, sent money for an abortion. He had graduated from Brigham Young University (BYU) with a degree in a field that he didn't want to work in. He was in the military during the Cold War—an employed vagrant—working a low-paying job on the side and uninterested in becoming a father in his twenties. He tried to see a future with young Sierra as a wife, but he couldn't marry her. He said they were far too different to be happy together. My grandmother said that my mother refused the abortion, but accepted the money and bought me baby clothes.

The second story concerned my mother's apprehension at sharing the news with anyone—including her own mother. She told this story over and over, and I escaped all my worldly cares as she recounted the tale, making me feel like a legend and less like a leper.

"I remember the day your mother told me she was pregnant with you. She came home a big ball of fretting and kept asking me strange questions."

I would perk right up and start listening to my very own fairy tale, and she would continue.

"Sierra asked, 'Is there anything that I could do that would make you not love me?'

"I would answer, 'Nothing!', but she kept pestering. 'What if I did something really horrible? What if?'

"After a while, I couldn't take it anymore, and I finally snapped, 'Spit it out, Sierra. What did you do?'

"Her face looked so fallen. 'Mom, I'm pregnant,' she admitted, flatly.

"Well I just threw my arms up in the air—with the gravy spoon still in my hand—and shouted a little. She got really scared at that, but I just hugged her. I knew, and I said to her, 'It's going to be a girl, and she is going to be *very special*."

I would curl up in warmth at that story, reveling in my grandmother, the prophetess. She seemed to be as sure about me as she was that Jesus lived, and I would fall asleep on her couch marveling at what I might one day become.

I gathered what I could from those two stories, but I had one question for my mother. I finally had a chance to ask her after I became a mother myself and knew the high cost of motherhood and the loss of cherished freedom that it entailed.

My curiosity came out. "Why did you keep me, mom?"

This question washed over her beginning-to-wrinkle-in-her-forties face. Her hair was flat and smoothed back into a ponytail for work at the jail, not the vivacious waterfall of red curls it once was. Her knee was injured badly and contributed to her inability to lose the weight her body carried. Her fingernails were not polished; she was not dressed in a single sparkling sequin. The hard-partying life in all its cruelty was in evidence all over her frame—her neck and shoulders seemed to bow to gravity. But she still smiled as much as ever when she replied, revealing the only shiny thing on her body: her warm, brown eyes.

"I knew everything happens for a reason." She answered simply.

There were many times in my life that I wished I had never been born. I wanted a reason for why I was here, why I suffered so greatly. There were a few times that my mother wondered why she chose what she did, too, as she buckled under the weight of childrearing and working. The simple, short sentence she gave me seemed far too insubstantial to

be a reason for choosing all the pain the next two decades brought.

Nevertheless, she made her choice: I came into the world during the darkest part of the coldest season. Sierra, after twenty-eight hours of unsuccessful labor, became a mother in January of 1988 via a Cesarean section. As she was being stitched back together, I had my first conversation with my maternal grandmother, "Granny," as she liked to be called. I was brought home from the hospital to arguably the poorest, most unsafe section of Provo, Utah. The rich, who organize services and charities, delicately dubbed the area "the Franklin community." Back when I was living there, the apartments were called, "Pebble Creek," but in a later failed revitalization effort, they were renamed "The Boulders".

I would be surprised if either my Granny or my mother had twenty dollars in their wallet when they arrived home with me. The apartment was small. It housed a broken television, plenty of cigarettes and ashtrays, and thanks to food stamps and my Granny's job, a fridge well-stocked with Pepsi, and a pantry full of easy-to-make processed foods. Sierra recovered well and set out for work, and I was cared for by a coalition of working mother, working grandmother, and helpful neighbors. My little world included a small play area, walking to the mailboxes near the duck pond, and those baby clothes bought in blind faith nine months earlier.

Sweet Disposition

As a mother myself, I understand the pressures of young motherhood. Sierra's pressures were coupled with an incredible desire for freedom after working a job and then being a mother at home. When I asked much later in life for a glimpse of understanding into those early years, my uncle divulged that my mother "partied hard." He knew because he was a teenager himself, and Sierra brought access to alcohol that he was too young to purchase. My Uncle John would bring all his young friends to Pebble Creek for a good time, and Sierra ran with a wild crowd.

I do not recall much from my toddler and preschool days. My very vague memories are mostly of loud noises on the other side of my bedroom door. From a very young age, I was fearful of night time, bed time, and loud noises. I remember staring in absolute terror at my bedroom door; its rectangular shape has been emblazoned on my brain. I could hear loud laughter and crashing and bumping. Rarely, I would hear fighting and screaming. I became exhausted easily because I would not sleep. I wet the bed often and constantly had stomach cramps. The onset of nighttime immediately produced great pains and the urge to urinate. I missed my mother and became frustrated with her apparent lack of

concern towards me and my pain, and her urgency in abandoning me at night.

My memories of this time are not reliable. I do not claim that they prove anything or even make much sense. But later in my life, I would have flashbacks of sexual abuse that occured during this period. I can't recall much. I remember the vulnerable feeling of my underwear being around my knees or mid-thigh. I remember the perpetrator being male, as I knew what a penis looked and felt like. I don't have any recollection of the horrible pain that actual sexual intercourse with an adult would have entailed—and with a three-year old, it would have left evidence that my mother or grandmother would have noticed. What I do recall is forced oral sex and molestation. My body reacted initially to touch by being aroused a bit before being completely switched off and shut down by pain. Whoever this person was, I knew that he was more powerful than me. But mostly I was convinced that this was love. A mommy-daddy love. I don't know when or why it stopped. I had no idea it was not normal, so I doubt I reported it. I know my mother did not, if she discovered it.

What she certainly did discover was that I had been molested, as I had picked up some habits and behaviors that no girl of my age should know anything about. I can only recall a handful of friends that I assaulted myself, thinking that it was loving play. I am horrified as an adult, and I try to reconcile what I did to people that I loved.

My mother discovered my sexual play many times, and I learned quickly to be ashamed of what I had done with those boys and girls. The screams that emerged from her mouth sent me reeling. I was punished. I remember being spanked on my bare bottom with a leather belt, a wooden spoon, or her bare hand, until urine ran down my legs and my throat burned and hot tears stung my cheeks. I remember standing in a corner so long that I grew dizzy (with my

legs buckled) and happily succumbed to unconsciousness. Many times I would hear her talking on the phone about me, and I burned with shame. I stared at her for so long as she talked to others or lectured me that she started to look and sound far away. I learned to leave my body in pleasant or, more often, unpleasant situations. The closeness that I felt with her faded away. I do not recall ever seeing a therapist for any help or correction. I suppose my mother had hoped that she had beaten it out of me.

But it was my mother who brought an endless stream sexual partners into our house: boyfriends, fiancees, clients, and husbands over the course of my childhood. I passed by the master bedroom to moans and giggles every weekend my mother wasn't locked away in depression. I frequently walked into scenes of sexual intercourse or at least fellatio. Restricted rated movies that depicted sex were a favorite on our shelf for any adults in my household.

··•●••·•

Dangerous men and threatening sexuality were constant themes in my home life. One of the men my mother brought home had an eighteen-year-old son. He had a system in place for taking advantage of small children. This man initially used to tickle me violently. It was fun at first, but once while doing this he knocked me onto the bed and held me down while he pulled down my pants and touched me on the top of the fabric of my underwear. Then he pulled his pants down and placed his legs on my legs. I was successfully pinned for his pleasure. I squeezed my eyes shut against the dry pain.

I don't know how, but after the first time he did that to me, I learned to go away. I don't know how else to describe it, but I think my mind was protecting me from what was being done violently to my body. I simply checked out, or passed out, I'm not sure which.

I knew something was wrong in the pit of my stomach, but my body came to enjoy it a little physically. Maybe that's how he loved me, I would tell myself. This is how we're a family. He was my caretaker. My dread at my mother leaving for work again, the fear of being found like that, the weekends with my mother ending, my anticipation of school as an escape—they were all signs that it wasn't right.

I finally resolved to tell my mother what happened to me after she left everyday for work. I was terrified. *Would I break up the family she was trying to put together? Would she fight my fight? Would she blame me? Would she send me away, not part of the family anymore? Would he find out and hurt me for telling on him for something that was probably unimportant? Would he find out and hurt us later? Would she ignore it?*

I stood in that hallway and spoke to her in the quietest voice I could muster. My sick, weak, thin, exhausted body felt like it would blow over if she walked away.

"He does something to me." I managed.

My mother bent down, concern and questions growing on her face. She had to pry hard to get an explanation. I hated being wrong to her; I was always in trouble for being wrong. And this was bad. Very wrong. I could feel it.

"Sometimes he holds me down on the bed and puts my hands above my head like this—" I showed an unenthusiastic pantomime, with my eyes unable to meet her questioning gaze in shame, "and he puts his underwear on mine and moves and I don't feel good and I can't get out. I tried. He won't let me. . . ."

My mom didn't say much, and when she did, it was after a long and serious look. I think she encouraged me to tell her any time someone touched me like that, or in a way I didn't like. That made me feel better about my confession. I think she hugged me quietly and privately, and at first I felt relief.

From that night forward, my bed was always placed against a wall. I slept with my back against the wall, my eyes toward the door. I carried the scars of these abusive encounters with me all my life. I developed panic attacks around weekends, nighttime, sexual sounds (such as heavy breathing or any rhythmic noise), any pornographic or sexual scenes in movies, and most especially, men. The stronger, the hairier, the sweatier the men, the worse it became. School, with mostly female teachers and a sterile environment, became my place of solace while surviving a living nightmare.

4

Hear You Me

Not all of my scars were physical, nor was my isolation entirely self-imposed. Before I had even turned four years old, it became clear that I often didn't hear or understand things that people said to me. One day, I found myself locked in a booth with a window as my mother and a doctor talked to each other about things that I could not fathom.

Before this, my mother had me talking on the phone to all sorts of dads, half-dads, grandmothers, half-grandmas, and a distant sister or uncle. I became frustrated at her insistence to put my right ear to the phone. I fought it often, without words to explain that there was no sound. I could not respond to the conversation at all, and lost interest. I forced my mother to give me the phone on my left side until I saw knowingness appear in her eyes. She was bent down with the corded phone, her mouth a little open as she searched my face.

She made an appointment with audiologist the next day. The sounds vibrated in my ear, but I heard no music.

I played in the cold white room with the booth behind me as the diagnosis floated through the air. "Eardrum intact . . . but nerve deafness . . . she will never hear . . . no need for a hearing aid . . . it's not possible to fix it." I finally had words for my spacey look, for my confused search for

the direction of my mother's voice. It explained my na-
ive attempts to cross the road without hearing impending
danger. It explained why my mother was so often frus-
trated with me. It wasn't stupidity.

After tears, my mother gathered her reserves of strength
to study into the night. She woke up with me in the early
morning and taught me all she knew—the alphabet in sign
language. And the sign for "I love you." It became our se-
cret code, which we shared with Granny. Every time I waved
goodbye, in a show of solidarity between us girls, and later
our whole rowdy family, we signed "I love you" until the per-
son was out of sight.

⋅⋅⦁ ⦁•⋅⋅⦁

In her loneliness and limited state, Sierra met a married man
at a bar and became unexpectedly pregnant again when I
was still a toddler. The man would not leave his wife and
family for her. She chose to give the baby up for adoption.

Who knows what cocktail of emotions this twenty-one
year-old faced during that pregnancy and delivery? I have
suffered and carried children into this world; I have cried
over the faintest idea of going through the misery of bear-
ing them only to lose them—to never be known by them.

The baby was a girl, and Sierra wanted to name her
Jessica, but the adoptive mother held on to Nicole. As a
compromise, her middle name was Jessica. And with that
one name and the gift of life, the baby faded from our lives
and memories, leaving only the shadows under my moth-
er's eyes.

It was not difficult for me to see Nicole go. By this point
in my life, goodbyes were the norm. My mother had been
with husband #1 (Eric Sullivan, who had adopted me for a
few months and still paid child support) only briefly and I
had seen many men, friends, jobs, and houses come and

go. Sierra frequently left me to go to work, and nothing was a permanent fixture. Perhaps it was better to have this skill for adaptation, as I would spend the rest of my childhood in transience. I longed for security, and I would beg, scream, and plead for her to stay with me to alleviate my fear and loneliness. But no amount of good behavior kept her from turning her back on me, whether it was at daycare or my own bedroom door. To get her attention, I attempted to be awful, but my misbehavior was either severely punished or completely ignored.

I developed a habit of crying, having the tears abate when the shock of abandonment was fully realized, and then punishing my mother in various ways for leaving me when she returned. As an adult I was stupefied to learn in my childhood development courses that my behavior had a name. I was triggered by words like, "disorganized attachment" and "ambivalent attachment styles," that were common in describing abused children.

Memories are faulty, but memories are all I have. As an adult with a little more life experience, I see my mother through new eyes, a softer, more compassionate view. As a child, I loved and feared her with fierce loyalty but didn't know who she really was. As I grew closer to adolescence, I eventually hated her with every fiber of my being.

My perspective was always one-dimensional—I did not work with her, I was never her husband or lover, nor her priest or therapist. What I record of her is only the knowledge that I can claim. I give her the same space of mercy that I now give myself. Sierra, like me, was a complicated being, carrying wounds and unrealized dreams and fond memories like layered sections of wallpaper. I have seen some layers; I can guess at some layers. Unless I someday get a chance to really unravel her, I will never know. I wish I knew who she really was, before mental illness coiled around her throat. I wish I could remember more of my

sober mother. My hopeful and energetic parent. But under-standing Sierra is not the point of this book. I write to be understood myself. Even to be understood *by* myself. And I am a very complicated creature indeed. In that way, my mother and I are the same.

Sweet Child of Mine

A year after Sierra's arms held Nicole for the last time she was married to her second husband and pregnant with twins—a boy and a girl. We moved from Utah to Colorado, and I hardly noticed the difference. It seems strange, I'm sure, to have such dramatic life events sandwiched together so quickly.

I went from Keira Sullivan to Keira Miller overnight.

I wonder if twenty-two-year-old Sierra thought about those things on her hasty wedding day in Colorado. I was four, and overnight I gained a smelly, unpleasant, rude, scary, tall, burly stepfather named David Miller. He had sandy blonde hair with his father's blue eyes, shaped like a cat's slits on his face. He was six feet seven inches, hairy, and he favored wife-beater tank tops and a mullet haircut. I certainly looked out-of-place in the photos; I had an extremely pale skin tone with warm, brown eyes and shiny, limp, hair that was nearly dark brown. My mother had a light skin tone with voluminous red, tightly curled hair. None of us matched the other. My mother was finally happy; I was very unhappy. David had a way of stealing the precious moments I had with her before the marriage.

The Keira who was a timid, quiet mouse emerged at this point. David was a bear of a man, and I learned that if I stayed small (mirroring my Granny), I would survive.

David played Def Leppard and White Snake in the car at full volume, so conversations while traveling were rare. This music felt like whiplash compared to what my mother listened to as a single lady. I longed for Madonna's gentle pop songs over Aerosmith's intense guitar riffs.

She delivered my twin siblings in March, and after that, even the occasional moments I had with her vanished. I recall my mother saying often to me, "You're such a good helper," and urging me to help out with my brother and sister. Later in my teen years, during an argument, I brought up that I always tried to be a good girl. Since I was little, I was always a big sister helper like she wanted. I learned early to be a people-pleaser.

Sierra, in her anger, sneered, "You were not helpful. You threw temper tantrums all the time!"

The information shocked me, but it was declared with such vehemence that I supposed it was true. I'm sure now that the truth is somewhere in between—I handled the change with emotional ups and downs that added to her own.

My brother Alex came out first, and he had our mother's round eyes, but blue. He had dark red hair and fair skin that would later be covered with freckles—just like Sierra. He was a long baby, which meant he would become tall and strong just like David. He was an extremely quiet child, never sick or disturbed, and he didn't speak until he was three years old—and then only rarely. This worried Sierra. She would often explain to others that he was not talking yet, reassuring them that this was still within the normal range of childhood development. Privately, I watched her constantly urge him to say, "mama." Now we know that this fit his personality well; Alex is the strong, silent type.

My sister emerged next. She was named Ashley, and she had her father's steely cat eyes and her mother's red, curly hair—but the curls were angelic and wispy, not tight. Her fair skin was best showcased on her beautiful chubby cheeks. Our mother had professional family photos taken and presented them to anyone who would take a gander. I couldn't help but notice that Ashley had become her new favorite—a lovelier replica of herself. Sierra pointed out details of what she adored about Ashley. I took note and tried to copy her, hoping I would earn my mother's love back. Eventually, Sierra started calling Ashley "mini me," which left being a "good girl" as the only way to earn her attention or affection.

Being a good girl meant many things. It gave me expectations and structure as I tried to please those around me and earn their love. Being the good girl afforded me many luxuries and favors. If other people were happy, I felt comfortable. I loved when someone said that I was nice, good, well-behaved, smart, obedient, caring, or kind. My heart sang with every compliment, and I did whatever monkey dance I needed to perform to please others—but mostly my mother. Her mere glance ruled my life.

I would gather clothes, fetch diapers, become quiet, pick up dropped items, clear my plate, say sorry, become extremely retentive with my bathroom needs, do well in school, and stay out of the way—whatever it took not to burden my mother. It seemed that her burdens were already big enough. She wasn't always happy, and she was always tired. She often lost her temper. I thought that if I could just stay quiet enough, if I could help enough in the very specific ways she wanted, she would love me forever and be happy again.

Transient as his trucker career, we hastily moved to Elgin, Illinois to follow a better position in a new company.

Sierra became pregnant by David, her second husband, again with a second set of twins—another boy and girl. Her burden (from what I could see) got even larger. I would often sneak out of my bed and crack open the door to my room to see my mother and David fighting. She would be tearful and red-faced, crying and screaming, with David not crying and screaming. I recall somewhere during this time, my sister Ashley became sick with pneumonia and ear infections that required surgery. She had tubes put in her ears multiple times. My mother never washed and primped her hair anymore. She was constantly tired, and I rarely saw her. I attended school and saw a little more of David when I returned home. We clashed often. He made my stomach hurt. I hid from him. I angered him with my bed-wetting. I was embarrassed.

I saw our mother crying often during mundane tasks and I didn't understand why. I was frustrated with her because I helped as much as I could, but I could never see her smile. She was twenty-five, but she had lived several lifetimes; the carefree teenager that became unexpectedly pregnant; the hardworking single mother; the loyal, black-eyed wife; the divorcee who lost herself in the bottle; the mother who gave her child away; now a mother of five children overnight—taxed, maxed, and frazzled. I joke with people who criticize my mother, "If I had lived through that, I would have self-medicated, too!"

Later, I read in a college textbook that the onset for bipolar disorder is usually twenty-five.

··ᶰ ●●∴•

I don't recall Sierra leaving with me. I can only tell what was told to me by others.

My Granny claimed that Sierra's close friend was getting married, and when she took me to Utah to attend the

ceremony, David "took the twins away." Sierra said that David was cheating (which would explain the fighting I witnessed). David's sister-in-law claims Sierra was suffering from a recently diagnosed mental disorder and had stopped or refused her medication. David's extended family says that they all pitched in to help with so many babies, but it wasn't enough. Whatever the full truth, Sierra left her toddlers and the second set of twins very shortly after they were delivered. She named her daughter Becca and her son Brandon before she departed.

I was not yet thirty when I learned all of this, and my instant reaction was to condemn my mother. I was slow to remember my own suffering with postpartum depression, or how six weeks after my third baby was born, I needed a break from my relentless motherhood and slept in a hotel room for a few days. The judgement I slapped on her actions stung my own cheeks. How many times did I weep under the strains and pains my body endured? I have spent nearly three years of my life pregnant. Sierra bore significantly more than I did, with fewer resources. We all eventually break if we are bent hard enough.

Vagabond

I do not remember how my mother got the news that her children would not be returned to her, but this meant that we were instantly homeless. She joined some sort of support group for mothers who had multiples pregnancies, and we were offered shelter by them. They heard her story and convinced her to go to court and get her children back. In the meantime, David had moved in with his latest fling, and they had taken family photos with the two sets of twins. This enraged my mother. She hired a lawyer. We did not have a roof over our heads, but we had a lawyer to fight for children she couldn't feed.

We moved around from house to house, homeless for about a year. I wonder how many tears Sierra wept at the state of her life. I saw her frequently angry, as she recounted tale after tale to anyone who would listen. I had no objective view of David or any of his family because I had been indoctrinated with all the evils of David. The more I heard, the more I feared him and thanked heaven that I didn't have to live with him anymore.

I learned to ride a bike with training wheels, but it was not my own bike. I spent my seventh birthday with strangers. I switched schools many times. I learned what Mother's Day was and found flowers in a field behind the

house where we slept on the basement floor. My mother cooed over my wildflower bouquet, but Mother's Day was not happy for her.

In contrast, I was happier. I got one-on-one time with my mother again. My duties of caring for everyone vanished overnight. It was back to being "us gals." It wasn't exactly the same as before, because my mom wasn't really herself. I tried not to think about it much.

And I was *such* a nice girl.

For me, it truly felt like one day we were homeless and hopeless, and then the next, we were en route to Illinois to "get the kids back." My mother was giddy and joyful, so I took this as a good omen. Sierra said I never had to see David again, either. The lawyer had fought for the kids and severed the ties we had with that awful man. Relief washed over me, and my stomach eased.

Still homeless, we moved to Utah to live in a double-wide trailer with my maternal grandfather until we could find our feet. This marked a turning point for me. I grew tired of moving around and switching schools often. I started to see my mother—not really as a *liar*, but as not fully truthful. Her enthusiasm and convincing arguments about why this next house, school, boyfriend, or move would be the end of all our sorrows rang false to my instincts. I would voice my concerns only to be out-maneuvered conversationally until I quite forgot I was pointing out a bothersome truth that had no answer.

She would protest, "This time it's going to be different. He has money, we're going to buy a house with a back-yard. . . . You'll have your own room. . . . We'll get a dog, honey! Just like you wanted. . . ."

I also began to notice that wherever we went, she wore out her welcome quickly and often. That troubled me be-cause I didn't like to think that others did not like Sierra, whom I loved, and did not like me, the one who strove

desperately to please others. Within weeks of staying with grandpa, grandpa's girlfriend Brenda wanted us thrown out. Brenda shouted with her raspy voice against my mother's musical and high pitched tone. Brenda won, and we scrambled out. We lived on Granny's floor until the government-subsidized housing had a place for us.

Lucky for everyone, a government-subsidized Provo duplex with a backyard had opened up, and it had three bedrooms and two bathrooms! It was a dream come true. My mother made it seem like we were here to stay, so I settled and was sure I would make friends for keeps at school.

What a fresh chapter of our lives! Granny lived less than a mile away and walked over every day to help with the children while my mother worked a new job. I grew extremely close with my Granny, rekindling the relationship we had in the Pebble Creek apartments. My mother seemed stressed, but it was an energetic, frantic, and angry feeling, not the depressive, neglectful feeling of the past.

When we misbehaved, my mother exploded with loud fits of rage. She started to punish us in unpredictable, severe ways. I strove to be the good girl I always wanted to be for her, but I could find no pattern for keeping her happy and me safe. I was often confused by her barking orders. She wanted things done in a certain way and quickly, so I often relied on her instruction, terrified to misstep or need her direction or correction.

I eventually learned not to attempt anything at all without her complete understanding and approval. Still she raged at me and I grew fearful of taking any action whatsoever. When I couldn't control how an action was done, I panicked and raged. My child's hands were imperfect at everything—I soon learned to hate myself with my unsteady hand and my small frame that couldn't move the broom or the vacuum like my adult mother could. I grew ashamed of drawing because it was not perfect. I found

relief in straightening my room. I started to sneak around wearing swimsuit tops as brassieres and stole perfume to wear.

Later, my nose in a book as a college student, I came across the outcomes of an authoritarian style of parenting, and I realized it had created in me a fear and desperate drive for perfectionism. I had no autonomy, and I never desired it.

In playing with my siblings, I was extremely bossy and felt that somehow I had sucked all the fun and life from games I used to love. That made me feel miserable, and I took it out on Ashley, Alex, Brandon, and Becca. I found their childish talk and problems a nuisance and yet, at the same time, I envied their innocence. I vacillated between playmate and lord, making fun of their pronunciations and nicknames like "blankie."

I thought myself very mature. Once, I snuck my scissors from the school supplies and played "Hair Salon" with them. I loved hair, especially my beautiful locks, which I was growing out to look like all the Disney Princesses, the Disney corporation being my most frequent babysitter. I set up a chair for my "salon." I cut a tiny piece of my brother's hair first. Then, I lifted up the bulk of my sister's red hair and strategically cut a piece from the nape of her neck. I cut a small piece of my own hair too. I made my siblings promise not to tell our mother. Nearly immediately, Ashley tattled. I suspect being mother's favorite, she told her everything, especially when told *not* to.

"KEIRA SHAE!"

Terror filled my heart to hear my mother's screams break the quiet air of our house. My neck nearly snapped to attention at the sound of my mother's heavy footsteps coming up the second floor to find me. My heart felt as if it would burst.

Sierra grabbed a fistfull of my long hair and dragged me down the stairs, shouting about my transgression. "I told you to obey. I told you and told you: I can be your best friend or your worst enemy. You just made me your worst enemy . . ." My feet weren't as fast as hers, and I watched them flop below as I heard her chant, "You may be book smart; you sure as hell aren't street-smart. . . . Common sense . . . you don't even *think*. . . . Common sense isn't so common!" Dinner was still cooking on the stove, and she forced me into a kitchen chair and started brushing my hair painfully.

I sat in wonder, but I didn't dare move. Why would she be styling my hair in the middle of dinner time?

Sierra then tied my hair into a ponytail, which confused me further, as I didn't like ponytails.

She grabbed the kitchen scissors in one hand and my ponytail in the other . . . *and cut all my hair off and handed it to me!*

I tried not to scream in horror. I cried as silently as possible with my handful of my beloved Disney-princess length hair. I touched my head and covered my neck, trying to solidify what had happened to me with evidence. I didn't feel very beautiful as a child, but I loved my hair. My favorite feeling was taking a bath with it. I loved feeling the hair tickle my bare back. I loved the feeling of how heavy it became in the water, yet it floated around my head like a mermaid's. To lose this part of my identity was crushing. I had only a moment with my hair before my mother chased me through the kitchen and living room to spank my rear end raw; Sierra was red from hairline to toenail beds.

I always had to stifle my screams and sob silently, yet she could rage and rage. In her rage, she swore. Screamed. Broke dishes. Hit children. When I displayed anger the same way, I was punished. She was never punished. The unpredictability made me wish at night for some better place.

None of her felt fair.

That was the moment when I stopped trusting my sister. That was the moment that I stopped adoring my mother. While I still had a relationship with my sister, and I still sought my mother's approval, I distanced myself from everyone, not quite sure if any place was safe anymore.

Blessed are the Penny Rookers, Cheap Hookers, Groovy Lookers

The next man in line was named Glenn. Glenn came just after we had nestled perfectly into our new little duplex and my mother's mind turned, as it always did, to the task of finding a man to complete her idea of a happy family. Bitterly, I liked to believe that she found literally the closest man lying on the street, drunk as a skunk, constantly reeking of tobacco no matter how many showers he claimed he took that week. Early in life I had learned to become cynical and critical of every person that passed through our door, but especially men.

Glenn was a terrible excuse for a man—sunburnt, pierced, and tattooed. He was a hair taller than my mother, his ever-shirtless body nothing but skin and sinew. Cigarettes cost more than shirts, and when money was tight—which was all the time—he could always be counted on to prioritize in favor of his fix. I avoided him with all the energy I had and only had to get close to him twice. I wondered how my mother could stand near him without her eyes watering, let alone kiss him with tongue like she did, and worse. He mostly came on the weekends, even when he lived with us, and would be raving drunk, amused and angry at nothing

and everything. I dreaded weekends, and I treasured school and the way it made me feel clean again.

And then one day Glenn became a full-time resident. Nobody consulted me or even tried to explain how it happened. One day his shirts appeared on the hooks in my mother's upstairs closet, and they smiled and giggled and ran off to the pawn shop together to get a ring for mother's bare, fat finger. I didn't even get the standard promise of a bigger house, money, a dog, or my own room to sweeten the deal of "a new daddy."

I asked for swimming lessons that summer and got them. I swam at an outdoor pool every morning at 6 AM. My mother must've been bringing in a bit more money with a boyfriend and worked to make my dream come true. I was thankful for the rare treat of a new experience for a few weeks, and I mastered it quickly. I was in love with the water. Glenn complimented me by saying I swam like a fish. "I mean it," he offered. "She's a natural!"

I corrected him and declared myself a mermaid. He didn't respond with anything but a laugh.

The money must have run out or I displeased Glenn, because my opportunity was brief.

Then one day, Glenn's shirts were just gone from Sierra's closet, and she moved on to the next well-muscled replacement, Troy. Then after a few weeks of watching them wrestle passionately on the living room floor, it was Byron. Then it was Michael . . .

I started to learn the face of lust.

Of Demons and Angels

I did not understand that what I was experiencing at home was abuse from an overwhelmed parent. But I knew that it wasn't pleasant, and I longed to tell someone. I started having regular weekend sleepovers with my Granny in Pebble Creek. Other than going to school, these visits were my only escape from the chaos of my home.

My Granny was a large woman who did not want to be large. She technically measured at five feet, nine inches, but she bent herself to appear smaller. She could have spread out and taken up space, but she kept herself in a tight personal bubble. She weighed over two hundred pounds, but she moved as quietly as a mouse. I could sense that she did all of this to ensure that others felt comfortable. I loved and appreciated her thoughtfulness and felt safe in her home. It was a stark contrast to my mother's heavy gait, bellowing voice, flipped hair and loud taste in clothing that filled our house with energy or terror. Being with my Granny was heaven.

There was always plenty of food, and my Granny would make meals for me and clean up afterwards—quite the opposite of my home, and a real luxury. There was so much food, in fact, that we would go every week to feed the ducks at the pond with leftover, stale bread. It was these

moments together—not accomplishing anything, nowhere to go—that calmed my cramped stomach and fried nerves. I could tell her anything, and I did. I confessed all the sins of my mother to her. It was extremely validating both to be heard and to see the worry lines creep across my grandmother's face. I was heard. This *was* a big deal.

Sierra was probably eager to have a break, too, so she never objected to my visits or weekend sleepovers. I would not return until mid-to-late Sunday. I felt relief for her permission because weekends with my mother involved alcohol and visits from men. At seven or eight years old, I couldn't say exactly why, but both of those things set me on edge. I found myself sneaking and curious and frightened when I saw her with strange men I would never see again. Something about them kissing made me angry or possibly jealous. Sierra never gave her full attention to *me* like *that*. Something about the way their bodies moved, or the way the man would touch Sierra, or the noises they made—something was very familiar to me, and I longed to enjoy it again. I felt aroused, yet I was experiencing a full-blown panic attack at the same time. I had no idea why. I felt sick to my stomach and wanted to cry. I often made plans to break up their activity by claiming illness or needing my mom, but I wasn't always brave enough to speak up. I practiced and envisioned myself stomping down the stairs in power, but their activity made me weak in the knees and frightened.

It was rare, but there were a few nights where I found Sierra watching a soap opera with a Pepsi, and studying for her GED on the couch. Watching her giving her full attention to a book did not produce the same feelings in me. I felt calm and proud to see her doing her homework just like I did mine.

I reported all these findings to Granny. I made lists of any of the men's names I knew (I saw many more drive up and park their cars for an hour or two, but I never learned their names) while eating a can of ravioli. Over ham

sandwiches, I told her about the beatings with wooden spoons or leather belts. I answered all her interrogations while swimming in the community pool. I looked to her face for answers as we walked the thirteen blocks to the library on Saturday mornings. She showed worry, but didn't provide me with any solutions.

Several times Granny anonymously reported what I told her to Child and Family Services, and having a caseworker come to inspect the home was a biannual occurrence with its own performance expectations. My mother was so infuriated with my grandmother's "nosy" behavior that, for several months at a time, she forbade Granny from seeing us. My mother eventually came around, but being on her bad side was a punishment for everyone involved. She couldn't seem to maintain relationships with most family, friends, or even neighbors. While losing connections was always devastating, losing my Granny, my best friend and confidante, was unbearable.

I was not the only one who shared everything in the relationship—I asked all sorts of questions, and my Granny gave me the complete answers—whether it was appropriate for my young age or not. I kept my curiosity alive because of her.

I remember holding a large bag of new paperback friends in her reusable cloth sack with a peace sign design on it. "You say 'rape', Granny. What is it?"

Her eyes got wide. "It's a horrible thing." She took a long breath. "It's when a man holds down a woman and has sex with her. He uses his *thing* to hurt *you*."

I thought about my own experiences, and what I had witnessed of my mother.

Words like "rape", "suicide", and "bastard" colored my vocabulary.

My mother was furious with Granny's lack of boundaries and wildly inappropriate sharing with her daughter and frequently flew into rages, once again cutting off contact.

I missed Granny and our walks to the duck ponds during those times. I didn't mind the things she told me. I felt they didn't affect me. Asking questions got me into a great deal of trouble at home, but not with Granny.

I began to ask her anything that came to mind.

"Granny, why are you trying so hard to quit smoking?"

"Because I had a stroke right after you were born." She answered.

"What is a stroke?" I asked without hesitation.

"It's bleeding in your brain because a vessel clots and bursts. It happened because I smoke. But it's so very hard to quit. Plus, whenever I quit smoking, I just replace it with eating and I get FAT." That was always how she used that word—as if she was spitting it out in disgust. I personally thought the cigarettes were more disgusting than fat, but what did I know?

"Why is it bad to be fat?" I questioned.

"Being FAT is UGLY. That's what your Granny is: FAT and UGLY. But if I smoke, at least I'm not FAT." She would say with a chuckle.

I learned to laugh along. I didn't think it was very funny. I loved my Granny with all my heart . . . I didn't think she was ugly. Fat—maybe. But was fat automatically ugly? If so, my mother was ugly, too. She was very curvy but had no trouble finding dates. I knew that all the Disney Princesses were beautiful and thin, so I concluded that the last thing I wanted to be was fat!

"Granny, why do we walk everywhere?"

"Because when I had my stroke, I wasn't allowed to drive anymore." She pointed to the left side of her face. "Do you see how this side of my face droops down more than this side?"

I searched the face I loved so well. Yes . . . now that I looked for it, I had only known her face in its post-stroke shape, where her left side slackened compared to her right.

I nodded, frightened at her distance in talking about her own body, and in such a negative way. "That's what the stroke did to my face. And I had to wear glasses," she concluded with disdain. She talked about her body often, as if it were a garment she wished she could shed but had to make do with. So, she often spoke of altering it and keeping it, but not by choice. She wasn't the only one—as Granny and I sat down to after-school snacks with Oprah on the television, it seemed everyone had a problem with their body.

I, too, started to look in the mirror at the body I was given and saw what I wished would change. How grateful I was to be skinny—but my mother and grandmother (from whom I received my genetic makeup) started out skinny too, so that was no guarantee. That panicked me. Almost no one on television had freckles, so I quickly made an enemy out of them. When I passed a reflective surface—windows to office buildings, lacquered paint, and car windows—I would immediately criticize and verbally lash out at my appearance. Someone might have mistaken me for a schizophrenic! I would murmur vengeful remarks and never look anyone—even myself—in the eye. I deserved derision. My dark circles grew, my pallid complexion belied my seething hate, and my cowlicked hair was a hallmark of my neglect. Ugly to the last detail, I dealt with my anxiety and fear by chewing my nails, an inherited habit that left me ragged in every sense of the word.

My mother often told me, "You may be pretty on the outside, but you're not pretty on the inside." Almost as if obeying her prophecy, my outsides became worn down, and I did not shine like a hopeful young child anymore.

Therefore, I became ugly inside and out. This budding self-hatred bloomed as I did. It is a pernicious weed that I am still fighting to root out. It would have been easier to extract my skeleton from my body than learn to become my own kind of friend.

Heavenly Father,
Are You Really There?

I always knew God existed, and I blame my Granny. She was always talking about him like he was a pesky neighbor down the street—God wanted her to get to reading that Bible, but she didn't have time yesterday. God wanted her to go to church on Sundays, but with the stroke taking so much of her ability, and lack of car, she watched televangelists instead. God always wanted her to quit smoking and swearing, to lose weight, and to forgive all the people in her life, and she did try. She was constantly in conversation with him or attempting to change all those things he'd wanted her to change. It seemed they were at a standoff, though. She never could give up all those things, and it seemed that he rarely, if ever, answered her prayers. She was always stuck in poverty, worrying about a wayward family member, and hopelessly at the mercy of her appetites. From this relationship the seed of faith in God sprouted in me, if you could call it faith. It felt similar to striving to earn my high marks from a hard-to-please instructor.

Believing that God exists and believing *in* Him are very different things, so I never trusted that God would give me what I wanted. Sometimes I hoped and asked, but I never

believed he would actually do anything for me. It was more of a wish than a prayer. Though it was a depressing way to supposedly live in faith, the mechanics of it seemed very simple to me—God was a busy man, what with keeping a universe together, and a lot of people prayed to him and disobeyed him, so he had to keep up with that. I was a single, needy person, and beyond that, I was a nobody, like my Granny. If he ever did answer my prayers, it was a miracle that he finally got to it. Otherwise, he mostly just left me alone to figure things out for myself.

As a young child I rarely bothered myself with God's apparent lack of interest. I suppose this mirrored my lack of relationship with my own earthly "father." His lack of attention or help didn't bother me just like God's didn't—unless, of course, I really needed him for something desperate. When I noticed the pattern as I grew older, I assumed that there must be something wrong with me, like there always was, and he would not listen or reward me until I fixed it. I transferred my pleasing personality, all my fears, and my drive for performance-perfection with my mother towards my God, too. Whatever crumbs he deemed me worthy of dropping, I took. Otherwise, I was a dog in his eyes. I was going to earn his love and approval, somehow. . . .

As a young teen, my anger toward God built, and I began to see Him as an enemy. When I thought he answered my prayers at all, He'd do it in a way that was exactly the opposite of what I had asked for—seemingly to torture me. God truly must have hated me. He cursed me. He silenced me. He didn't approve of the desires of my heart.

Just like I didn't understand His communication style, I never understood His punishment style either. While our mother might not be in church every Sunday (or any Sunday), God punishing or ignoring her punished us children all the more, and we had no control over her choices. As I watched her men, as I watched her drink, as I watched

the news, it seemed that, while God had some rules, bad people did whatever they wanted and rejoiced. In contrast, I was an innocent child who made every effort to please others, and I felt like consequences of staggering proportions were heaped upon my head. If my mother moved, divorced, or simply couldn't come up with rent, I lost my school, my neighborhood, and my friends. If my mother brought over a man, I was the one kept up late and made sick—I was being punished for her sins. She never had a stomach ache from *her* doings.

While my Granny was God-fearing, I had heard my mom pray only a few times, always the way people do when they realize they're not in control—the way a person does when they're driving on the freeway in a snowstorm, or gambling with their last five dollars.

My only childhood prayer that *was* answered was that God would send angels to help me. I should have been more specific, as I wanted to move into a giant castle and for my mom to win the lottery and never have to work so we could be together all day. Instead, he sent the Mormon missionaries to our door. Compared to the chaos our family felt in that house, the missionaries *did* feel like angels.

I can't imagine why my mother invited them in when they knocked on our door, or why she would be willing to have them come back often and teach. It was strange, but I found that my mother acted more pleasant and our house became less chaotic in the days leading up to and the few days after we were visited by my Mormon Elder-angels.

They invited me to be baptized, and I accepted. I had hoped that this would finally put me right with God. The only reason I had been punished all those dark years was because I wasn't square with God. This was going to change everything; I was sure of it. God had certain expectations outlined—just like school and Sierra did—and I would find that checklist and obey instantly and as perfectly as

possible. I read their scripture stories and memorized and recited them. I was baptized and confirmed as soon as possible. Now with the Mormon church, I knew exactly what God wanted, and I could please him directly and lift the curse from our family. I was reassured that God did love me; I simply had to obey.

Then my greatest childhood nightmare came true. I remember it feeling like a bomb went off in my head. It was the day David stood in front of the newly baptized me on the porch of our lovely home, next to our lovely church, and my mother *smiled*.

She took him back.

I was devastated and terrified. He had hunted me if I didn't eat. He had taken my siblings away. He had ruined our little life. He caused fighting wherever he went—they fought, his parents fought, my grandparents fought, all together or separate, it was all contention! His eyes were wicked like a tiger's, he lumbered like a bear, his teeth were white, and his tongue lashed words like a snake. His sarcasm towards me always shattered my heart. He was destructive to everything I held dear.

I struggled to find an emergency lever in my mind. WHAT CAN I DO? *How can I control the situation? What can I say?* My brain was like a panicked rat in a maze, sniffing desperately for a solution.

The solution came to me after dinner one night—I remembered! I ran through the words in my mind, careful not to stumble or stutter, although when it did come out, it didn't seem rehearsed at all. In spite of my preparations, it came out in a feeble squeak. I hoped she would scoop me up into her soft, strong arms right when I said it and understand everything immediately. As bedtime approached, I saw an opportunity to talk to her without David around. I followed her quietly, looking for my moment.

"Mom . . . ?" She was busy locking the child gate, so I ended up talking to her rear end by accident.

"Yeah?" she replied offhandedly.

"You remember how you told me to tell you if anything made me scared or uncomfortable?"

She stopped what she was doing and turned toward me. She actually turned and LOOKED at me! Most of the time I prattled on as she accomplished tasks or cared for the babies. Hope bloomed in me.

"You remember you said that?" I asked again, careful to use the exact words she'd chosen when she told me long ago. I had to be sure that she was onboard for this discussion—hook, line, and sinker—that she knew the subtext of this conversation: *This is serious, mom. Listen to me!*

"Yeah."

I glanced quickly towards her bedroom, my heart pounding in my throat, the ticking time of the opportunity was very obvious to me. I knew David was in there, but I couldn't see him. I hoped that meant he was otherwise engaged, but I made sure to talk extra quiet anyway. "I don't want David here. He makes me uncomfortable. I'm scared. You have to get him out of here. You said that if it made me uncomfortable, you would fix it, if I told you. Make him go." I glanced again—relief!

My mother smiled and laughed a little, and my heart started to break. She smoothed my hair and told me it was all going to be okay then moved into her well-rehearsed self-justifying script.

"He has a job and money . . . ," she started.

"But—"

". . . we'll get a big house . . ."

I started to protest that I liked THIS house. She cut me off, ". . . things will be different. . . ." I had heard it many times in my short eight years of life, and it wouldn't be the

last time. She urged me and coaxed me and wedged me into the room and shut the door before I could protest.

I was crushed. Beyond crushed. My ace-in-the-hole, which I had finally tested, was not as powerful as I had thought. I was powerless to stop her from riding this roller-coaster again. I cried in my living nightmare. I prayed that David would simply disappear. That maybe this wasn't real, or he wasn't, or that he could just leave and not come back. I snuck downstairs to find them passionately engaged. It made me ill, and my depression swirled and deepened. I cried until I fell asleep. God wasn't going to save me after all.

We moved less than two weeks later.

Entropy

As we packed up our belongings yet again I found—hidden far away in my mother's piles of papers, lumps of laundry, and stashes of momentos—a single, tiny photo album, about the size of an adult's hand.

I had never seen the album before, but I knew what it was. Our mother had talked of our long-lost sister only a few times. I thought she had forgotten her just as we all had, but now I knew that she remembered all too well. I held in my hands the proof of her private hurt.

I peered inside, expecting to see photos of us, but what I found instead surprised me: photographs of a little blonde-haired, brown-eyed girl stared back. Her name bubbled up to the surface of my mind: Nicole. The photos showed her riding a beautiful tricycle, hugging a clean, white bear, and ecstatic in a room filled with toys—most notably a doll-house taller than she was. She was dressed well, her hair clean and her face lively, and she stood proudly by a beautiful, white wooden four poster bed like a princess.

I looked at her happy life filled with toys and dresses, and it hurt. While we sat here, miserable and moving again, she had a wonderful life, the attention of her new mother, and the secret devotion of her old one.

That's when I learned to covet.

··• ●••.•

The house was as David promised—much bigger than the shoeboxes we were used to living in. It sat on a large piece of land that abutted a horse pasture. It was next to train tracks and corn fields. It was idyllic. I got a room all to myself, and we hung a pink unicorn sign with my name on it. I hated that my mother was trying to win me over with a house like this. But I also liked it.

The boys, Alex and Brandon, loved the treehouse in the backyard. The girls, Ashley and Becca, loved the toy room in the basement. I loved the rusted bars next to the shed that I used as monkey bars. It was the end of summer, so we spent most of our time out of doors, with the wind chime tinkling as our background music and the position of the sun in the sky as our only clock. We all enjoyed having pets for the first time—there were dogs, cats, and chickens. There were even horses to pet if we walked down the dirt path to the west. We played until we had calluses on our hands, we reeked of dirt, and our eyes stung with exhaustion. David was gone often, as the life of a truck driver often dictates.

I faintly remember my "rich" grandpa pointing out the empty fridge on a visit and then coming back later to fill it with bread, milk, a sack of potatoes, and, most amazing of all, meat. I didn't worry yet.

During the second week of our stay at the house, I explored a lot of territory: the corn fields that hugged the train tracks next to our house, the chicken coop where I was pecked at, the living room filled with angry screams after bedtime. This was just like Colorado and Illinois again. The safety was with the sun, and I started to fear dusk. I couldn't always understand the words that Mom and David said to each other, but I could hear the angry tones. Whatever they fought about, their insistence left me

shaking, my heart hanging in the pit of my stomach. Sierra once caught me listening to them and sent me to bed. My room felt completely overcome with darkness, and all of the sudden I didn't want my own room anymore. I wanted to find comfort in a flock.

A few weeks passed, and I went to my first day at yet another new school.

In general, attending a new school every year was daunting—being the fresh punching bag for some new bully was depressing.

I think my mother knew that. Even through bouts of homelessness, another divorce, or a job loss, my mother, caught in a trap of her own making, would sometimes remember my pain and try to cheer me up.

I found notes written on the napkin inside my lunch. I found smiley faces and balloons and hearts on a random page of my fresh notebook. She always wrote my name so beautifully, and it was in that moment that I remembered she had picked my name out for me long ago. My name had been treasured next to her heart for years before I took up residence in her womb. Her semi-cursive handwriting sprawled across the page and mirrored the way she spoke when in a loving mood.

Her notes spoke of beauty inside and out; of intelligence, of kindness. I believed them almost as much as I believed what she said to me when angry. She seemed to say both sides so easily, I couldn't believe she was speaking anything but truth.

By the time I returned home in the afternoon on my second day of the new school, I found police cars at my house. I searched for clues on the scene like a small, freckled Nancy Drew. My grandpa, the felonious enforcer, was more hostile and wordless than usual. David's parents sided physically and emotionally with their son, standing opposite my grandpa. My mother seemed alone, even though

her father was there. I knew this meant goodbye, so I escaped to the treehouse with my tiny brothers. We wept on the sandy, wood floor, our sweet dogs looking up at us from their tethers as the sun set on our last day in this home. My grandpa's live-in girlfriend, Brenda, went into the house to tidy and pack without first comforting us. Her daughter, older and wiser than us, seemed hesitant, then decisive, and joined us in the tree house. She was hopeful and positive as she tried to comfort us. I was happy that David was gone, but I knew my siblings were losing their father, monster though he was, and that had to be painful.

I moved through our spacious home one last time and realized that it was spacious in all the wrong ways; it had enough bedrooms for everyone to remain separate and alone, a bare kitchen, a mostly white and hollow fridge, an abandoned backyard, and an empty driveway. There were no mismatched frames of happy family memories, no love gathering in corners. Hope had been there, then died and settled like dust in the bright, uncovered windows. I found myself relieved to be leaving this graveyard of our dreams, then I turned toward the future at eight years old, hoping there would be warmth waiting for me there.

Homeless again, we drove silently to Grandpa's house. Our things were unloaded into his basement, and we slept on his living room floor. The morning cold on my face froze the expression I had made in my dreams. I reeked of tobacco. Dark bags took hold beneath my eyes. And as my mother hastily brushed my hair in the early hours before school, she didn't seem to notice that my eyes were tired and worried. My face was pale beneath the freckles. Life drained from me as I searched for meaning in our wretched circumstances and in our broken family. My hair was as awkward and unattended to as my heart felt. Cowlicked, rumpled, and frumpy, I started off to another new school. This time, I hid behind my third-grade teacher and my

giant purple coat when she introduced me. *Who could love me? Who would want to be my friend? Who would treat me fairly?*

I don't remember a single friend from school. I remember coming home after terrible fistfights with both girls and boys. The pattern of bruises on my limp, skinny body added to the awful ambience of my rejected soul.

When the news came that we were moving, I was relieved. We had been on a waiting list for a government-subsidized duplex for quite a while, but we finally received word that our application was next in line. Happily I transitioned from the smoke-infested rooms of my grandfather's Spanish Fork home to a sparse, clean, three bedroom home in Provo.

As we zipped back and forth from Spanish Fork to Provo on the I-15, hauling our few belongings in the back of the Ford Windstar, I got a view of the Utah Valley to the East. I saw the massive triangular shapes dusted in white, the long lines on the face of the mountain looking like clawing hands. We passed signs for Las Vegas to the South and Salt Lake City to the North. Walmart to the West. Hiking trails to the East.

Late one night, as the toddlers nodded off in the vehicle running at sixty-five miles an hour, I peered through my window to see lights up on the mountains.

"Mom, why are there lights up there?" I pointed out a line of pale yellow lights that stopped halfway up the mountain's face.

She glanced briefly from the freeway. "Hmm? Oh. Those are houses."

My eyes widened at the new information. "People live jutting out the side of the *mountain?*" I breathed in disbelief.

My mother made a grunt in the affirmative.

"Isn't that dangerous? Do they have no other place to go?" My curiosity bubbled up.

"It is a little more dangerous; you have to build a home in a special way. Actually, the really rich people live up there on *purpose*." Sierra said with an accusatory note in her voice.

I couldn't imagine why. I stayed quiet, in case she wanted to speak longer instead of ignoring my chatter by blasting the radio.

"Yep, that's the rich folks up there. Using all their money to build fancy houses that look down on everyone else in the valley, while the rest of us struggle." My mother took a swig of her thirty-two ounces of Pepsi, which she ordered "with very little ice" from the Crest gas station drive-through every morning for breakfast. This time I knew that she took that drink to sweeten the bitter thoughts on her mind about rich people.

I peered even closer at the lights on the mountain, maybe hoping to glean a little more information from the tiny white specks peeking out of the trees. I immediately adopted my mother's prejudice against rich folk, but especially ones who built their homes on the hill.

How ironic that I would grow up to marry one of them.

The Glass and the Ghost Children

By my ninth birthday I had stopped playing pretend. I knew it was silly, and I gave it up willingly. I didn't imagine anymore. I scoffed at my siblings when they brought up impossible things, like being able to fly. I hated movies like *Peter Pan*, or *Alice in Wonderland*, or even *Cinderella*. If magic happened, I wouldn't have been hurt. If wishes came true, we would have a warm home and be a happy family with a dog. If prayers were heard, God wouldn't have put so many awful things in my life all at once, and He would have told me He loved me. I couldn't see any evidence of that.

My own pain caused me to make sure that my siblings hurt too. I was critical of their attachment to stuffed animals that had no heart. My mother started to leave me alone to babysit the kids; whether it was legal or not, she left at every opportunity, uninterested in my feelings or the look on my face. They became my kids, and I bossed and ordered them around. I mimicked my mother and exploded with rage when they made mistakes or disobeyed my orders. When I didn't know how to handle their rebelliousness, I smacked them and fought with them just like I saw my mother do. I never had fun and was convinced that fun was unnecessary. I instantly grew up and went to work on household tasks. I wasn't a child anymore; I put away childish things.

I even acted like an irritated parent to my own mother when she had her giddy, manic episodes. Every once in a while, she would crack a playful smile with me. Mostly, I waited up with the work and the children to glare at her drunk ass when she tiptoed into the house at all hours of the night.

I found solace in school and stories. School provided me with a library to linger in during lunchtime, and was filled with kind teachers and librarians to befriend. I knew that I could go to them for help, and I did. They watched over me in their flock like mother hens. They handled my family's strangeness with wit and wisdom. They never lost the sparkle in their eye, even when they heard my stories.

I searched for strong characters who fought bravely in literature. Early on, I treasured C.S. Lewis's *The Lion, The Witch, and the Wardrobe*, J.K. Rowling's *Harry Potter*, and Dahl's *Matilda*. Annoyed a bit with fantasy, I started a quest to only read books about *real* people who *really* lived. I was drawn to the tragedy of the Titanic and admired the true biography of Pocahontas. I longed to know that people survived horrible events. Since I could not find any stories of daughters in horrible single parent homes at the elementary school library, I faintly hoped I would write the first one to help some lonely child like myself.

Like Matilda before me, the library was my only exposure to the world of knowledge, both with books and computers that accessed the internet. My mother gave me MTV and Madonna. We never could afford internet or a computer at home, so I started to search Wikipedia with all my questions my junior year of high school. I bought my own cell phone at eighteen, and even then, texting only became mildly popular my senior year. Facebook was released to college students in my freshman year of college—it was non-existent my whole childhood. In my little world, if I didn't have the library, I spent my nights reading

the labels of shampoo and toothpaste—I could not pronounce the ingredients, but I could read them!—bored to tears without school.

My memories of my school and home lives are utterly separated from one another, and to a certain degree, unlinkable. My life in school was dreamy and perfect, and my life at home was troubled and fearful. They were two worlds; two lives that rarely intersected. I felt safer in the walls of my school than I did in the walls of my own house.

Sometimes I asked to go to the bathroom during class time just to wander the quiet halls without fear. I would stop and read every plaque, examine every picture, and run my fingers against the walls to feel the texture of painted cement brick. I trusted the doors that locked. I looked out windows and only saw blue skies or Christmas snow—no dingy parked cars signaling little sleep, no televisions spewing unwholesome stories, no adults who didn't belong. Everyone had a name, a job, and a reason for being there. There were clearly defined rules and even clearer values of kindness and learning. Everything had a place. Things made sense. Adults could be trusted, and they came back day after day.

Still, socially, I was nothing. There was never a year of school that passed without bullies and ridicule. The hunched and humble way that I carried myself must have made me seem like such an easy target. I had learned early in life from my beloved Granny not to stand up with confidence or look others in the eye, especially boys. I never felt right asserting that I wanted something to stop, or to be left alone. I didn't want to hurt anybody else's feelings the way that mine had been hurt—for any reason.

In first grade I was pursued by a loud, cowboy-boot-clad, redheaded troublemaker. He would spend days stalking, chasing, and hunting me. I never told him to leave me alone; I simply avoided him, hoping he wouldn't notice me. He

would knock me down and whitewash me in the snow until I couldn't breathe. The further I moved out to the snow-covered soccer field, the more he tried to overpower me. After he kept my head in the snow, turned my puffy insulated body around, and touched whatever he wanted, I learned to stay in the herd at all costs.

Second grade, third grade, fourth grade—every new school, every new start. I could recall five separate elementary schools. Every year I was an outcast. My clothes were rumpled and second hand. I didn't know how to style my hair, and I always looked sick and exhausted. I was too eager, too hyper, too loud, too smart, too withdrawn and scared, and I was always the teacher's pet because I enjoyed school and loved to read. My buck teeth, my freckles, my flat hair, my skinny sickly body, my pale skin. Nothing I was or did was right. I befriended outcasts—girls too fat, bespectacled, tall, or simply not white—and they taught me how to keep my head down, especially around predatory boys.

There were some years when my only friends were the teachers. Some spent their lunch hours listening to me. Later, school counselors became my confidants. Librarians reminded me of my Granny as we talked. They were introverted, and I treasured the beautiful worlds they shared with me. They showed me how to turn inward.

Children may have mostly hated me, but at least adults adored me—even trusted me. With them, my good-girl behavior was handsomely rewarded. I always succeeded, got the best grades, and loved competition. School kept me wholesome and hopeful. It was like stepping into a fairytale for hours every day. It made me realize that the problems I associated with my life at home were not permanent or intractable. I aspired to be a teacher, and my teachers encouraged this goal. They shared with me—like a newly initiated member of their hallowed profession—how they had done it: Teachers attended college. I knew that my

mother hadn't been to college. It didn't occur to me that this should stop me from wanting to go, so my dream was born. I wanted to go to college like my teachers had. I wanted to be smart, and helpful, and share a heart of gold like they did.

With the Birds
I Share this Lonely View

I was always hungry. I woke up hungry, quickly filling myself with anything I could find . . . usually 2% milk and *King Vitamin* cereal. WIC (The Women, Infants, and Children Program) and food stamps paid for certain brands of food, but you could instantly tell from the packaging which types of cereal were exclusively funded by the government. I must have read the lame box a million times. I found out very late in my time at school that I was eligible for both free breakfast and lunch at school, which could have saved me so much trouble and frustration in my academic career. With the meager breakfast I usually had, I was often hungry again before the first hour of my learning had passed. I could not hear my instructor's precious jewels of wisdom over the crash of my sugar high or the dull whine of my stomach. My limbs felt lifeless, and I learned to tell time quicker than I normally would have cared to—lunchtime was at 11:20 AM. I would despair when I glanced at the clock's white, open face to discover it was not even 10 AM! At recess I could usually find something discarded, and I never missed a brightly colored wrapper tumbling forgotten around the edge of the playground. To

my disappointment, most of them were light and empty. Anything truly tasty was sure to be gobbled up to the very last crumb.

Combining my cereal at home and my very tiny portion of breakfast at school gave me the energy to concentrate and engage in class. I especially loved school lunches when they were warm. Pizza, french fries, hoagie sandwiches. Even sloppy joes—though the mixture was a little spicy with green peppers—were a delight; I skipped to my line everyday. I was always at the front of the line, even if it required a bit of sneaking or pushing, not realizing in my innocent youth that my actions said so much to onlookers.

I'm not sure when exactly it happened, but early in my school lunch career they offered chocolate milk alongside white milk. It was like Christmas every day! My favorite drink in the whole world all to myself! There was never a day it was offered that I didn't scramble to get my carton at the end of the counter, the chocolate milk being like a happy exclamation point on the end of a very welcome sentence.

I would not claim that this situation happened often, but sometimes, that lunch was the only meal I got. It was certainly the best meal I received throughout most of my elementary school days. It brought great joy and I am thankful for every single calorie that filled my little body.

In my adult life I have often been asked how I could have gone hungry with food stamps, WIC, and school meals. People were incredulous that all of the programs in place still left me wanting. As a child I didn't understand it, but I recalled my mother often offering to drive my handicapped grandmother to the store. My enabling grandmother would load her groceries on the conveyor belt, and my mother would orchestrate a way to pay for the groceries with her own food stamp card. We would load her groceries into the trunk and Granny into the passenger seat clutching her plain, black leather purse, her

metal cane in between her knees. From where I sat I could see my Granny carefully unbutton her billfold and silently slip my mother the cash she would have used for the newly purchased groceries.

Who knows where that cash went.

We Don't Belong to No One; That's a Shame

My weekends away from school and Sierra were not always spent with my Granny. My mother's first brief marriage when I was a baby had Eric legally tied to me.

He worked at convenience stores and doughnut shops that paid little, and his child support for a child he didn't produce cut into that already tiny paycheck. He was an artist at heart, he said, but that doesn't pay. The only art the residents of Utah County would pay for was his homemade tattoos. I suppose a visit now and then was my mother's apology for the child support mess. Or maybe, she just wanted a babysitter.

And what a babysitter he was. I would enter Eric's girlfriend's mother's house where he lived and get a mere seven uncomfortable minutes in the living room. He asked me one or two basic questions while playing video games with his buddies or his latest girlfriend. I got startled every time they hollered and whooped at the outcome of the virtual race, mission, or fight. The girlfriend's mother was a shriveled, tired, and bowed-over lady with no courage left in her. The only time her mouth didn't look like it was full of lemon juice was when she handed me a porcelain doll

and a faint smile struggled to lift cheeks that carried the weight of many difficult years.

The doll was my only ally, and I held to the expressionless thing tightly. My legal "father" Eric would then take my bag and direct me by my arm to a far room. Even when it was still light outside, he told me to go to bed and not come out. The guest bed itself was dusty, and there was a 13-inch screen CRT with a VHS player in it. The noises from the living room bounced down the hallway and off the wooden floor as it seeped under my closed door, so I could always be assured that my "guardians" were up to no good. Particularly rowdy outbursts would make me jump with fear throughout the long nights. The only VHS tape to watch was *Apollo 13*; the television reruns were always my babysitter.

I spent those nights intermittently waking to noise and confusion about where I was.

After getting up the courage to complain, one thing improved—I got a coloring kit to keep me company. I even got to use some oil pastels like my "father" to create a sunset above the ocean—which was lovely because it was double the sunsets with the reflecting water. Eric promised to take me places where I could add precious rocks to my rock collection, and his girlfriend promised to let me have fake acrylic nails for my birthday, but the two were soon so swallowed up in the drug culture, work, and their own children that they forgot I ever existed—which was fine by me.

I Won't Tell 'Em Your Name

Martin (last name—he never went by his first name) was a horse of a man. Muscle everywhere underneath a muscle shirt. My mother's latest catch was plenty of fun—every week he took the entire family on dates, not just my mother. I'm sure other men had thought of that brilliant idea in the midst of a sober period, but taking seven people anywhere—even if it were a free activity—was costly enough to deter it. It was a treat indeed to have fun every week!

That we did all sorts of adventurous things was surprise enough, but it was all the more surprising that my mother attended since she was not the active type. After learning in school about food and weight, however, I realized how out of shape she was. Perhaps in this circumstance, her changing for a man could be a great thing for our family. He made us low-fat meals and protein shakes to drink. Martin took us on all his adventures, and I admired all his varied interests and his passion for life. We biked on trails, hiked and went rock climbing in Utah's canyons, went swimming, and and even watched him act the part of a vampire in a local play. Poor Brandon, the baby of the family, was terrified of him for weeks after seeing him on stage. It felt like we were a real family, enjoying real life, just like I saw on television. It was so nice to be an involved

family, as a group, instead of watching my mom always try to escape us through men.

I was wary of him, but he was creative in the ways he infiltrated our lives. He understood how much I didn't care for any of my names, and he helped me come up with a nickname that I could own. "KaShae!" He exclaimed on a hot, summer day in our dining room. "It takes the 'K' from the beginning of your name, the "A" from the end of your name, and add your middle name, Shae. *Kashae!*" It warmed my heart, and I thought the name was unique and cute. He started to call me Kashae to garner loyalty, and it worked.

My mother quickly married Martin, and we moved into a government-subsidized, beautiful four bedroom, two bathroom house in Southwest Provo. Sure, I had to move from Westridge to Sunset View Elementary School, but the house had a backyard. It was perfect. I don't remember the ceremony, I just remember her proudly displaying the cake topper in the kitchen and finally wearing a wedding ring again. I thought we could build a real home there, and we settled in happily. My mother took a night shift at a call center and my stepfather cared for us multiple evenings during the week.

In a summer's time, we became the Martin children.

Our happiness with the arrangement soured and left as quickly as it had arrived. First, he stopped taking us places after they were married. We never went anywhere anymore. No more family nights, no more activities. It was as if he had courted us to get what he wanted, and then immediately stopped being fun once the deal was done. Moreover, my mother had promised that I would have my own bedroom in this new house, but after a very assertive discussion from Martin, my mother buckled (she never buckled!) and agreed to make it half-office or study for Martin, as if his one bedroom wasn't enough.

I was once again critical and cold to the temporary man in the house. My mother seemed to bend to his will at every turn. They started fighting at night once she got home from work. I could hear him shouting her down, and I imagined her back pressed up against the door. His voice travelled easily under the door and rang through the linoleum-clad halls, "Don't you fuckin' talk to me when I'm talking!" At ten, I knew what this was. I had watched enough *Lifetime* movies at Granny's to know that all men were scum. Trying to be brave, I gathered my scared siblings under my arms like a mother hen. They sobbed and cried, and it was then that I suddenly realized that I didn't have enough hands—I couldn't protect them from what was assaulting their ears. The door started shaking and my mother made noises, although to this day she swears he never hit her. Since I couldn't do it myself, I told them to cover their ears as we huddled in terror.

I tried to remember what you were supposed to do when you were scared. Grabbing at a faint memory, probably from some Disney movie song, I had them "laugh their problems away." We aimed our laughter, through tears, at the door that stood between us and the one-sided fight we heard raging in the hallway. He eventually heard what we were doing, and with his angriest tone and most colorful vocabulary, told us to shut up and go to bed. I didn't think it was right to sit in the hall all night waiting for this to end, so we disbanded.

As their pseudo-mother, I snuck into their rooms and comforted each sibling in their bed, but I knew it was no use.

Eventually, the anger died down and the sick feeling in our stomachs unknotted enough to allow us to slip into a blissful escape.

Every day after school we had to complete our chores and our homework, and then we were allowed to watch television. It felt great to have a schedule, and Martin was

strict about it. In spite of my feelings towards him, I took his word seriously and excelled with the structure.

I could never read Martin the way I could sense my mother. His anger was low-burning, always simmering, and he sprang to total violence out of nowhere. The rage escaped like a brush-fire—it could go from faint sparks to roaring hazard in seconds, and you were never sure what would fan it. Because of his temperament, my tailbone rang and sang in total fear any time I saw his giant figure appear in a doorway.

Once I didn't do my chores correctly, so he proceeded to pull the hairs on the back of my neck like a kitten and march me through the house. He pushed my face into my failed tasks like he was house-training a dog. He threw me up against the wall by my neck and let my head rebound again and again against the wall—smiling as he did it. I wasn't sure if it was something I could tell my mother about. After all, ten-year old me reasoned, I *had* been wrong, and stupid, and lazy, and it's not like he left a mark.

Next, I saw him rage at Becca, who was about four, and I followed him as he dragged her violently to her room. She was to have time-out on her bed. Martin proceeded to throw her skinny body onto her metal bunk bed, and her skull hit the metal post as she flew through the air. Martin marched out of the room unapologetically and shut the door on her, and I backed away as quickly as my legs would let me. He didn't seem to care that I had seen it all.

After being yelled at and spit on repeatedly, I tried to devise a way to talk to my mother without him intercepting. Dread rose in my gut whenever she grabbed her purse and prepared to leave us alone with him. I remember trying to once to catch her and being intentionally intercepted by Martin before I could speak to her, as if he knew what I was about to do. He saw her out the door, and she was gone for

the night, with nothing but Martin's victorious smile to let me know he knew what he was doing.

I knew that if he found out about my "reporting" I would have a nightmare to face. I wasn't sure if I was right, or what my mother would do. My young mind raced at the chess game against this grown man. *It would take a miracle to win against such odds.* My heart fell into hopelessness at the thought. God hadn't granted me a lot of wishes in my life.

That night, before our strict bedtime was enforced, my sweet brother Brandon had gotten in trouble. He was sent to time-out to sit in a corner, for "doing something stupid." Martin circled him like a vulture, so I passed from one room to the other, pretending to be busy and glancing down the hallway. I could always smell impending abuse.

Martin-the-vulture descended into shouting. Brandon quietly looked at the wall. I couldn't tell if he was defiant or broken because his face lacked any muscle movements. He was such a tender soul. I panicked and went hot in my impulse to defend him from the next blow. Martin grabbed the back of his neck, and I felt ice through my veins. *I am the witness!* Rang through my head.

"Bend down!" I heard him yell while I hovered near the hallway. I came back again and stopped pretending. I was frozen in fear, unable to stop what I saw. Brandon was on his hands and knees. Martin had his hand on the back of the five-year-old boy's head, slamming it into the ground. Each time he hit Brandon's head on the floor, Martin quietly, firmly said, "You. Are. Stupid," punctuating each syllable with another strike. I was so afraid and unsure of what to do, all I could do was watch in tears, hearing every thud. "Stupid, stupid, stupid."

That night, I snuck a note next to the phone where Sierra would see it, right after she got home from work. The adrenaline kept me up well past my bedtime. The lower

half of my body was melting in despair, my upper half electric with anxiety. "Mom, Martin is hurting us a lot when you are gone. He slammed Brandon's head on the ground. Please help us. Come talk to me alone." My fifth-grade mind couldn't come up with a better explanation, so I decided that an in-person conversation would make it better.

I prayed and hoped God wasn't too busy to answer this one prayer, as He had been for so many of my other prayers. This one was important. I was sure if Martin saw the note I wrote, I would end up dead. My mother would never know, and after school he would have free reign to beat me until I didn't exist. *Please God, don't let him see. Please God, just let my mother see it first thing when she walks in the door.* I released all my hope when I carefully set my note next to the phone charging station, and snuck back to bed.

My kidneys ached; I was sure I had to go to the bathroom again. I picked at my nails and fretted like I'd seen my Granny do in emergencies all my life. I tried to think of other things, but the darkness crept in again at the corners and nine o' clock seemed like forever.

My mom approached the door, her voice soft, and so safe. "Keira, do you need to talk to me?"

I was full of both relief and anxiety at her voice— *My prayer was answered! She got the letter! It was still a secret! Would she believe me? Would this change anything? He had to leave!*

She came into the room and silently closed the door behind her. I hurried in hushed tones to whisper: "Mom, he hurts us. He's hurt all of us. He spits and screams in our faces. He threw Becca on the bed and she hit her head! He grabbed me like this—" I demonstrated by grabbing sharply at the back of my neck with anger in my eyes like he had for me, "and dragged me through the house. Then tonight he slammed Brandon's head on the ground and told him he was stupid, over and over again." I paused to search her

face, wondering how she was taking this. I expected her to be enraged and powerful, but instead it seemed she was carefully thinking about what I said. I thought she didn't believe me, but she seemed serious enough that I had hope. "I'm scared." I concluded.

Her comfort was short, her assurance small, but she had a set face and told me that I was right to tell her. I was still terrified, but not swimming in despair. A short time later, he was just gone. She had saved me from his wrath, which made me sick when I thought about how she accomplished it. I was so thankful.

I didn't have to carry that evil man's name ever again. Rescued dogs in shelters had more stable identities than I did. I hoped I would be Keira Shae Sullivan forever.

God Help the Outcasts

I stood at the bus stop in the morning with the fat, the pale, the hoary, the pierced, the belly-shirt wearers. They gabbed and gossipped, smelled of cigarette smoke like me, and reapplied lip gloss. I thought they were my friends, even as they heaped scorn and shame on me when I failed to meet their vapid standards. We were a pack of wolves. They would build me up and crush me with laughter and with one word, "Ka-SHIT." They were loud and crude, but my quest for acceptance had plumbed the depths for a group that would offer it. Here they were—good, bad, and ugly.

Everyone had a name for me, and each name came with its own constellation of meanings and expectations. I often wished that I didn't have any names at all.

I was a target for relational aggression. When I wore a dress to school, the queen bee of our grade would say that I lacked the beauty to match the dress. When I dressed down, I was slovenly. When I made friends, she was sure to tell them disgusting jokes about me. When I played soccer with the boys, I was an eager whore. When I hung out with the girls, I was a brown noser trying to fit in with the social bullies. When I danced, I wasn't trained well, when I excelled at school, I was teacher's pet.

Every time I walked past her house on my way home from school, I was gripped with terror: what fresh hell awaited me there?

I wished I was invisible.

•‌•‌‌•‌•‌‌•‌•‌•

My siblings and I were quite a clever pack. We recognized the cycle of feast and famine that came with the food stamp card being reloaded with money. The first week of the thirty day cycle was decadent: chocolate milk or juice to drink, not simply water; unlimited bread for toast with butter and a combination of sugar and cinnamon sprinkled on top, just like Granny made. Pepsi was in stock by the twelve-pack. The second week of the cycle was punctuated with more microwaved potatoes for dinner accompanied by cans of vegetables, and fewer sweets. The third week included more meals of ramen noodles or boxes of macaroni. By the last and final week, microwaved popcorn could be a meal. Our hunger made us inventive, and we devised a plan.

We were well-aware of our Christian surroundings and used it to our advantage. Becca was the smallest, most humble of the group, so we always had her beg the neighborhood for the most expensive item: a can of tuna. Brandon was the smallest with a beautifully round face and warm brown eyes, so if Becca was unwilling or unsuccessful, he would step in. Ashley was cocky, talkative, and smart as a whip, so she could get anything out of anyone. She could shoot the breeze and get a box of macaroni from the unfriendliest of people. Alex and I were softer—I certainly felt humbled—so our attempts were rare. I often burned with shame when my mother called me to beg. I learned her strategy quickly and foisted the task onto my younger family members. We would gather our scraps and combine the ingredients into one pot and all hover over the pan as I cooked, and

then waited for it to cool. Without dishing it out, we would greedily eat the entire pot and lick the wooden spoon. It was the same spoon used to beat our bare asses.

Confluence

I was ten, the next siblings were six, and the second set of twins were four, and we had already endured four broken marriages and several types of abuse. Bikers Against Child Abuse (BACA) came to our house (the whole organization, it seemed), and at least forty people showed up on our street. My mother brought out the camcorder she'd bought with the tax return money to immortalize our excitement. It was a frigid February day, made more harsh by the lack of snow. Utah was in a drought, so the grass was merely frozen into shards. Instead of a white Christmas that year, we looked upon the dead-yellow-gray that had greeted us the entire winter.

We each took a turn riding on a *real* motorcycle, and I think Alex was the only one who cried in the privacy of his room over such an experience. After the roar of so many engines, the neighbor children peeked out of their front doors and gaped in awe at our cool house. It was a parking lot of motorcycles! Some cheered as we rode past, and we waved proudly from our perch.

One of the BACA members was Becca and Brandon's preschool teacher at Mountainland Head Start, and she sat down on our prickly lawn to talk to us. Becca and Brandon sat near her, which was stunning to me. They never trusted

anyone. Alex wouldn't let anyone near him, but he was pretty happy, out of the spotlight.

"Let's be serious now. We are your family, now, forever. We're going to protect you. We're not going to let anything bad happen to you anymore." Her voice broke. I copied her emotion, knowing what she meant but feeling as empty as a drum. I had no feelings left in me. She meant well, but she wasn't our family. No one who had *said* they were family actually *were*. Boyfriends, husbands, my mother's varied 'best friends' all made the same claim, usually to get power over us. Even when they had the best intentions, we all knew that in a few years, we wouldn't even remember who they were.

The Biker Against Child Abuse-teacher-lady kept talking, "We brought you some gifts; open them!"

Each child got a plastic grocery bag. Inside were tooth-brushes, toothpaste, shampoo, conditioner (things that even food stamps couldn't buy), BACA stickers, and our own jean vests with the "BACA" symbol affixed to the back. "See? If anyone ever gives you trouble, you just show them what family you belong to. They'll learn not to mess with you."

It was painful for me to see total strangers give us vests and then try to force my very shy brothers to wear them. The boys would not even look at our guests, and they would not be pressured. My mother laughed nervously and all the other adults followed suit. I was just old enough to be embarrassed, knowing it looked like ingratitude. They just didn't understand my quietly stubborn brothers. *Just leave them be, they'll be all right.*

The girls eagerly opened their presents and threw on their jackets. My brothers were prey animals—the thing they desired most was most often the one thing they shoved and hid away. I learned this from watching horses. If the horses wanted to drink water, they didn't walk directly

toward it. They took their time with an unrecognizable pattern, finally, gingerly, sipping the water. You wouldn't know it then, but later, those boys never took the vests off. While they rode their bikes in the half-frozen Utah desert, they proudly wore the BACA symbol across their shoulders. We were the talk of the neighborhood.

Children's Justice

My mother and her "girls" walked up the stairs of a beautiful, old white house in Southern Provo, with a lovely lawn and shining windows. I immediately wished it could be my home. I remembered watching all those episodes of *Oprah* with my Granny—the ones where Oprah would give crowds of crying poor children and parents free cars and houses furnished with fresh beds and well-stocked pantries. Maybe these people would hear our story and give us this home when they were done using it as an office. The purpose of the house was clearly stated on its door: *The Children's Justice Center.* Soon after we got our justice, I hoped, it would read, "Our Family Home."

As we stepped inside, I was more convinced by the minute that this was a perfect home for us. The first room was filled with toys and comfy couches, and the fireplace mantle was flooded with teddy bears.

Each of my family members had a chance to play with the various toys in different rooms, and each room was themed and fun. Each child was able to pick their own room when they were interviewed, but I was the only child who was told that they were going to ask me questions and not just watch me draw pictures. I noticed a camera in the

corner of the room the first moment we stepped through the door.

To my great disappointment, the gift of the home never came. My disappointment quickly turned to rejection. As with most poorly attached children, the shock of not having what I wanted or needed led to rejecting the very thing I had hoped for—a pre-emptive move.

The Children's Justice Center gave every child in our family a trusted adult, calling them by a new word: "Advocate." It eased my disappointment to have visits alone with someone assigned to my broken heart.

We visited the home often, and my advocate would often urge me to choose activities with her at the Home, such as baking cupcakes or playing outside on the jungle gym, but I would always refuse. Why play in such a delightful home when you knew you couldn't sleep in it? Why play with lovely dollhouses that were never yours? Why snuggle into couches that were full of the smell of everyone, and walls with hidden angels you couldn't take home to watch over you at night? Once I realized that people in business clothing and shoes walked around in a place that felt like home, I had no interest in seeing something perfect ruined. I shoved memories of that place away.

Years later, when I went back to speak to the director and the entire board, I nearly cried as the familiar feeling of peace welled up from a buried memory. You see, when you bury the bad without words, you forget the good too. I forgot how old the building really was, but how white it still could be with loving care. I cried when I encountered the familiar smell, and when I realized how much tinier the house was to a twenty-four year old than it was to a ten-year old. The mantle with teddy bears was still there, now at eye level. The same old photographs and pamphlets sat, disorganized, in the same display. To my right was the forgotten hallway of a kitchen, where I refused to decorate

and eat cupcakes for Halloween. The banister to the up-stairs that felt so thick and sure and elegant in its stained wood was old, outdated, and tired, but still strong. This house radiated old elegance and hadn't changed a bit.

I was sure that the bad guys I reported just went to jail and that was that, but I don't remember a court case at all. My mom didn't seek justice. Child molesters and abusers harmed us without consequence for the damage they left behind. Thanks to their unpunished handiwork, I shrank from men for years afterward.

A few years after our abuse and visit to the Children's Justice Center, Ashley and I saw Martin in a mall. We shud-dered in fear as he walked near us. I knew that he recognized us. He saw us mouth his name to each other in horror. He was more pierced and tattooed than before and had a big-ger belly. I guess he stopped eating rice and rock climbing; that was never who he really was. I knew he was just a big pretender. He walked away without a word, to our great re-lief. But he was free. Free to lie to another woman, free to beat the word "stupid" into another child's head. It made me angry that no one had listened to us, though they pre-tended all the time that they were just "looking out for the children." How can you protect children if you don't take seriously what they say?

Kissing Queen

By my twelfth birthday, my mother started a rotation of seeing several different men at once, for each day of the week. Sierra started looking forward to drinking on the weekends; I started dreading them. I stopped keeping a list of the names of men that woke up in our home. The last page I remember writing for my Granny had a list of thirty-two men, and only *one* of them hadn't stayed at our house. I grew tired and depressed again at listening to them in the next room every night. I wondered what neighbors thought of seeing a different beat-up car outside our house each evening.

During the school day, I lacked friends and was bullied mercilessly by the physically dominant Fetu (a Samoan girl) and the socially destructive Lacey, but I found fun and validation in flirting with boys. I loved books, and I memorized radio lyrics. I wrote a poem about this brief period of time in my life, lamenting my wasted time.

> *Oh little girl of thirteen*
> *Trading in your beloved books*
> *For a couple good beats*
> *And title of kissing queen.*
> *From the pages of dreamers*

To the empty affections of teenagers
Living in your life of sin,
Bartered off, to be counted in.

My mother's rotating boyfriends would infrequently have an activity for all of us to enjoy. One man, Gavin, lived with his mother on a horse ranch. I hated the man but was willing to go along with anything for a new experience. *Just like my mother*, I thought. *Kissing and compromises to pass the time.*

Gavin bragged about "his" ranch as we walked up the muddy drive, attempting to get chummy with us because he had heard that we were impressed with his horses.

My mother had probably informed him beforehand that I was tough to win over, because he allowed me to mount a horse all my own. He handed me the reins with a confident smile completely inappropriate for a thirty- something man still living with his mother. "She's real tame," he explained. "I gave you the best horse."

I had very little to say to him.

My riding lesson came to an abrupt stop before it began. As Gavin closed the gate, the clicking sound frightened the "tame" horse and sent her flying. You would have thought he had branded her backside!

I was terrified into stiffness. My small hands pulled back, but it had no effect. Gavin had failed to tighten or cinch up my saddle, so I found myself sideways in less than a minute. I knew this horse could cave in my ribs; I held on to the reins as I started to fly off, screaming. I was dragged by the horse for some time. I suppose I always freeze in fear. I let go of the reins and crashed. My body would hurt for the next few weeks because of that landing.

My mother raced to me to inspect me. "Are you okay? What hurts?"

I cried into her shoulder after a few moments of silent shock. Nothing was broken. I was terrified of all the horses around me.

She saw my fear. "Keira, listen to me." I looked at Sierra, hoping for great relief and comfort. "You have to get back on that horse."

My eyes widened, and I shook my head violently before I could spew out, "NO!"

Sierra, the firm and powerful, the woman who called me "compliant," used a voice that came from deep inside her gut. She grabbed my shaking head. "Keira, if you don't get back on that horse now, you're only going to know how scared you are."

"I know, and I am, and it's because . . ."

"I *know.*" She interrupted. "But you need to know that riding horses isn't always scary. You need to face this fear now. Get on that horse. Just for a minute."

I looked at her, incredulous at what she was asking me to do. Did she really expect me to get on the thing that caused the bruises now taking form across my body?

"I'll hold the reins and walk alongside you." Sierra offered. I wonder now where she got her confidence with facing her fears. Was it in the amber fields of Kansas?

My compliant soul got on that horse. She walked alongside it, first taking worried glances at me, then smiling.

"See?" she pushed. "That's my brave girl. Now you know that horses can be good, too."

After I wrote this memory as an adult, I started taking horseback-riding lessons. There was something soothing about putting your trust in a beast that runs on instincts. I learned to listen to my own again.

I Gotta Take It on the Other Side

As pressure mounted, both within and without the school walls, I began to stutter. Normally the chatterbox, I withdrew and found myself less eager to speak up in public settings. My seventh-grade classroom projects were becoming science-oriented, and I couldn't utter most of the strange words. I was mortified when I tried to pronounce them.

In total dismay one day, I plastered myself on the couch. Ashley saw my dramatic pose and pried an answer out of me.

I opened one of my books. I pointed to a word. Ashley was far above her grade level for reading and understood the word immediately. I groaned, "I can't say this word."

She barely paused. "Oxygen?"

I nodded in shame; maybe she would tease me like my classmates did.

She shrugged, "Let's practice."

In my humility, I felt so small in front of her, yet she was four years my junior. I was embarrassed to feel this way, but the coaching made it plain that I was at another's mercy.

Ashley's fierceness pushed me past my anxiety, and her fire never dimmed as we repeated and repeated "oxygen."

In thirty minutes, I could finally skip over the word a bit, saying, "Ox-EE-gen," as she had suggested.

By the end of the night, my persistent, unforgiving sister had used her unfailing faith to help me utter the dreaded word.

I paused for years over it when I read it, but somehow, by pushing myself, I was able to pass my science unit.

My heart swelled in gratitude for my sister's talents.

Farrer Middle School introduced me to *The Diary of Anne Frank*, and I read it all in one night. I fell in love with everything about it—that she was my age, that she had a dark and difficult story, and being able to see the power of her pervasive and positive spirit. In her confession I found a connection to her. I found hope in learning about her. I treasured the book, and she became my teen hero.

That was when I realized that anyone could become a writer so long as they conveyed truth. It struck a chord deep inside me. My mother could sense it, and she bought me my first journal. From that point on, I never stopped writing. I poured my heart onto the pages with ease.

I never knew what to call myself, but I read Anne's book and cracked open the fresh journal—I even addressed it as "Kitty" and confessed my whole world to her. I hoped that these journals would be filled with my journey to becoming a model or an actress and would trace my path to stardom.

Instead, they were tear-filled places of refuge as the swirling storms of poverty, abuse, and neglect continued to rage around me. I found solace in dumping out emotions, and I found wisdom in reviewing and analyzing the writings later. I never wanted to stop. It was from the sprawling, tear-stained, and spidery hand-written pages that this book found its genesis.

Fire and Rain

The first time I saw Dan Cox was *after* hearing the noises he made with my mother in the bedroom, but that's how I usually met her boyfriends. I wasn't impressed. It seemed he had just recently dumped a woman in a trailer park who had two small (and physically handicapped) children and he had a drinking problem. Between my mother and this other woman, my mother was the more stable choice, even if she had three times the children in tow. She offered him a lift out of the trailer park, and he became a fixture in our family for the next four or five years.

Life with Dan was great—it was the first time in my life I remember not paying for groceries with food stamps or feeling the shame that came with brandishing the salmon-colored Horizon card at the register. We took our only family vacation—camping in Utah's mountains—because of him. We had *two* old cars and fairly great birthdays. The first few Christmases were overwhelming to the point of shock, and Dan had an endless supply of beer. It was also a time of indulging appetites for all of us—with trips to the "just expired" hostess outlet to buy all the snack cakes we wanted. Twinkies, Zingers, and handheld pies overflowed our pantries and we were joyful. Once, for my fourteenth birthday, he asked me what I truly wanted. Then we went

and bought just that—a pair of skater shoes, *from the mall*. Only the popular girls could afford those. Finally someone had a heart to see outside themselves—even if it was to help a teenager who didn't always reciprocate.

I would come in late at night just to talk to him, and he really listened to me. I'd lie next to him and he would rub my back, even though he was so exhausted from his night-shift as a welder. His hands were perfect—always dirty, but he kept his nails short and slathered his hands and face in petroleum jelly, so they were never harsh.

I'd share my perspective on the fights I'd recently had with my mom, and after he understood, he'd try to help me see hers. In the end, he would still agree with me that she was fiery and difficult, not logical, and impossible to convince when she was sure she was right. Life was easier with a peacemaker in the home.

He asked me about school and often told me how much smarter I was than him. After he had tried to write me a few notes of appreciation, I realized I was a much more dedicated student than he had ever been. Then I realized I didn't really mind. I would share my writing from my journals with him. After September 11th, 2001, I expressed my fear at what the world at large was capable of, and yet how it seemed nothing had changed in *my* world. I wrote a poem.

> 9/11
> *Downturned mouths*
> *and tears to cry*
> *Everyone watching*
> *and wondering why*
> *Why something had*
> *to happen like this?*
> *All of those people*
> *We'll greatly miss.*
> *We are all angry,*

sadly so.
We are all hurt,
but this, I know;
Up in heaven,
they all wave
To the land of the free
and the home of the brave.

Dan put me on cloud nine with his awe of my expressive writing. In offering support in a way I had never seen from one of my mother's boyfriends, I realized that I loved Dan like a father. What's more, I trusted him. When he argued with my mother, I placed myself firmly on his side, and when a disagreement escalated to threats of abandonment, I secretly hoped that he would take me with him to raise as his own daughter if he left. We could go fishing together, and he could explain to me again the science of carving trees. I didn't mind his smoking; he never made me sit in a smoky car, and he never blew it in my face like my mother's other acquaintances. I didn't mind his drinking; he wasn't a vile drunk like my mother. Alcohol made him friendly and hilarious if it even changed his behavior at all. He would sit with all of us for hours when he was drunk. It wasn't his vice—despite my mom's frequent accusations that it was. For what I'd seen, it seemed to make him act all the more virtuous. I felt that alcohol helped him see me more clearly and tolerate my mother's moods more readily. I'd lived with her for years . . . I could never hate him for drinking it.

Since he had not married my mother, it was easy for him to walk out when things got heated. And he did. He lived a block from his mother's home, so he would take a clean shirt or two as my mother screamed and quietly walk out. I asked him why he always walked away.

Always a man of few words, his answer was, "I'll never hit a woman. I figure I'm the trouble, so I just leave."

Semi-Charmed Kind of Life

I don't know when I started to notice something was wrong, but something was wrong. My mother suspended herself from her job for "health reasons" I didn't understand. She was "tired all the time." She claimed she had depression. Even with the loss of her income, Dan must have been making a lot because we never ate more decadently. There were days I would have more than one Twinkie for a snack. With my stomach full, I didn't ask a lot of questions.

Things didn't add up. Money wasn't tight, though my mom had lost her job. Dan and my mother would stay up all night, but he would still go to work as a welder the next day. At times, I would catch them wearing a look of bleary, blissful happiness that flew in opposition to the difficulties they faced or the amount of sleep they were getting. My late-night reading binges afforded me a clear view of their nocturnal lives, and oh, how lively they were. Night after night they would retire to the bedroom and do one of three things: play Yahtzee (complete with the sounds of die being cast and raucous laughter to accompany it), have loud sex, or sit in total silence with the light on. The last one scared me the most, as I knew they were awake, but the door was locked and no one would answer me. My mother slept all day and became a dragon when awakened.

My mother left the bedroom less and less until eventually she just stopped leaving it at all. She ate and drank exclusively in there, and a fetid smell started to permeate the room. We rarely saw her and tiptoed around her presence, even her bedroom door. She showered less frequently and was in a state of anger until Dan came back and they could lock themselves in again. It was like she was hungry for something all the time. The aura about her and the room filled every one of us with dread.

We became autonomous. We knew how to run the house, except the laundry. Dirty laundry piled up in her room in baskets, and she never could pull herself out of bed to do it. When really desperate for clothes, Dan stepped up. I wondered why he was being so understanding about my mother's complete laziness. I began to hate and resent her because she drove us like servants and would whistle at us like dogs. I seethed. I did dishes, made dinner, played "mom," lost my chance to be a child, while she grew to monstrous proportions on her pile of laundry and Hostess Ho-Ho wrappers. She reminded me of Jabba the Hutt.

With the newfound income from Dan I started going to the dentist and doctor more, only to discover that my mouth was a mess. I knew that my teeth caused me headaches. I knew that I had a habit of grinding them at night in stress. I knew some of my baby teeth hadn't fallen out, but I didn't think anything was seriously wrong. I was surprised to hear that if I didn't have oral surgery and braces I would lose my front teeth before I turned thirty. My eyes widened in horror at the news, but I couldn't give words to my fear with the dentist's fingers in my mouth.

After an account reckoning with the front desk, I found I was thoroughly privileged (and my mother thoroughly

relieved) to have a significant portion of this orthodontic cost covered by Medicaid. They usually wouldn't pay for braces, I thought, since it was cosmetic, but they made a special exception when tooth loss was on the line since it could affect my ability to be nourished.

It was a happy coincidence that Dan came into our lives when he did. They weren't married, so in the eyes of the government, my mother was still a poor, single mother with five children. We received all the benefits of that demographic category—subsidized living, food stamps, medical insurance, public education, free school meals, bus rides—but because of Dan's high-paying welding job, we could maximize these benefits and afford my braces. It was probably illegal, but at the time I couldn't care less. My mouth was killing me! Even after all the the government help, we still had to pay an extra $100 every month plus the deductible for the oral surgery.

We scheduled the oral surgery almost immediately and removed four impacted wisdom teeth and removed my milk canines. With those out of the way, they reoriented my adult canines to stop them from destroying the other teeth whose roots they threatened. From there, the braces would force my teeth to "grow" down into the right location.

I came home from surgery in a narcotic daze, my body not working correctly. It was my first experience with the effects of drugs, and it made me ill. I lay on the couch for days in pain.

I was given a bottle of Lortab when I left my appointment, and I vaguely remember that my mother took it from me. She said she needed it to help her sleep better. I barely nodded my head, confused, but too tired to protest much. She shoved some ibuprofen my way and left with the full bottle, which I never saw again. Perhaps she used it. Perhaps she sold it to pay for the costs I was incurring.

My overbite, buck teeth, and crooked teeth would align and disappear! When my wits were back about me, I was thrilled, looking in the mirror at my mouth for hours and imagining what I would look like with my movie star smile.

Things were looking up.

Rest in Pieces

The summer before high school, I was full of hope and promises to myself. With a new school, more choices, and the "best years" of my life ahead, I decided I was going to be different. I was going to take better care of myself, keep myself nice and pretty (unlike my mother as of late), and become popular. I started staying over at friend's houses to get away from my own, which was decidedly imperfect. I made avocado face masks (what a luxury—expensive food used on my skin!) and painted toenails with my girlfriends, learning to do my hair in the latest styles for my upcoming freshman year.

It was May 5, 2002, a Sunday. I was dreading having to go back home because the weekend was over. It was around noon, and I was sure my mother would be calling soon, wanting my freckled rear home to chain me to the sink with a weekend's worth of dishes. I'm sure I'd have to listen to her Dan have sex in the next bedroom that night, too, or maybe their endless yahtzee dice landing on the cardboard box. They might fight. Every day I felt like I had aged a hundred years since breakfast. I tensed when the phone rang, and didn't answer it.

My friend's mother answered the call, then hollered for me at the top of the stairs. It was Ashley. I didn't even

have the consideration to greet her, my eyes rolling in exasperation.

"I'll come home soon, okay? I'm not done here yet. We just started the movie . . ."

"Keira, please come home now," she begged quietly.

The tone in her voice slowed me down, but didn't stop me. I knew that meant there was a fight. But I really didn't care. . . . *I'd like to be fourteen for a few minutes! Fights happen, I don't need or want to be there to protect everyone all the time! Dan will just leave to his mother's house down the road and we'll start the cycle again.* "I really don't want to, I'll be home. . . ."

"She told Becca to go get a knife to cut her throat. She swallowed a lot of pills, I think. . . . She's acting really mean . . . she's drunk and she cut her wrists. . . ."

My face drained as I held the handset; I felt like a skeleton. I didn't remember her ever taking pills before. *And cutting yourself is really weird—I've never heard of anybody hurting themselves on purpose. . . . I would understand better if she had cut one of us.*

"Um . . . okay. I'll get home now. Just hang on."

Ten-year old Ashley barely whispered a reply; six-year-old Becca sobbed in the telephone receiver's range.

I only remember briefly racing down the freeway in my friend's parent's car, with her mother responding to my stark white complexion. "I don't think she actually wants to die, and she won't. Don't worry. Some people just do this as a cry for help, not seriously wanting to die. She's just asking for help."

Then why doesn't she just ask for help?! I wondered silently. I couldn't say anything. I didn't understand anything, but I knew that the burden of this was on me. *How could I solve a problem I didn't understand? How can I help her when everything I do doesn't change a thing? I work hard just to keep things at the horrible level they're at now.*

How can I make it better if keeping it from getting worse takes all I have?

I felt like I was walking through the door into pandemonium. The two older twins were huddled around mom, who was lying in the middle of the floor in the hallway. The two younger twins were flitting like birds around in the living room, unable to sit on the couch quietly.

I approached her rolling, nearly three-hundred-pound body to see that she had thrown up all over herself. The shepherd's pie we had eaten the night before as a happy family now covered the blue carpet tile. To this day, I do not make shepherd's pie because I can't stand the smell.

The older siblings seemed to feel they were relieved of their duties, and stepped back to make way for my friend, her mother, and me: the supposed "rescuers." I felt very sick. I didn't know which part of my house was the floor. The only adult in the room started talking, and she did so loudly, like she was talking to a resident in an old folks home, "Sierra, are you all right? What did you take? Keira, get the phone and call 9-1-1. Can we get you up, hon? Are you just drunk? Did you take pills?"

I don't remember how long it took the ambulance to get there. I was cleaning up the vomit, because cleaning was all I knew how to do. I tried to comfort my siblings, but I was just one of them. I had nothing to give them. No information. No hope. No stability. I felt hollow and concave. My arms couldn't hug them right.

The way the paramedics talked to my mother scared me—as if she was mentally challenged or something, and she wasn't. Or maybe she was? Maybe the pills got to her head? What would happen? Would we go to foster care, be split up? I couldn't think that far ahead. I didn't even know what was happening now, so I couldn't know anything else.

The paramedics looked at all of us huddled in the living room. The look of pity was alarming—were they going to

report us? They seemed to look at us and at each other for a long time. The police were interviewing my mother and my friend's mother—the latter looking at me with the same concern found on the paramedics' faces.

I finally decided I liked their pity looks. It made me feel justified in my selfish desire to just be fourteen. Someone had just given me permission to be indignant about what my mother did to us. It didn't change anything—it didn't add a single dime to our bank account or an extra helping of potatoes to our dinner—but it changed me. Normal people don't go through this. They don't have to. My mother wasn't acting like regular adults. I had a right to be mad.

My friend's mother talked seriously with the paramedics. Outside, neighbors whispered to each other. It came to me then that neurosis is when someone you love is burdened enough by your behavior, they start talking to anyone else but you to change it.

I sat on the front porch in the May sunshine and called Dan just to yell at him, too. I screamed that I couldn't believe he walked out on my siblings when he knew what my mom had done or was going to do. To his credit, every single time my mother attempted suicide after that, he always came back to be here with us. He took care of it. It hurt a little less when I knew he was there.

My Granny became very grave when she heard the news. I was starting to call her daily to update her on the fresh hell we were experiencing across town. After a long silence between updates, she barely whispered, "After Randy died—" her voice broke, as she rarely mentioned her son since his suicide in 1984, "she *promised* me she would never do this."

What could I say?

". . . she *promised* me."

More fuel for my rage, I felt, as I thought to myself, *She hurts everyone I love.*

My mother recovered from the pills in her stomach, but never from the hollow hole that took root in her.

I turned to greed.

I lost myself in the radio and wishing for money; I was sure it would solve everything. I loved watching MTV's shows about stars and their expenses, their luxuries and lifestyles. I thought if I could just be beautiful, and then get famous by being sexy, and have money . . . well then, I'd be beautiful, popular and rich! No problems! I dreamed about all the boys who would fall over each other to get to me, the girls who would regret teasing me and want to be as beautiful and skinny as I was. When I looked in the mirror, I could never match the dream and the reality. I often tried to skip meals and exercise, but life always got so crazy, I forgot. I started and restarted my mother's diet books, determined to stick to it. I wanted a nearly concave stomach. I liked my breasts, but I wanted everything else to stretch out because I was going to be so tall. I spent hours hating myself in front of the mirror. My eyes had such dark circles under them. My skin was too pallid. I would sunbathe, but I would only come out burnt and freckled and blistered. My vanity left me parched.

My mother continued to gain weight, reaching the proportions that force you to wear stretchy fabric pants if you wore pants at all. She favored throwing back mudslides and two-in-the-morning Wendy's runs, dipping her fries in her frosty, and downing junior bacon cheeseburgers. Sometimes she would pawn our VCR to get twenty dollars and blow it on Wendy's. I loved those nights. We would pretend we were rich for a day.

The next day, though, she would be nearly comatose in bed. She tired quickly of yelling. She would whistle at us like dogs to bring her glasses of Pepsi, or the phone. Once, she whistled to summon a child, and I came into her storage unit of a room. She was laid up in bed as always, unable

to move her massive body, wrappers and Pepsi cans every-where. "What do you want?" I asked, irritated, as always, at being treated like a slave.

"Remote" is all she spoke, and I searched around with my eyes to see that the remote she wanted for her personal TV was literally three inches from her hand.

I reeked with disgust and hatred. I moved it toward her fingers, but didn't pick it up. I snorted in disgust and left the room. Triumphantly, I regaled my siblings with the tale. We all shared a personal disdain for her and her whistling.

The Mystery of the Universe Is Feminine

In spite of the school maturation program, I relished becoming a woman. I wanted my life to be like the feminine razor, Dove chocolate, and *Herbal Essences* shampoo commercials of the early 2000s—an endless journey from one blissfully orgasmic experience to the next. I looked forward to decadent, foamy lathers, deodorant, perfume, and make-up. As I bloomed slowly, my mother distanced herself from me and treated me as an enemy. She acted threatened by my existence, and I became withdrawn and fearful. I would experiment with make-up applications and end up being questioned for hours.

My Granny said that my mother was worried about me. By fourteen, she had already lost her virginity. I exploded, "Well, I'm not *her!*" and my Granny shrugged in defeat.

I asked my mother for my first disposable razor and took a bath one summer night. I treasured shaving my legs in careful, straight lines, just like in the commercials. Once I was dry I began to itch terribly. I knew some women put lotion on their skin after shaving. I carefully snuck some of my mother's lotion, then bolted from the bathroom in

a shirt and underwear to my bedroom, looking extremely guilty.

I was completely unaware of my mother's mood as I sipped ice water, and I was cheerfully, decadently practicing being a woman by lathering my first-time smooth legs in expensive lotion. How strange! How wonderful! Self-care and good hygiene were now expected from me, and I was happy to oblige!

My mother burst into my room and shot me a withering look. Her shrill voice pierced the quiet room, "*You little whore!*"

I sat in my oversized shirt with fear and blank eyes. The doe eyes look she hated. "*What?*"

She pointed to the small, square window at the top of my room, "PRANCING AROUND IN YOUR UNDERWEAR IN FRONT OF THAT! You are disgusting." I whipped my head around to see the blinds weren't turned flat.

I shook my head violently in a desperate attempt to control the inevitable storm, "No, mom, I didn't realize...."

She pointed to my face with contempt contorting her lips, "You put on makeup today—you were going to sneak out the window, you little *slut!*"

As I stumbled to say no, I watched her take her fingers and dip them into the ice water next to my bed, and she flicked the water directly in my face. She leaned down close enough that I could feel her breath on my nose and hissed, "I disown you." Too fast to stop, her tough, fat hand slapped my cheekbone with a sickening thud.

It smarted. I started to cry without meaning to. I was shocked at her initial accusations, but the violence knocked it all out of me. I laid back on my bed to sob at the meaning of all this. I hurriedly searched my behavior for any violations that would justify such a wicked punishment.

I heard her stomping away, and then, huffing, she turned around and came back. I uncovered my eyes just to see her

grab my large cup of ice water, and she threw the water all over my body and my bed. She pointed the cup toward her face to inspect it. The last remaining water at the bottom of the cup she flicked it in my face with disgust.

She threw the cup, and it rebounded off my skull, and then she stormed out of the room.

I stood in shock at what just happened. *Nothing like this had ever happened before.* It was unprovoked and childish. I could hear a distant crashing and screaming as the clean dishes I had placed in the drying rack were thrown to the floor. I heard a deep, drum-like beat as the pots tottered and a violent clinking as the Corelle dishes split and shattered.

I sobbed at the rejection. I felt completely devoid of self-worth. I used to be her girl. She would come to me after a bad break-up and preach feminism. *We were going to get through this world without men! Us girls, taking on the world! Women can be strong, as long as we're together through the tough times!*

Despite her bad habits, bad decisions, and bad behaviors as a mother, some part of me still lived a fiction in which Sierra and I were true friends, united by blood and bond. That pleasant fiction died, once and for all, not with the strike, but with her jealous, withering gaze. We were a team (with feminism being less of a banner in those moments and more of a blanket), and I showered her in love, compliments and recognition on birthdays and holidays. She adored me, and had since I was little. *What changed?*

Why was it that, at thirty-two, my mother was throwing temper tantrums? Why was I more put together than she was? Why did I not deserve a mature, true, strong love with my mother? Why would she hate her own flesh and blood? I would never do this to my own kids.

Feeling truly hated, I brought myself to a fetal position and whispered my wish that Granny were here. That my

neighbor Bonnie who taught me the piano for free were here. That my concerned neighbor Teri were here. Or one of my teachers, or school counselors, my "mother hens." Somebody who loved me.

I wanted to die. Then, I would cease to be a target for my mother's hate.

With Dan's income, gone were the days of each child begging a different neighbor for food, but along with a full fridge came a well-stocked liquor cabinet.

Dan and my mother were drunk every weekend, and every weekend I wondered if this was the one where their fights would turn to death threats. Most of the time, they were violent to each other, which felt like living next to fire: necessary for safety but never safe. But I waited for the volcano, where no one and nothing was safe and where the damage was unpredictable and inescapable.

I still spent weekends in the summer at my Granny's house, where I would unload all of my cares and stay up late and eat junk food. One June Saturday, Dan and his brother picked me up from Granny's Pebble Creek apartment, and I assumed we were headed home. They told me we were instead heading over to Dan's mother's house, down the street from our government-subsidized home, and I was instantly bummed. Dan could see the disappointment evident all over my face and said, "You won't want to go home once you get there."

I perked up. "Why?"

He smiled, "Because there's a very cute guy at my mom's place, with no other teenage girls around to keep him company."

He was absolutely right. I wasn't looking forward to Saturday chores and militant bossing anyway. After the

fact, I wasn't sure it was the right decision, but I had so much more fun.

The cute boy's name turned out to be Jake, and he was seventeen and very uninterested. His cousin Nikki, a fourteen year old like me who was desperate for a companion, filled me in on the details. I still had hope, as I sipped soda and wandered around aimlessly in the house with Nikki in tow.

As the sun set in the West, the entire family group at the house (including Jake), congregated in the large backyard. Dan's mother was firing up the grill. Someone turned on some music and a make-shift dance party had started. I watched Jake and hoped he would ask me to dance.

"Go ask him!"

I considered it for a half-second, my dry throat giving out a weird sound. I was too chicken.

Dan smiled, leaned back into his chair, and recalled some stories where he, too, was chicken. It made me feel a little better to laugh.

I felt a little braver and said, "I'm not going home without a dance."

It was then that Dan realized that I was stuck. In his drunken impulsiveness, Dan got up and walked right over to him. I watched him, embarrassed and excited at the same time. I saw him point to me with the only free finger he had in his beer hand. I looked away.

I soon found Jake, probably heavy with obligation, standing near me, asking me to dance. We slow danced to a country music song and he told me he was starting his own rock band. Butterflies fluttered as we named favorite bands, and we both enjoyed his hands on my waist.

I came back to my chair next to Dan, and he smiled and slipped into memory-lane mode again. As we got on the subject, I mentioned that Jake was seventeen, and I had never seen Dan snap out of the effects of alcohol so

quickly. He had been leaning his chair back, and abruptly snapped it upright. "Seventeen?! You didn't give him your phone number, did you?!"

I actually hadn't thought of that, or even thought that I had a chance, so I certainly hadn't. "No."

"Oh good," he sighed and relaxed into his chair again. "Because you ain't seeing that boy again."

I smiled. It felt really good to have someone who cared. My valuation went up at his comment, not at the interaction with the future guitarist.

We made our way home, and I nearly floated through the door. *What a wonderful night!* Dan was buzzed and ready for bed, and I had great memories to replay until I fell asleep.

The butterflies dropped dead the minute I closed the door. My mother was standing at the end of the dining room, fuming with a look of pure hatred on her face. I had forgotten all about home; I only remembered then that I had spent the whole day away from my family. I had not done a single chore. I didn't even call to tell her I was not coming home. I hadn't worried about my siblings. That day, I was the freest person alive.

I would pay dearly for that freedom.

She said nothing, but snarled like a beast and walked away. I hurried to the opening of the corridor to see her stomp her way back to her room. Her path was a complete zig-zag, and her fat jiggled with every heavy step. She slammed the door so hard that the mirror in the hallway she had just navigated dropped to the floor. Fear overtook me down to my fingertips. Dan decided to be a hero and followed her to the bedroom. I crept past hoping to go unnoticed. I was grateful for him "taking the hit" this time.

I unpacked my overnight bag from Granny's in my room; there was no way I could fall asleep immediately while they were shouting in the next bedroom. Fear stole my breath,

and I wanted to cry in exasperation. My mother ruined anything good. Every time I was having fun, she would call and want me to come home and play house. Every time I had a party, she would get drunk halfway through and scare all my friends. Every time I got settled into a new place, with steady friends, she would announce that we were moving. Now she was pushing Dan away. I really loved Dan. He was as close to a father as I had ever had. I could tell him anything, and he always stayed with us.

I heard her turn from sobbing, inconsolably and without rhythm, to screaming until Dan raised his voice. Granny had just said that Dan wouldn't take this much longer—*couldn't my mom learn to get along?*

I heard glass breaking in the room, and it felt as if it travelled up my soul from the floor. *Apparently not.*

I came out of my room, battle-ready, my eyes scanning to get a better idea of what we were up against. She screamed, "Get out of my house or I'll kill myself!!" I went cold and hoped that Dan would just leave if what she threatened were true. I heard more glass breaking, and then the sound crashed on my ears as Dan opened the door quickly and made his way out. "Get this shit out of my house!!" More alcohol bottles crashed all over the floor.

She quickly selected a very heavy bottomed liquor bottle and ran out of the room, making her way down the hall with more accuracy than when she had previously walked up it. Her anger must have sobered her. I followed her, screaming too. "I'm fourteen! I shouldn't have to deal with this!" I knew she was going to throw that bottle, but I wouldn't dare touch her to get it away.

Luckily, Dan was a tactical drunk and used the back door as cover as he exited. He shielded himself with the painted metal door as she threw the bottle—she missed badly and made a large hole in the wall. The bottle fell to the floor; it didn't even break.

She followed him outside and said some of the dirtiest things that I'd ever heard. It was as if she needed to convince me to let him leave. I was so stunned with the nasty words, half of which I didn't truly comprehend because they were rooted in sexual ideas that I had never seen on screen or in person; I said nothing and stood there crying in silence. The noise in the house woke up my siblings, and as I watched the scene unfold, they stood behind me for protection like a little herd. I wanted Dan to stay, and my mother to go find somewhere else to be until she could be trusted. She was the problem with all our lives. Dan Cox was a calm, happy drunk. But alcohol turned my mother into the most ruthless person I have ever had to share the same stinky air with.

Trying to figure out my next move, I attempted to mediate between my parents in the driveway. Neighbors would start to come out; I was sure I could already see their lights on. I spun around from from the twinkling lights of our neighbor's windows to see my mother smack Dan across the face. He took it without retaliation. I couldn't believe it. Agony hit my chest as I saw the face I loved pink up. He started to leave and my mother screamed, "You coward! Walking away from a fight! All you are is a pussy!"

I whispered my goodbye to him with a broken heart as he drove away in his old Honda. I didn't ever think he was a coward. I would never have taken what she did to him. I couldn't figure out why he ever came back. I hoped it was because he loved us.

I didn't call the cops, and none of our neighbors did either. I regretted that later. I wish I would have—she would've hated me forever as a traitor, but I just couldn't take it anymore, especially as I watched our first line of defense driving away in his aging, gold car. Now there was nothing standing between the children and my mom's cruel, alcoholic rages. . . . Nothing but me. I was overcome

with stomach pain and sickness in the bathroom that night as I heard her destroying dishes in the kitchen. I'd have to clean that up tomorrow. It was always a reverent and gentle task, like preparing a dead body for a funeral.

I lay on the bathroom floor, weak and weary. My own personal Hell—what would my friends think? What would a nice boy like Jake think? If they only knew my life was Hell. I never thought I would describe my life like that.

During the following break-up period, my mother drowned her sorrows with sugar, alcohol, and unknown men. Her business was successful at the truck stop off the first exit to Springville, Utah. Truckers drifted in and out after a meal at the Flying J, and in their loneliness or unmet desire, they used Sierra's services. On their CB radio units, they joked with each other about how "Sierra could suck the chrome off a ball hitch." My trucker grandfather confronted her with her reputation. She returned to sugar, alcohol, and sleeping during the day. I saw evidence of every single coping mechanism she had.

Send Me All of Your Vampires

Dan made his way back into my mother's heart before summer ended. We prepared for the school year by getting Walmart clothes and scraping pennies together to buy school supplies. Ashley and I bleached our chunky, expensive skater shoes in the bathtub to make them look new.

High school began without much fanfare. I quickly gathered together a safety net like I'd always done when I started at a new school, and found a few old acquaintances from my time at Farrer Middle School to pal around with. I worked *the formula* in all my classes to form new friendships as quickly as possible—jokes, unique words, sassy clothes, relaxed posture, like nothing truly mattered. *Rinse and repeat.* Just like my mother.

I had been at Provo High School for only two weeks when I came home to find my newly-reunited "parents" packing boxes. They happily announced that we were moving.

Dan drove us over to see our new house after dinner, holding hands with my mother in the front seat. They sparkled with the hope of a new start. It was suddenly very important to them to get out of government subsidized housing, (which happened to be my favorite housing we'd had) upending my life just as it had begun showing a

shadow of stability. I would be transferring to Timpview High School. Just like that.

I was finally old enough to grieve what was about to happen. I packed my things and cried. I'd loved this neighborhood and my friends. It was the first time in my life that I felt even a little sure. I had made plans for the future built on living out my time in this home.

At Timpview, isolation re-entered my life with full effect. I didn't have a friend to sit with at lunch, as I wasn't accepted by the differing tribes for differing reasons. Here, popular kids had two things in common: they were rich and they appeared to be orthodox Mormons. Being neither of those, I was immediately cast out, and finally found a few friends hanging out by a broken elevator. Compared to the other overweight or oversexed girls in the group, I was a fresh, skinny, virginal dream. I was used to being looked at like fresh meat by males. The familiar dread in my tailbone returned. I sunk lower in anticipation of the hunt.

We started skateboarding at night and wandering the streets looking for half-smoked cigarettes on the ground. I was the constant object of lust for two of the boys in the group, and I loved any attention I could get. There were promises of starting up a band and teaching me guitar. This rekindled my greedy dream of becoming famous, popular, and wealthy to escape my miserable existence.

One night, after tiring of skateboarding in the nippy September air, we sat around on the concrete steps of my 1920's bungalow home before I had to go inside. One of the boys who was usually pretty tame seemed bolder than usual with me. He sat beside me, lightly rubbing my back and stroking my arms, pulling the bra straps out from under my tank top. He slid his fingers underneath the straps and stroked the exposed skin. My tailbone started to tingle in a sensation of anxiety and arousal—he was unwrapping me. I did not want him to unwrap me. I wasn't

ready. Others in the group could sense my hesitation and started to make comments.

"Hey, you need to cool it. It's not like you can get anything done on her front steps!"

"Why don't you just back it up a little, give her time to warm up to ya!"

"He probably couldn't get it up anyway . . . he's smoked too much!" Laughter.

It slowly, very slowly, dawned on me where I was and who I was with. I never thought they did drugs. We saw each other at school, mostly, so our conversations were restricted.

I was so stunned that I couldn't react. *I'm a good girl. I don't hang out with druggies.*

The goosebumps traveled all over me, and I still couldn't find my voice. He started to kiss my exposed shoulders and my neck—all things I fantasized about with my ear pressed to the radio broadcast of Enrique Iglesias' voice. But this felt wrong somehow. I was in a fog of fear. *What could I say? I must have led him on. It's my fault.*

I looked up to the window to see my step-dad Dan looking at us through parted curtains. I realized what this might look like to him, and I grew cold with shame. This boy was wrapped all over me. I dismissed my friends from my steps and quickly and quietly went inside.

Dan approached me lovingly. "You don't have to worry, Keira."

I didn't turn to meet him immediately, but I paused on my path and hoped that I would not get in trouble.

He continued, "It just happens. One day you grow up, but that doesn't mean you have to hide it or stop talking to us. I want you to be smart about it."

I turned. *What was he saying? That this was okay? I didn't feel okay.*

"When you want to finally do it, just don't be afraid to tell us. We can get you some protection. We want you to be safe. It's okay to tell me that you want to be sexy. If you want to be sexy for that special guy, just tell us and we can buy you something nice to wear. You know, take you to Victoria's Secret and get you something nice . . ." He trailed off, seeming to feel that his efforts were futile to my deer-in-the-headlights look. "I just want you to come to us."

I couldn't believe what he was saying, and it didn't fit in my brain. I would never go to my mom with concerns about being sexy. She might hate me. I didn't know. She wouldn't approve, I was sure.

I nodded faintly and went to my room.

The next day, having lunch with my skater friends, I broke away from the group. I felt weird, as I had no concept of consent nor did I have any language built around consent or rejection. One very kind and quiet boy, a junior and seemingly wise beyond his years, talked to me softly. At first I thought he was just interested in using me like every other boy in the group, but he never got within arm's reach of me, to my relief. He seemed worried about my stress level after the previous night.

He offered to give me pot to help me cool down.

I missed a beat in shock. "What?"

"For jitters," he said, with a genuine smile, no harm intended, truly a concerned friend.

"No! I don't want *that*! " My "say-no-to-drugs" school ribbon was still pinned to my valiant heart. "Why would you even offer it to me?" I realized how blunt I was being and shut my mouth.

He simply smiled it off as he made his way to class. "You might need it."

It reverberated in my head. I *might need it. I might need it. I might need it.*

I need to get new friends to sit with, I concluded, clearing the repetition.

My parents fought again that night, and Dan left with shirts and no return date.

I might need it.

··⦁●⦁·.

The next time my mother had a suicide episode, I got to see the entire fight between her and Dan and finally hear her nonsensical threats for myself. "If you leave, I'll kill myself! If you won't be here for the long haul, I'll do it!"

Dan had become increasingly uncomfortable with the government-mandated inspections and other policies that came with the use of our previous, subsidized home. In spite of the increased costs, he had finally prevailed upon my mother to move into our new place, forcing my move to Timpview High along with it. Dan Cox had always said that he refused to marry anyone, but if she was already going to lose the benefit of government subsidy, Sierra saw this new house as a good reason for the two of them to finally tie the knot. These threats were obviously her dysfunctional way of forcing a difficult issue.

She got what she wanted. On that October day, Mom picked us all up from school with Granny in tow and said she had a surprise for us. This was truly a treat, as we always walked or rode the bus home. Granny had already guessed they were getting married, so she had herself dolled up in a blouse and mascara, toting a camera. My mom looked rather ordinary for a bride. She wasn't wearing anything special, and Dan was in his jeans and sneakers when we arrived. I don't remember if they even had wedding rings.

The ceremony at the courthouse took minutes, and I was unhappy and disinterested. As much as I loved Dan (probably more than I loved mom), it didn't change anything.

He wasn't part of our real family. He would leave when things got hard again. My mom wasn't going to be different. This just meant they'd probably have more sex next to my room, and I was disgusted at the thought of their "honeymoon" being just on the other side of the wall. My biggest worry had been the move. I was still hurting from having to change schools again. I grieved another death of life as I knew it—another version of Keira to be reborn from the painful ashes of my mother's burning desires.

Our family photo was snapped with Granny's one-time-use camera: The plain and average couple stood smiling and facing each other, and the front row pew filled with our motley crew. I was slouching in my hoodie, Ashley's hair was trying to curl through her attempted straightening, both brothers wore their cheap clipper-buzzed short hair, and Becca looked like she had just rolled out of bed. All of us wore scuffed sneakers.

Our family was crowned with a fresh step-dad in a wife-beater and jeans. Mom looked sad through her smiling double-chinned face. I hardly knew the picture was being taken, and years later, when I found it, I was surprised and embarrassed at the sight of us. I wondered if the judge could peg just what caliber of people we were. Did we really go out in public together like that? We were one awful mess. None of us were happy, and in fact, those who didn't look dazed looked miserable. And we were. Our lives were punctuated with peaks of great dread between valleys of absolute isolation and boredom.

Your Love Is Gonna Drown

As my body became more of a woman and less a girl, it screamed at me. That Saturday after the wedding, I had the worst menstrual cycle of my life. I spent most of the day on the bathroom floor writhing in pain. I had no idea why my body would punish me like that. I called to my mother a few times, and no one heard. She was down in her cement-for-tified basement, sleeping for hours. I did everything I could to make the pain go away, and no one seemed to know I was out of commission. I fell asleep in the tub twice, waking up freezing cold. My mother still wouldn't come upstairs.

I might need it.

Wrapped in towels, shivering on the ground, I finally heard her specific heavy footing up the stairs and across the kitchen. I got up and peered out the door, "Mom!" I croaked. I hadn't had any food or water all day, except to swallow pain medication.

She paused for a brief moment. "What."

"I'm in so much pain. I just started . . . can you please help me?" My voice was very quiet; I doubt she heard most of what I said over the raucous television.

"Hmm. You'll be fine. I'm running errands for the rest of the day." With that, she beelined for the door like a bat out of hell.

Eight hours later, with no dinner, no call, and almost no food in the house, I started to worry. Darkness fell suddenly, and I realized through my fog what she had said.

My mother goes to the grocery store to get food. She runs to the post office. She pays a bill. She never says "running errands" so non-specifically. Something was really wrong. I felt the familiar feeling of panic begin to rise in my chest. She might have just run off without us.

What would happen to us? Would people find out soon that our parents had left? Would my family be taken to foster care—split up and spread out? Would I be able to take care of them on my own to keep us together? Maybe I could do some babysitting and we could beg for rent money, and then we'd get the food stamps for food. . . .

Dan came through the door an hour after my first panic attack. I was so relieved to see an adult back in the house, I didn't notice the cloud over his face. He was never so negative.

"Your mom took a bottle of pills . . . on my front lawn . . . we got her to a hospital. She had her stomach pumped and because of that, she's doing really well. We can visit her tomorrow, as a family, and try and support her and love her. . . ." I wasn't listening well. I was embracing wrath.

Rage, like a tiny match touching a lake of gasoline, erupted inside me so quickly, Dan probably witnessed it whiplash my facial expressions. I said nothing then, and nothing when we corralled the kids through the halls of the hospital the next day.

Love her and support her? Through what? She sleeps all day. She doesn't work. She is lazy and fat and continues to lie there and eat. What does she do? She isn't loving or involved; she barely lifts a finger—literally! All she spends her energy on is fighting with Dan. She exists solely to have the title of mother and then withhold being a mother at all. I cook dinner. I worry about the bills. She leaves me in charge

every evening and every weekend. What does she have to do now? Why can't I run away like Dan does?

Unsurprisingly, she spoke about herself the entire time. "I had to swallow this nasty charcoal stuff to soak up the drugs . . . the counselor here is getting me the help I need . . . I am going to get better." She bubbled at the attention. I loathed her.

Yeah, well, I'm so glad you're getting your pampering here, while your fourteen year-old worries about feeding the family. I tried to read Dan. He seemed to win the medal for being "in it for the long haul." I was painfully wary. *Whenever there's a sure thing, that's the first thing to die.*

My mother returned home with orders to get some rest for herself. I made it a point to roll my eyes every time that excuse was mentioned. I hated her more with every passing day. I never wanted to go downstairs to her dungeon, but having to pick up her laundry and take care of things, I visited often.

I found so many odd things down there, only later realizing they were signs of Meth use. Her glass knick knacks were stashed in the basement, and some of them were broken, though all in exactly the same way—with a hole on one side. Lighters littered every table, chair, and shelf. It was smelly, dirty and dramatically colder, and I wondered why they were living down here. When I walked around the edge of the bed to leave, I saw a magazine. We could never afford magazines, so curiosity drove me to pick it up and leaf through the pages. As I peered closer the nature of what I held began to dawn on me. My mom wasn't that kind of mom. . . . My step-dad wasn't this bad . . . or were they?

Naked women in various positions were lined up like they were selling sweaters—you could fit at least twelve on a page. I didn't know how, but I knew clearly that something about this was very wrong and I threw it down like it had burned me.

I never stepped foot in their bedroom in that house ever again. The entire basement was haunted for me, reminding me of my encounters with men who wanted to see those exact parts on me. It was as if these kinds of men wanted to know so much of me, and yet they knew so little of me. I tried to stop the visions that crept up into my mind of my sexual assault as a little girl. The lust in the eyes of men that haunted our home all my life.

I might need it.

I marched up the stairs, and in my shaken state I screamed and beat up any younger sibling that got in my way. Once again, I was left with them after school getting laundry done and worrying about dinner, squeezing in math homework when I got the chance. I was trying to succeed at school and please my many teachers, all while keeping up with my family's ever-increasing demands.

I made my way to the bathroom and looked in the mirror. Anger was etched into so many places on my face. I could see my mother in that mirror more than I could see myself, and I hated what I saw all the more deeply. I thought of what I had just done to my "disobedient" siblings and of the pictures downstairs.

I searched my eyes. *What is wrong with me? I do what I hate. I am what I hate. I am ugly on the inside and the outside.*

I might need it.

•●•

At school the next day, I was exhausted with nightmares I couldn't remember and anger I couldn't forget. At lunch Sterling, the leader and most attractive guy of the group I hung out with, showed me his new pants, which already had a rip at the bottom.

"That sucks, they were brand-new pants!" I commented, pointing to his inseam near his foot.

"Oh, I did that. I *stole* them! Walked right out of the store with them. All you have to do is rip off that plastic tag that sets off the alarm!"

I tried to look way less frightened than I was. I hadn't thought of doing that. I verbally over-approved to show how cool I was with it.

"You should come with me." He flashed me a smile. He seemed to know I was a lost puppy at heart. I watched him with fear and delight as he closed the distance between us in the tiled hallway. "We could sneak in a stall together . . ." he smiled and gestured, and my knees melted. I'd rob a bank to get a few minutes in a closet with him. Even if he used me, I'd like being used by him. I agreed to it.

Blue and Yellow

After lunch, feeling overwhelmed and frustrated with my mom, I went to class hoping to put my head down, but realized on arrival that we had a test. . . one for which I was completely unprepared. With everything I was forced to do at home, there had been no time to study.

I took the pile of papers and examined the questions to see how much trouble I was in. After a few moments, the boy behind me impatiently tapped my shoulder with his pencil to remind me to keep passing. I snapped in anger. "Cool it. Give me a second. My mom's in the hospital and I've got a lot on my plate." I didn't even say it to him, really. I just wanted my emotional status to be apparent to everyone so they would tiptoe in my presence. Just like I did for my mother every day.

I met the eyes of the girl sitting next to me. "Your mom is in the hospital?" she said kindly. "Mine too." I was surprised, but felt a flicker of anger. *How dare she steal my thunder.* "I'm sorry about that. It's hard." she said simply, then with an understanding smile, she went back to her test. My anger diffused. *Someone made an effort? Color me surprised.*

"Thanks," I said, as if in apology. I became cautiously optimistic, though. I still didn't care to ask why her mom was in the hospital. It was probably some ordinary reason,

because her mom was probably a good person, unlike mine. "My mom tried to kill herself."

I had said it for the shock factor—and nobody's life could out-shock mine, especially those of my strict Mormon neighbors. I liked the attention I got when I brought it up.

I turned and left it at that. For whatever reason, she still passed me a note.

"*Hi, I'm Brittany!*" After a few quick, friendly exchanges, she got my number. It was weird. No one is nice to porcupines.

Right?

·•¿ ●•∴•

The leader of the skater/druggie clan, Sterling, took it upon himself to announce our next group outing: we would be going to the newly constructed Provo mall to steal clothes from Hot Topic. He'd even selected a day. I wanted some new pants anyway, so I thought I would give it a try.

I came to his house with a girlfriend of mine only to despair that obviously Sterling liked her more than me. She was older and certainly intense, and he was only a freshman but seemed to be confident in his ability to woo older women. Maybe it was my braces, or maybe it was my graying sports bra. I have all the luck.

We had to wait for his mother to return so she could take us to the mall. We "toured" the house, which was nicer than mine, but a mess. A cat wandered by. Who knew where the younger children were. Pizza boxes lay on the floor next to the garbage. A pile of dishes lay untouched in the sink. Most things in the house were inoperable, but at least they owned it. That's more than I could say.

We eventually made it to the basement, and my stomach filled with butterflies at the opportunity of seeing his bedroom. Sure, Sterling liked my friend more, but she didn't go to the same school. Maybe getting into his room

meant a level of intimacy I could use later, when she was gone.

His bedroom was a stereotypical mess and smelled just like he did. I reveled in it. I loved the way boys smell when they sweat lightly. I wanted to be the cause of his light sweat one day.

Sterling seemed eager to pass the time with a game of truth or dare. I jumped at the opportunity, hoping to have an excuse to kiss him. I was the lucky girl to be asked first—I picked dare—I had a semi-truck loaded with hope, backing up into his room to be used at his disposal.

He grinned. "We're about to go steal stuff," he said, playfully. "You sure that's not too many dares for one day?"

Not nearly enough. I tingled. "That's not daring. I want you to really dare me." My teenage recklessness pounded in my ears. My nose ran a little. My pupils dilated. I had been lit on fire.

An idea spread across his face with hunger, and I nearly jumped out of my seat to hear his reply, "Kiss her." Sterling pointed. "For me. I want to see it."

Crestfallen, I looked at my friend. She was quite a wild child and seemed impressed with the request.

"What, is that some fantasy of yours?" she retorted without blinking. She was so brave. I sank visibly into my freckles. He leaned forward in eager hunger—much more innocent than I'd seen from the males in my childhood, but absolutely recognizable lust.

"Oh yeah!" he said, ravenously. He might as well have transformed into a whistling cartoon wolf. "You can imagine what it's going to do to me!"

She didn't miss a beat. "If I do it, your dare is to show us what it did to you." She motioned towards the crotch of his stolen pants.

I was scared of being caught in their play, so I kissed her quickly before leaving to wander some other part of

the house carrying my disappointment with me like a bucketful of lead. . . . and never did get a ride to the mall or locked in a changing stall with Sterling. While I always felt drawn to the beauty of the female body, more so than the male body, I was not attracted to her specifically, and therefore I felt nothing in that kiss except used. I couldn't quite place it, but I felt a little like the girls on the pages of the magazine in my parent's basement bedroom.

Welcome, Happy Morning

Brittany-from-class sat at lunch with me a few times; she was lonely too. I didn't want to sit with my skater friends anymore. I didn't know anyone—not even myself—anymore. She invited me over to her house, and we would belly dance in front of the mirror to Gwen Stefani's voice through the fuzzy radio in her room. We talked about piercing our belly buttons if we could, and not our noses like a cow. We squealed over boys to ourselves. We both wanted to run away to Hawaii. She lived in a divorced home too, and they were poor—but somehow happier—than us. She had cuter clothes than I did, and I always wanted to borrow them. I was slightly taller and curvier than her, and I was way more pale and freckled. All I thought about was how I wished I had a stronger will to become anorexic. I glared myself down in front of her full-length mirror.

She invited me to a party one weekend, which turned out to be an LDS (Mormon) teen church dance. It was a shock to attend a huge dance where you prayed before and after the activity, but the number of cute boys in one small area had me so buzzed that I didn't even care. Prayers or not, the boys remained in the room. It was strange to me that these boys seemed to have an innocence around sexual matters that I had not encountered. They nervously kept

their hands in safe places as we danced, and they actually looked at my face. While I still felt removed from my holier-than-thou, thrifty, educated, and financially successful religious neighbors, I did very much appreciate these good Mormon boys.

I met a boy, Chris, whom I started to date steadily at the young age of fourteen. He made me feel special and all brand-new. He was endearingly innocent, as if he was still holding on to boyhood. I liked that. I had met too many men. Too many thieves.

The day that Chris gave me his sweatshirt to wear, I felt like my every problem would be solved by that rough piece of cloth. I met all of his friends and loved them very much. I felt like I finally fit where I belonged—a group that had good, clean fun. They read books, told jokes, and still went trick-or-treating. I felt I could hide the bad in me around them, and they accepted me as their own. I fell in love with Chris because he gave me a good life at school—a sense of stability I clearly lacked at home. He even talked with me about his church on occasion. His house wasn't like mine—it was cleaner, but not ornate. It had a good feeling in it.

I started to believe in love for myself, as I watched my mother's two-month marriage crumble. One night, as I sat on the couch, Dan made his familiar path through the house to the front door, a few clean shirts tucked under his arm. He stopped just long enough to look me in the eye and say, "Your mother has chosen what she wants" before disappearing out the front door and into the night. His face left me in tears. His lack of explanation made me hollow.

My mother tore up the stairs looking for him but as she scanned the entryway, I must have caught her eye. I was wearing Chris's sweater, sitting on the wrong end of the couch and plainly in sight. With Dan already gone, she closed in on me like a missile.

"Take that sweater off."

It took me a moment to register what she had said, and a look of loathing crossed my face as I did. I didn't move.

Her eyes burned like cigarettes again, "I will cut it off your body myself if you don't take it off right now."

I was still angry, but the familiar feelings of fear began to creep in. My siblings, huddled around the television moments before, grew agitated as they began to notice what was happening.

I seethed inwardly, but outwardly I complied. Inside, my blood was laced with revenge. She looked at it in disgust before stomping away to begin crying not moments later. I ran to my room and slammed the door, cursing her under my breath.

I just wanted to talk to Chris. He would joke about it until it didn't exist anymore. He allowed me to live in a dream world, and it was always a crushing shock when I met reality at home. I wanted to marry him. He was my great escape; he soothed my wounds.

Except, his boyishness annoyed me sometimes. Did he really not *ever* grow up? He never seemed to understand the gravity of my home situation. When we talked on the phone, there wasn't sympathy as much as there was silence. He was playing a video game every time we talked. I didn't know him, but I adored him as my world grew darker. Spending the holidays with someone was a warming thought I couldn't let go of. I pushed thoughts of me becoming like my mother out of my mind.

The night Dan left, I put the sweater back on, jammed spare clothes into my backpack, and ran away into the December night air to Brittany's safe home. Homeless again, but this time by my own will. I pounded the cold cement wearing shoes stolen from my brother, with the familiar line popping into my mind, "Step on a crack, and you'll break your mother's back."

I made sure to step on every crack I could.

It didn't matter. Her back and her will remained un-broken. Every time I ran away, Sierra called the authorities and had me brought home.

Safe 'Til St. Patrick's Day

When I wasn't running away to Mormon households, I started going to the Mormon church for youth activities during the week. It was free fun, with a free ride. We took a trip with Chris's church up to Temple Square in Salt Lake City, and I had never been to Salt Lake before. I had seen their temple once or twice in a picture. It looked like a princess' castle. It stole my breath to see the bright lights against such a dark sky. Every inch of every tree was wrapped in lights, and the temple seemed to glow. I felt a warm burning inside . . . something that I thought I had buried—hope for a grand and beautiful future.

A well of innocence sprang forth from memories long buried and forgotten. Dimly, I recalled smiling so long on my baptism day that my cheeks ached. I remembered my white dress and a white Bible in my hands, mirroring the white light in my little soul. So much grief had buried it since then.

Brittany led me to the warm building next to the Temple, and I followed her up the curved ramp to the very top floor. I made my way slowly around to the seats, trembling in fear at the large, white statue of Christ; it was roped off. When I thought of Jesus—and I didn't often think of Him— He was just like He was as we stood in front of that statue.

He wasn't even real. He was otherworldly. I never felt so far away from him as I did at fourteen. He was made of something stronger and better than us, than me. His eyes were opaque, unseeing, unknowable. He was larger than life. Untouchable. Even in the mystery that He was, and how far from real life He seemed to be, I was still moved and weakened. I knelt in awe. Whatever He was, and however far away He was from this world of hate, I still thought the idea was marvelous. I could admit that.

I pondered this baptism-feeling. I wasn't very happy at that time in my life, but I nonetheless felt good at that moment. I wanted to do what He wanted me to do so I could feel happy again, but I didn't think there was a path to Him for people like me. If there was no way for me to get money, there was certainly no path to God. Brittany's mother said there was, and it was prayer, but prayer often seemed to not work for me. It was always radio silence. Or maybe it was a one-way baby monitor.

Either way, we left the temple with its gigantic Jesus. A few days later—back to my merry-go-round life—I lost those feelings and concluded that there must have been something in the hot chocolate they served there. I didn't know why I thought that what I had felt was real.

⦁•⦁

Like other Christmases before, Sub-for-Santa was our gift plan, and we wrote letters to "Santa" to tell him what we wanted. I knew the "rich people" would be taking care of it, so I made very specific requests—low-rider jeans, cute clothes, a blow dryer, and real makeup.

I remember the day the rich family paraded through our house with the secret stash—I was the only one around besides my mother, and they looked so beautiful and happy. They had the nicest clothes, and the wife led while several

blonde daughters trailed behind. *Pretty maids all in a row.*
I became quickly embarrassed at the state of the house—
our heat had been shut off, and we were using the electric
stove to warm up the house.

We gathered around the stove that night, and I kept
thinking to myself that this couldn't be real. We aren't in
this deep! Mom shooed us away from our makeshift heater
so she could cook a meager dinner, crying over the pot
and lamenting being alone again for the holidays. Later
that night, she called Dan on the phone and begged him
to come back, even if just for Christmas. He did, and my
mother bubbled next to the Christmas presents about be-
ing a real family. I didn't even have the energy to roll my
eyes, but my love for presents I received transported my
mind elsewhere.

•∴●•∴•

Christmas passed, and soon after, my birthday. That was
enough time for the emotional high swirling in our home
to drop into depression. Whether it was addiction or
mental illness that caused the rapid decline, my fourteen
year-old mind couldn't decipher, but the chaos the same
either way. My step-dad had to tell me face-to-face for me
to recognize it.

Partly to irritate my mom, I'd started attending
Mormon church sometimes with Chris and Brittany. My
mother hated that my housework slacked when I left
during the week and refused to work on Sundays.

"Free excuse to not help out the family! Being Mormon
is a great cop-out to be lazy! Wish I could be so selfish, but
I'm not religious!" I rolled my eyes instead of letting tears
get the better of me.

It wasn't just my church attendance that irritated her—she was enraged all the time. Her insanity swirled, percolated, and erupted with no rhyme or reason.

Dan stayed that night, to my surprise, and after everyone was in bed, I went to him like I did some late nights for a shoulder rub and a talk.

He sat next to me watching TV, and as though he were casually confessing that he'd gone to the bar after work, he told me that he and my mom were addicted to meth.

Meth . . .

The *drug?*

Not much was coming to mind. I had one experience with alcohol and had never touched a drug. It was merely a noun listed on the "Say No to Drugs!" sheet from elementary school. The drugs on the paper were listed in order of addictiveness, with crack cocaine being the ultimate monster on the list. The second to last: Meth. I was stunned that one of the worst drugs on the list had a presence in my life at all.

I didn't believe it—and couldn't. I completely rejected it. It wasn't true. The only reason the comment stayed in my mind was that it explained my mother's erratic behavior. But Dan?

His face was open and honest. "We tried to stop. We can't stop. I told her, I said, 'Sierra, we've got to stop this,' after we had stayed up all night and hadn't said a word to each other in seven hours, just playing Yahtzee on the bed. . . ."

On those long nights, my youthful naiveté had convinced me that they simply weren't tired. I thought they didn't answer their locked doors because they hated children.

My mom was a druggie? My beloved Dan?

You might need it.

The beat was getting stronger every time that sentence entered my thoughts. I pushed back violently, panicked. I left in a swirl of emotions.

I raged onto the pages of my journal, unable to make sense of it. *She was the one who wanted me to sign the "Drug-Free" pledge. She told all of us what drugs do to you— she knows it! She brags about not smoking cigarettes like all her friends and family! What a hypocrite! How can she teach us to never do drugs when she turns around and does them? How can I ever trust a thing she says?*

She stormed up the stairs that night and beat Dan badly. He never laid a hand on her except to restrain from hitting him. She screamed at him, "What are you, a coward? You can't hit a woman? Look at the marks on my wrists from your hands! I'm going to tell the police you're a bastard who hits women!" Unable to move anything, she hoisted herself and spit in his face. He tried to mollify her. I stood in awe, murmuring to myself that I would never take that from her, but later, in my honest moments, I knew better. I'd been taking it in a different way for years.

She shoved him into the bathroom and swung her fists like a windmill before crashing into his body. Her weight knocked him off his feet into the large old claw-foot porcelain tub. Blood marked the edge where his head hit. She screamed, and I stood there in the doorway, unable to make any difference with my waif-like fourteen-year-old arms.

He pulled himself from the tub and shoved her out of the bathroom before closing and locking the door behind her. She released her anger on the barrier, smashing holes and screaming insults at the top of her lungs, many of which were new even to me, a seasoned observer of domestic abuse. I never would have believed that my mother had been holding back all those years. If I wasn't shaking with indignation and worry, I would have been objectively impressed at how horrible she could make others feel. The fight ended with her commanding me to keep my freckled ass out of their business as Dan left, slamming the door behind him.

Dan and my mother took a break, but he returned at her pleas a week later. That's when things started unraveling fast. He would make that same path up the stairs with her shrieking behind him, and I wanted to know so badly what exactly was the problem. I yelled at them, too, begging for an answer. I already had it, of course, but I simply couldn't believe that my sweet papa-bear Dan would allow (or worse, *bring!*) meth into our home. Sierra faced Dan, "Tell her what I bought you with the $1000 check! Go on, confess to her what you did with that check!"

He wouldn't answer. He didn't look at me. I begged them both for answers so I could make it stop. My mother's eyes glittered. "What stuff for your brother?" My head swung between my two parents in worry and agitation, trying to be the judge of a situation that I couldn't fully grasp. *Where was the wellspring of hate coming from?*

Dan finally spoke over my mother's crazed sentences, "Ask her who she's been talking to. Ask. That's the man she wants to spend the rest of her life with. After all I did. And I forgave you for sleeping with two guys at the same time— you know what? I'm gone for good."

I wept in horror and spun around to face her. Who could be better than our Dan? Why was she turning away from the one good thing in our lives? She went into a fit as he left, and threw objects around the room, hitting Alex in the process.

··•●•·.

Confused and terrified, I met with the Mormon bishop at church the night of my youth activity. He seemed weighed down by the news. It was a relief to tell an adult who might be able to make a difference. Dan came back a few days later, tense and ready to scat at the first sign of trouble.

I told him that night that I had told the bishop what was happening with Sierra.

For once, he was not loving or kind. "You told him *what*?" he asked, in shock. "Do you know what you just did? They could take you kids away and split you up. You probably just ruined the family! You were stupid to tell anyone." I would not have been more shocked if he had slapped me in the face. He was usually understanding of my teenage stupidity; I went to him specifically because he never shot me down. I knew I had made a grave error. Even in this horrible case, our family motto remained "Don't tell."

Even Dan was under that banner.

Being my confidant, I thought that at least my mother wouldn't be told. I found out I was wrong the next day when I got home from school. My mother came up from her dungeon, angry and with her emotional wall up. The pricking in the air kept me silent. I finished all my chores and started cutting potatoes for dinner. I told her that I thought I did well on my test, with no response.

"How was your day?" I started up, timidly.

"You don't care," she shot back like a five-year-old.

I hesitated to say any more, but I wanted answers to whatever problem we were facing now, so I said, "I do care. Of course I care. Why else would I ask?" My heart thudded in my throat like a hunted animal. Wrong move. The fury and disgust and hatred condensed around our conversation.

"You're really good at pretending."

My heart sank. So, Dan had told her this time. And what a time to choose to stop keeping secrets. My mother answered the phone in a happy phony voice and went downstairs. I picked at my nails and chewed them into oblivion, channeling my Granny's demons in the ritual. The anxiety she had been cursed with was flooding through my veins. I

felt more soft and unstable than the potatoes I had cut and boiled for dinner.

Dan walked in later and immediately went downstairs. I had no good words to say to him anyway. Minutes later, my mother ran heavily up the stairs in tears and locked herself in the bathroom. He walked up with a handful of shirts. Not again. Anger rose to the surface quickly. *Could they stop fighting for* one *day?*

He passed me, loudly saying, "Your mother has found another man and is gonna spend her life with him."

My mother ripped open the door, "That's not true!" She charged at him and he went for the front door. "What about her? Are you going to go back to letting her suck your uncircumcised dick? Nobody around here likes it! You coward!"

The door flung open and my mother gathered her things to go. They got into the car but didn't leave. I watched as my mother shrieked at him and waved her arms like a madwoman, vacillating between beating the steering wheel and flipping him off. She took scissors out of the glove compartment and started cutting the shirts he'd taken with him.

The four siblings made their way up to the front steps and stopped, fearfully watching the scene in the car unfold. My mother rolled down the window. "Say goodbye to Dan Cox forever," she yelled in a sing-song voice. We all said a quiet, sad goodbye. Dan looked devastated. Without pausing, my mother punched the gas, backed the van out of the driveway, slammed on the brakes, and quickly shifted to drive, her tires squealing as she left. His voice was stifled by the windows, but I heard him call out her name. She threw his cut up shirts out the window and into the street. As my family and I gathered on the front lawn, I shoved my frayed nerves to the background and played mother hen again.

Later, a child protection worker called to see our family in our home. Sierra had us hide in the basement with the door closed, the fetid smell making me nervous—the smell of demons. She lied through her smiling teeth to the professional. I hated the fact that, by hiding, I helped her lie about something that I had reported myself to the bishop and wanted resolved.

My mother left right after that and didn't say a word to me. I was finally able to get her to pick up her cell phone, and she just screamed at me. My blood boiled. "You little shit," she seethed. "You turned me in. I'm gonna send your ungrateful ass to Eric Sullivan's. I never want to see your fucking doe-face ever again!" She screamed into the cell phone until her voice was distorted, then she arrived home, bursting through the door to yell at me to my face. She drove me backwards to fall on the couch as she screamed and spit into my face. "I don't give a flying fuck whether you live or die, you traitor! I ought to slap your motherfucking face off to get that stupid-ass look off your face! You don't know shit! And you always look like you don't know what the fuck is going on! You may be book smart, but you sure as hell aren't street smart! You're the one tearing our family apart, not me! I can be your best friend, or your worst enemy, and I sure as hell am going to be your worst enemy! I hate every fucking thing about you, you 'holier than thou' Mormon hypocrite! You may be pretty on the outside, but you sure as hell are ugly on the inside."

Her last mantra landed on a deep growling note, the claws tearing into my viscera. She meant these words more than she meant a desperate prayer at the wheel of a spinning car or a moan of pleasure from her latest adulterous lover. Her words were venom to my senses as her face panted in front of mine. My heart seared shut with her final caustic words.

She turned to the other stunned children, "Get a pillow, blanket, and PJ's and get in the car." They immediately obeyed.

"Where are we going?" I asked feebly. I wanted to die, right there. I wanted to commit suicide myself, right then. *You might need it.*

"*You're* not going anywhere." she snarled with a grin. "But we're going to a *nice* place." My chest swelled with anxiety for my little sisters being in some strange man's home. I knew where that led.

Making sure to not be seen, I had one of the children ask her where they were headed, and I got a short answer—they were sleeping over at Jason's house, a guy she met on a dating service recently. *So what Dan said was true. There was another man.*

After an evening there, she planned to ship them off to their father's house in Arizona. It felt so far away that it might as well have been another country. I panicked and cried. No food at home, she gave me one more catlike grin and left.

·•⦁ ●•∴•

The moment she was gone I ran away to Brittany's. With a backpack full of blank biology homework and a borrowed sweatshirt, I ran.

Soon after I got to Brittany's house, her mother Lisa had me filling out police reports about what was happening at home. I was given a bowl of chicken noodle soup. I fell asleep, unable to eat it. I understood for the first time what it meant to have no appetite. I went back to the house to gather a few things, fearing the entire time that my mother would drive past the house to check on me, then quickly returned to the sanctuary of Brittany's living room. I fell asleep on Lisa's couch and awoke at the slightest sounds

of a car's passing outside the window. Anxiety had left me puffy-eyed and hypervigilant. I went to school in a blur.

In the last class of the day, a messenger from the front office came to to retrieve me. I felt completely ill. I tried to act casual and ask who wanted to see me. *Please let it be some school administrator.* . . . The messenger didn't know. I asked her what they looked like.

"Oh, she has red, curly hair . . ."

I heard nothing else.

In a short walk, I entered the school's security officer's room. Sierra sat chatting away with the uncomfortable man at the desk, working that *Sierra Formula.* I wanted to scream.

"Hey, Keira! I was just telling him how we're moving to live with grandpa with the divorce coming up."

"We're moving *again?*" I paused for emphasis. "I'm not moving with you." My nerves sparked wildly, ready to leap into action at a moment's notice.

She *laughed* and turned to look for validation from the security officer. *Laughed!* I'm still not sure why—I hoped it was discomfort at my reaction in front of someone with authority, so he wouldn't suspect her—but I'm pretty sure it was because she knew she held all the cards. I felt sick and powerless.

I was so tired of living on her rollercoaster.

Was there no way to make her stop playing with my life like a board game? Her very voice commanded my downfall.

"Of course you are!" she replied, with a calm, fake smile. "Where else would you go? We can get the kids back from their dad's when I get into a better place . . ." she continued.

I glanced at the policeman. His tired face made it clear that he didn't intend to intervene in this family quarrel. She was using the same lines I'd heard a thousand times before: "Get the kids back." "Divorce." "Living in a better place."

I am so tired of this tug of war! Send the children away because they're the cause of Sierra's every ailment! Get the kids back because it's the only thing she has power over!

The timid, mouse-Keira was melting away. She emerged in early childhood in the face of so much trauma because the quiet helped me stay alive. Something deep inside me had been locked away—and now it had a voice.

I REFUSE TO BE A PART OF THIS ANYMORE! Every cell in my body screamed. And I did the first outright disobedient, self-preserving, self-pleasing thing I'd ever done:

I looked her straight in the eye, turned, and . . . I *ran.*

My skinny, awkward legs felt like jelly. I felt like I did in all my nightmares—I couldn't move fast enough; I couldn't get any air in my lungs. Did I have asthma? What is wrong with me? My backpack was too heavy, but I couldn't leave it. Why was I running so slowly? I was sure she was right behind me, ready to pounce at any moment, but I didn't look back. It would only slow me down.

I reached the waves of Jansport backpacks and the seas of Abercrombie & Fitch outside at the curb and searched the line of yellow metal buses towering above the masses. I boarded my bus quickly, got a back seat, and sank below the level of the windows. A boy behind me laughed at my obvious anxiety, and it angered me that he didn't notice the world crumbling around us. He irritated me with his carelessness.

I arrived at Lisa's house, feeling impending doom. Sierra would know where I was. She would hunt me. I couldn't find a way out of this. I had no advocate, no believer, no money, no help. I wondered if a soul in the world would take my case; if there was a way to rescue me. My mother threatened often to report Lisa to the police, and she kept bringing up the same sentence, "aiding and a bedding a minor." I didn't know what "a bedding a minor" was, but I

was sure she would do it. Every time I thought someone would help me escape, my mother would take them away. It was a chess game, and it seemed like my mother knew an unexplainably extensive amount about the law. She quoted it verbatim! I was toast!

I opened the door and said, "I just want to die." It sounds dramatic, coming from a teenager, but it was wholeheartedly true. It seemed death was the only escape from *her*.

"Come pray with me right now." Lisa grabbed my hand and led me to a back room.

Pray?! God didn't care about one little teenager. He had bigger problems in the world. What good can a prayer do? Really, it's just stating what you want. To a guy who probably won't grant your wish. It's not like He's going to talk back and start telling me what I need to do to get out of this mess.

I knelt down next to her; she readied herself and stayed silent. I glanced from the patient prayer stance I'd learned at church . . . she remained silent for *me* to pray. I didn't see any point, but I felt the pressure to do it. I opened my mouth with utter hopelessness and despair. I hadn't uttered an actual prayer in years. Even hopes in my heart were just small thoughts; I had given up long ago on addressing Him.

"Heavenly Father—"

That's it. That's all it took. One moment, my complete and utter destruction was imminent, and then the despair was gone. I felt the greatest peace I have ever felt in my life.

I didn't have an answer, but the peace was so reassuring and so real, I became less concerned with an answer.

It was as if God—no—Heavenly *Father* had been waiting so long, and so intensely, for me to merely say His name, and the instant it fell from my lips He let down a deluge of love. The future was as foggy as before, but He had my hand, for the first time in my life. It was at that moment that I caught hold of God, and He caught hold of me

instantly, and I knew for sure that He was *real*. Even if He never cared about me again and went back to being Master of the Universe, I would never forget Him, and that He existed, and that He had listened to me when I felt I was at death's door. He captured my heart. I have no idea to this day what I prayed for. I was too dazzled to make things coherent.

I exited the bedroom calmly. Minutes later, a police officer came, a social worker showed up, and my mother entered that tiny living room. We established the situation, and then the police officer said, "So, you won't go home, no matter what?"

I was completely rational and tired. I sat still on the sofa. "No."

The social worker piped in, "But . . . that would mean you are willing to go into a foster home?"

I had never thought of that solution. *Of course!* There was an escape! I hoped they would let me go anywhere else but back home to the demons.

I'm sure my demeanor changed. I looked around the room and emphatically said, "Yes," to something I wanted for the first time in my life, and watched the reaction around me. I was perfectly still and calm for the first time in weeks. The police officer and the social worker looked at each other—they seemed burdened with worry, not relief. They gathered their papers and things. My mother cried out a little in protest, and then her tears fell silently. I didn't believe she was really sad. At least, she was not sad at losing me. She was probably just sad to lose control over someone—just shocked and betrayed, but I never felt for one second that I was abandoning her. She had deserted me a long time ago, and I wanted out.

The police officer was readying himself to get into his car, and I assumed I would be riding with him. My mother negotiated with him to let me ride with her. I was furious.

NO! Why would I ever want to see you again, once I've de-cided that this is the end? I want nothing to do with you! You are the enemy! She'll just drive off with me!

The cop agreed to let her drive me, and I burned and protested, but had no choice. I sat in the front seat of grandpa's borrowed green Chevy, as close to the door as physically possible. She was going to leave with me and escape. She'll out maneuver the cops and take me away, and I'll have no cards left to play. I felt like a tightly pulled guitar string.

She sobbed, and it had no effect. She was dead to me, and her feelings did not exist. She yelled through her tears about what I was doing to the family, but she had killed our family already. She fell silent at my lack of reaction. I think she was learning that I was serious. "You would rather go with a complete stranger than *me?*" she cried, as her last plea, her final heartache.

I didn't dignify her with a look in her direction the whole trip, but I quietly and fiercely said, "yes" to the window. It was the truest thing I have ever said in my life. I'd live under a bridge and shower at school to leave the pit of Hell she had created for me. At least it would be the same school. I would skip happily through life to forget her face and never hear the sound of her whistling at me like I was a dog again. I hated her. My address or name or age would change, but that feeling never would. I refused to live in her world anymore, with the nightmares she dressed up as fairy tales.

My grandmother became a woman at seventeen with her pregnancy from rape. She stood alone. My mother ran away at sixteen and became a woman on her own, and then a teen mother. Whether I knew it or not, I craved that same freedom. It burned in my veins, my destiny written in my DNA. I wanted to be the author of my own life.

Part Two

I Almost Fell into That Hole in Your Life

As my mother and I approached the gray Social Services building I knew so well in South Provo, I didn't walk alongside her. I walked through those doors first, eagerly, and as my own person. I left her trailing behind and kept as much distance from her as possible. Her sniffling in the elevator irritated me. My body language couldn't have been more clear: *your display has no effect on me.* My compliance, my charity, my meekness and humility, my submissiveness to her every whim, was dried up and gone. On such a parched and leeched desert, a massive wildfire came alive in me. It gave me power, and I liked it.

We entered the waiting room, and I found my state advocate, who asked me to wait. I had nothing to say to Sierra, but when it was time for me to leave, she asked if she could hug me. There was nothing I wanted less. She pulled me into a hug with my body revolting in every possible way. She held me tightly, and her hand grasped the back of my head and neck tightly, like a baby. She had never held me like that before. I was alarmed at first, then shocked and softened for a brief moment; the gesture made me think of a time long ago when I was her girl. She sobbed into me,

and I hardened again. I don't remember what she said. I didn't exactly treasure it up.

She released me, and I felt free and light as I made my way back to the caseworker's office. A cloud started to loom in my future. I didn't know where I would go. Or if I would go.

My caseworker started making calls, and at first it sounded like she was begging. I wasn't paying much attention, or else I might have worried. I walked to the window as she left the room in a hurry, telling me to wait. It seemed like she didn't have an answer, but intended to find one. I looked at the gray, cloudy February day. Utah was surrounded by the rocky mountains, gray as the sky. The sun was weak, there was almost no snow on the ground. Any that existed looked more like stray plastic grocery bags than snow. Everything icy let out the secret that seemed impossible in the green bright summertime—Provo was a dirty, polluted city, going through a drought.

·⦁• ⦁• •⦁·

My caseworker didn't return for a very long time. I started to wonder where she was and whether or not she had forgotten me.

When she came in, she was talking a blur and looking happier than she did when she left, ". . . and Jane has agreed to take you in. You'll like her; she's very nice. . . ."

I really didn't care who this old lady Jane was, and I thought it was odd she was trying so hard to sell her to me. I'd meet her when I'd meet her, and whether she was nice or not didn't matter much to me. Anyone would be nicer than Sierra, and I knew how to get along with strange adults—if you keep your head down, behave well, and don't ask for much, they let you coast through life. She didn't even have to be nice to me.

My caseworker and I met Dan and his mother in the waiting room. They had packed two overnight bags for me. I was grateful, and I cried as I let Dan go. I think he was disappointed in me, but he knew there wasn't any way to undo it. He had walked out so many times, I really shouldn't feel ashamed of walking away myself. I did anyway, though only a little.

We didn't have much to say to each other in the car, Ms. Social Worker and I. I wondered about this lame person driving me to foster care—she was skinny and nervous with frizzy hair; I glimpsed a wedding ring, but I knew she didn't have any children. And how could she? Even if her tiny body could somehow swell, her anxiety and frailty wouldn't be hospitable to a baby. She drove a nice car, but the only thing I knew about social workers was that they didn't make much money. What a miserable person she must be. Any money she had went to a nondescript car.

I'm glad I'm not her, I thought. But she was probably thinking the same thing of me.

We got to the house—it seemed gray and white like the sky and the fences, the concrete and the pitiful stray snow. I walked up, feeling as dirty and dejected as the hoodie I was wearing. What a long life it had been. *And now I have to get up the energy to make a new one.* I didn't even square my shoulders to the task; the gray of this day had won.

The caseworker knocked on the door.

I heard little feet run to the closed door, and eventually I heard an adult's voice and the familiar sound of a lock disengaging. I didn't expect anything like the person who answered. Before me stood a short, happy, bespectacled young adult with two tiny children hugging her legs. One of her legs had a bright, purple cast on it. The cast looked like it weighed as much as her whole body, and it held her down to Earth. She smiled brightly, and her fine, straight hair hung down around her face and tangled around her shoulders.

She wore one necklace—a cobbled-together thing mostly consisting of the face of a man's watch. *How odd.*

She was friendly but kept her mannerism casual. Ms. Case Worker rushed through the introductions and handed me her card in case I needed to get in touch, but her body language screamed, "*Off the hook!*"

Jane Nelsen invited me back into her kitchen. I made sure to keep myself humble, small, unassuming, and shy. I wanted to stay, so I acted the way I knew I should to signal "*I'm non-threatening!*" She invited me to the kitchen table where she was making Valentines cards and waiting for her daughter to get home from a party. I wondered how a complete stranger could plop on her doorstep and she could continue finishing her trivial task.

I perked up at the mention of a daughter, but after asking, found she would turn five in two days on Valentine's day. I started to get nervous. *This foster mom would probably make me babysit and cook. I hope at least there's steady food.* Of course, there are about as many family members here as there were in my family, so food would be just as hard to stretch. My anxiety was once again rising.

I peered from the kitchen into their living room and saw a picture of Christ with children above their fireplace. A good sign that they probably went to church . . . at least I could be myself here. I couldn't even see a TV. They had a few family pictures and they seemed very happy. Of course my family did, too, in our pictures.

I shook off feelings about my family. That's not what I wanted to think about right now.

The little five-year-old princess came home from her tea party, and I was displeased that she acted a lot like her dress-up clothes—she was definitely the oldest and enjoyed being a girl. She loved performing and being the center of attention. It reminded me of myself, which was annoying. In the chambers of my heart, I found myself repeating the mantras that women in my life had rehearsed

when witnessing my childish light: *How nice it must be to be young. To be innocent. To have dreams. You will come to know the real world in time.* My heart rejected her in disdain.

The man of the house, Ben Nelsen, was also supposed to be returning soon . . . with pizza. It was after six, and I was running on fumes. It had been such a big day, and I was equally hungry and exhausted. I hated waiting. But I had to look patient because I didn't want them to think that I was greedy. When the back door near the garage finally opened, I was filled with relief and looked anxiously toward the incoming pizza. I was shocked, though—three men came in, not one. I couldn't figure out which one fit with a woman like Jane.

The men took their time with getting plates and dishing out pizza. I was burning with anger and impatience. I ate my piece quickly and wanted many more, but felt so ashamed. One measly pizza for their whole family meant one or two slices left, and I'm sure that the "parents" would take them. I wanted them to sense my hunger and offer something else, but I grew tired quickly. My body sensed being satisfied, even a tiny bit, and slipped into exhaustion.

My room was in the cold basement, and my feet never did get warm that night. I fell asleep with dry eyes and a dead heart. I couldn't seem to stay asleep—panic took up most of the bed and all of my dreams. I had dreams that gangs were pursuing me at school. I couldn't run fast enough, my feet were too heavy and large, and, of course, I was weaponless. I would hide to no avail, and when I informed my teachers, they didn't believe me. I couldn't use my mouth and say what was impending and imperative.

I didn't have time to understand what it meant. I awoke with the sounds of cars—my window faced the backyard, not the street. I was sure my mother would find me here and march me home. Terror etched dark circles under my eyes. Here there was no violence, but my future was unclear.

Stand Inside Your Love

I wanted to scream what was happening to me to all the people at school who lived in their own world, blind to what was going on in mine. Even so, it was odd that my anger depressed me into silence. Even Chris, in his sweet blindness, tried to ask me about my foster home, but I didn't think he really wanted to know. I could barely wrap my mind around the gravity of my decision, and he lived in another universe. I offered very little, and felt distance growing between us. Maybe God wanted me to not date and lean on boys. I cared for him, but whatever it was we had, it wasn't enough to make me feel secure.

Before I had even lived at Jane's for a week, I felt safe with her. She was stable, even if a little ordinary, and I wanted to build my life on hers. I began to hope that I had finally found a family I could use as a launchpad—that, perhaps, I wouldn't have to worry anymore. After just a few days at her house, my feeling of security led to an outpouring of tears.

Ben was at a church meeting, and the young children were asleep for the night. Jane was lying in her bed, and when I came in she let me lie down next to her. I'll never forget that night. I couldn't face her, I couldn't hug her, I felt afraid at my great need for her affection. I didn't dare touch her myself, but I wouldn't flinch if she touched me.

I eventually lay down beside her and she stroked my hair. She was kind, just like I felt a mother should be, but I had not experienced maternal kindness in a long time. I melted, and the dam burst. I was so confused about everything my life had become in the past week—especially that Chris didn't seem to care too much about me, or even know me. I felt used. I didn't feel I had a friend in the world—especially if I decided to break up with Chris, who was the reason I was able to dump my druggie friends. His friends were now mine. Where would I sit at lunch? Who could I call when fear and anxiety showed up to take over my day?

Jane replied to my emotional torrent in a way I had never heard before in my life. "I think you need to pray about it and get your answer. I believe that you'll know the right thing to do and do it."

Simple as that. As if she trusted me completely. As if I had power, authority, or the confidence to have the last say in my life. It was terrifying. I thought she would tell me the right thing to do, like my personal Jiminy Cricket! She did no such thing.

Ben came home from his church meeting to find me in his spot on the bed, and I was scared. I left quickly. He gave little show that it bothered him, but I felt that I had violated an off-limits area. Just to be safe, the rest of my evening was spent in the basement.

I didn't bother praying about it—I was pretty sure God would frown upon a fourteen year old making out with a sixteen year old, no matter what their home life was like.

The next day was Valentine's Day, and I didn't get anything. As friends of mine were delivered balloons and candies and flowers, I felt like the most tired soul who walked the Earth—and I was walking in stolen sneakers. I sat slumped

and frumpy in my morning classes when I figured I should grab a pen. I opened my backpack and found one of the Valentines Jane had been crafting the night I entered their home. Written on the front of the heart were three words, "We Love You." Inside, it simply stated that they were happy I came into their home. It was a warming, softening thought, but I didn't believe it. *How could you love someone you just met?* I had spent a year or a lifetime with many people who had no trouble leaving. I glanced again at the simplest card any person could make, and tears welled at just the hope. I liked the way it felt, but I couldn't trust it. Not yet. I tucked it away but still carried it in my backpack for a year. And now that I have become a mother, I know that it is entirely possible to love a stranger.

I broke up with Chris that day. When I did, I felt like I had just thrown my anchor and rope overboard, never to be grounded and sure again. It was painful. I don't remember eating much. *Probably for the better,* I thought. Years of Wendy's and twinkies on paydays and Ramen noodles on lean days made me think I'd be ballooning into my mother soon. I avoided looking at my face as I applied mascara in the mirror. I quickly dressed and tried not to notice my curving body—so dejected from my own neglect, so enthralling for every teenage boy.

Jane required that I attend church with the family, but I didn't have any church clothes. It was a dream for me to go shopping with her. I worried briefly about owing her money, feeling indebted, or otherwise upsetting her and Ben when things were going so well. She calmly explained that when you get a foster child, you get some money to spend on things that they need, and with that money, she took me to buy a dress and a skirt. We went to a real department store, and I picked out a dress that I was sure was too fancy and could only be worn to a school dance—it touched the floor. It was a bright magenta. Jane and I were

the same size (although I was a little taller), and she tried on the dress that I ended up buying. We giggled when she tried on my dress and it matched the cast on her left leg. She bought the dress and skirt for me, and she bought my heart, too.

I hated that money was a way to my heart like it was for my mother. I didn't think I was greedy. Maybe I was. I reveled in my new dress downstairs for hours in front of the mirror. I'm pretty sure I caught everyone's eye at church on Sunday. I felt beautiful, but quickly convinced myself that it was because I was so out of place.

·•¸ ●•∴•

Jane's two thousand-square-foot house was like the dream home of my childhood—it was a *mansion* to me. It had five bedrooms, three levels, and three bathrooms. It had two different living rooms and a large backyard. There was no fence, so I had an unobstructed view of the beautiful, snowy Mount Timpanogos behind us. Every morning when I came up the stairs to breakfast, and every night when the lights were out, I would peek out of the curtains to stare at her: the mountain's profile against the night sky looked like a beautiful girl lying down. I imagined she was like Snow White, waiting for the Sun to finally kiss her face and break her snowy spell. She was strong and close, and I started to feel safe and protected. The mountain's diamonds in the snow eventually did melt. March made the greenery pop and the white disappear. April brought freedom from layers and coats, and May ushered in an itch to get outside into the warm air and the fresh grass. The winter passed into spring with ease for me as I grew more and more hopeful that this home, sheltered by the lady of Timpanogos, would be where I would stay.

·•¸ ●•∶•

Starting in March I was required to visit a therapist and my mother on a regular basis. Both requirements angered me. I got to a point where (to my therapist's annoyance) I would just repeat to her that I did not need fixing because I was not broken. It was my mother and my family that were broken. There was all this talk between case workers, judges, legal teams, and psychologists of returning to my mother's care, but I refused. My mother was the one who needed to see a counselor every week, not me. If they could fix themselves, then maybe I'd consider going back to live with them, but the way I saw it, I would be living comfortably in Hell before that happened. They still couldn't keep things together—my mother struggled with holding a job and managing her weight and depression, and the children with keeping themselves and the house clean, and they were still moving more often than I'd like—and to stupid places, like apartments in Spanish Fork, Utah. Yuck! I was fully confident that Sierra would never succeed at keeping it together . . . they would see. I could stay at Jane's until I was eighteen and then be on my own. I'd never have to speak to my mother again.

At first I panicked and refused to see my mother in March, even if it meant not seeing my siblings, who had returned to Utah to once again be at the mercy of Sierra's lifestyle choices and moods. I didn't want her to know where I lived, since she would surely take any transportation she could manage to get to the house and drag me away. Jane seemed reasonable about that point and agreed to meet in neutral places.

A month into foster care I had my first meeting with my former mother. My shrink didn't do a lot of good, but she did teach me about boundaries. I didn't know I had so much power, and so I immediately enforced it. I knew that

my mother would use the meeting as part of her grand scheme—a great showing of affection and emotional banter about abandonment or loneliness. I asked Jane to inform my mother that I would not allow her to touch me. I may have been required to see her, but I sure as shit did not have to touch her.

Sierra saw love as a weapon, and the word "family" was her passcode to her nuclear option. Jane acted engaged and interested in everything that Sierra said, and I became concerned.

Did she not see that everything Sierra said was a lie? Nothing was said without careful reason. *You have never seen her work! You cannot trust her!*

I got away with avoiding my mom almost entirely, even during the photo Jane took of all of us together. I hugged all my siblings and performed a surreptitious check to see if they were *truly* okay. I even separated them from the rest of the group while Jane and Sierra talked to gauge their emotional and physical well-being, just as I had learned during visits from Child Protective Services over the years. I wanted to know what was really happening. Either they were too scared to tell me, or there really was nothing to tell. I doubted it, and I hated that Sierra had walled them off from their only hope of rescue—me. They had no idea how good life could be.

It seemed that I was constantly going to some sort of meeting or appointment—dental, shrink, "team meetings" with the child's lawyer (Guardian-ad-litem). Caseworkers quit and changed often. It seemed that everyone was concerned with my welfare at the conference table, and they deliberated on many points, but no one seemed to hear me say, *I'm not going back to her!* I continued to have dreams where I was in danger and would scream with all my might and nothing came out. *I don't want to return to my mother! Why is everyone making it seem like I am the problem?*

She's the one on drugs! I'm the good girl! Why is no one checking on her, making her go to meetings, analyzing her progress, telling her she needs to improve? I'm the teenager who dumped a boy for God, who wants to go to church, who ratted her mother out for drugs! I'm not the one with the problem!

The judge still ordered reunification at our hearing. I don't remember if I was ever asked *my* opinion. Nothing she could do would be good enough. I knew it would be better to stay with Jane. They wanted me back home before Christmas, which I'm sure warmed my mother's little heart, but that was too soon. Less than a year was way too little.

I was notified that I would be changing schools into my foster family's boundaries after my freshman year ended, my third high school by sophomore year. I spent my last month with my friends grieving that I wouldn't be staying with them. I had a glimmer of hope that I could start fresh in Orem, staying in foster care through high school. How popular I would be with an actual house and money to buy clothes! With two parents who supported me!

My grades improved just before summer break. I was almost back to B-grade levels, which was impressive, I told myself, with the stress of this semester. My foster parents checked them often and made me feel good about myself. Someone cared enough to check, and I wanted to please them.

·∴ ●•∴.

My fifteenth summer passed by lazily. I almost completely enjoyed it. There were pockets of despair amidst oceans of elation. Everyone seemed to be convinced that the consequences of years of dysfunction and abuse could be fixed by Christmas.

On a positive note, I made many friends in my new neighborhood and at church. I spent my summer at a different friend's house each day. I went boating with youth groups, I went to two youth camps, and I even got to take a guitar class, which was just another step toward my dream of fame and fortune. I met a boy named Josh at church who loved Ballroom dance like I did, and we started to practice for a competition in October. I felt free dancing in his arms, living in between two parents, and expanding my world between the boundaries of church, school, and family.

I finally felt that I was where I belonged—a teenager who had dreams and goals and got to pursue them like they did in TV shows, instead of a secondary mother stressing about when the food stamp card would be reloaded. I never had to babysit, and when I got home, Jane was always there to greet me. She wanted me to call her to tell her where I was, ask permission to change locations. I even had a curfew. I hated the restrictions, but I secretly loved that somebody cared enough to create rules for my safety. Someone cared to be accountable for me—even if it was only because she would be sued by the state if something happened. Caring was caring, whether it was enforced by law or not.

I was sure that I could change the course the judge laid out for me and make concerted efforts to show my deep love for my new "family." I made a big deal of birthdays, Father's Day and Mother's Day. I cleaned up while they were gone without being asked. I kept my room nice and even made my bed if I thought they might come down to my room in the basement. I read books from the local library and called when I was away. I tried to keep my grades up, and listened to their lectures. I asked questions instead of arguing every point. I kept my head down, stayed quiet, went to church, and obeyed every rule. I liked being the obedient daughter; being obedient was almost easily done in such a good home.

It's a Hard Knock Life

One summer day, before school was about to start, I argued with Jane. I wasn't really wanting to, or trying to . . . the anger just sprouted. I didn't know what to do with it—I loved my "new" family, and I had a plan to keep them. That plan was sung and preached and testified in church, and I wanted it to be true for me, too. Anger and frustration spewed forth from a place that wasn't "me," and, ashamed, I lay on the couch and hid my face under a blanket in my childish temper-tantrum. I was so ashamed. Why couldn't I get my emotions under control? Everything was riding on this foster home working out, and I was poisoning it with habits from my old life.

I walked outside into the blinding summer heat. My feelings were complex, and it felt good to punish myself, in some small way, by putting myself out in Satan's parlor—high-noon in the heat of a Utah summer.

Jane opened the sliding glass door and stepped out to talk to me. She talked a few things through with me, her approach gentle, and I responded in kind.

"If you're going to go back to your family, you . . ."

I cut her off, "But you could just adopt me. If I don't want to go back to my family, because they're awful, and you already have me here, and it works so well, and you love me,

then just adopt me!" The adoption fantasy I'd harbored since I read *Matilda* at six years old cropped up at a bad moment. I had hoped to package it differently to make it enticing, but the impending change made it all come tumbling out.

She seemed stunned. I don't know why. It was the logical next step, right? She had the space, both literally and figuratively, so why not?

"Oh Keira . . ."

I'd seen that look before. The "you poor, pitiable, mistaken child" look hurt, but that it was on Jane's sweet face made it all the more crushing. Hadn't she seen *Matilda*? Heard of *Annie*? Read *A Little Princess*? *Heidi*? *Anne of Green Gables*? There was a whole genre that deals with this same opportunity! She was my Miss Honey, my Oliver Warbucks, my Mr. Carrisford, my grandfather, my . . . savior.

My heart fell twelve stories. Jane slowly explained that it wasn't in her power to adopt me. Something about giving up rights, and judges, and law. I didn't listen carefully. Shock made me deaf and then hardened my heart. Here I thought God had led me to an angel. If she was one, her hands were tied, as were her wings. No one was going to save me. The termination date was real.

Every New Beginning Comes from Some Other Beginning's End

Like most eager teenagers in doomed situations, I fell in love. Right on the streets of Orem, Utah, in the sunshine that forced its way through thick maple leaves, to the beats of the cha-cha Latin music. As Josh and I practiced I found my soul drawn to the smell of our sweat. My heart enlarged as we retraced step after step until we were breathless. My face involuntarily broke into a smile as wide as the Mississippi when we finished a dance perfectly. It didn't take any effort to fall in love with him. It was chemistry.

In retrospect, the reason I loved Josh so much was also the reason that we could never be a good match: we were so *similar*. I was enthralled by how we lived life on the same vibration; I was drunk with every contact we had with each other. I wanted to own him, like a lucky charm. He made me feel that dreaming was not crazy, and that hoping was not hurtful—and that in time, everything I had previously endured could be laughed off.

Most importantly, he made me feel feminine, and I delighted in being so. We were dance partners for months at a time, and this became a symbol for our relationship. He asked me to dance, and he reached for both my hand and

my attention. I was reluctant to give it, but when I finally did I was committed, body and soul. The problem was that I then perceived my own value entirely through his eyes—I went from diamond to dirt and back again with the direction of his eyelashes. My people-pleasing nature made love a rollercoaster.

I got what I wanted for a moment, but I lacked what I needed: commitment and stability.

I never thought a man could possess the respect, hope, and grace that I found in Josh, who became my compass for finding someone to marry. I am thankful I learned to date and fall in love around wholesome Mormon boys.

At the same time, I was experiencing a slow death without dying. My soul had been feeling ill for months, and I knew there was an end in sight. It really broke my heart that what I thought was true—my desires and concerns—were not important enough to be addressed or even considered. Because I was the runaway teen, all the *fixing* was focused on me, to prepare *me* to return to *them*. No one seemed to care that my mother had serious and documented problems with deep depression and attempted suicide. She got a few "parenting lessons," like all she needed was some coaching to get back into the game, but since I made the choice to leave, I got all the labels, the blame, the shame, and the rejection.

Nothing was solved. My mother had a job and an apartment that she could squeeze six people into, but that hardly seemed better than where our family was when I left, and it was a sizable step down from what I enjoyed in my foster home. I would rather have slept on friends' couches or lived in temporary shelters for runaway youth

than be at home anymore. Everything that made me who I was screamed a single message:

I. NEVER. WANT. TO. GO. BACK.

The more I voiced this the more exasperated Jane became. After a while, I realized I was pushing away the one person who might love me, but I couldn't help it. She wouldn't be my foster mom, or mom of any kind, anymore. Just a few months and she'd be free of me. She'd continue her peaceful life that I loved so much, enjoying moving about her full kitchen, her biggest worry being a lack of planning to get their one car for some event.

She announced to her family that she was pregnant, and everything felt a little more final. She even had a demanding replacement for me on the way. No matter how much I wanted to stall things, I couldn't go back. They simply wouldn't have room in their lives anymore.

I became moody and distant during the months before my departure. I would spend time practicing with Josh, elated at our friendship, his loving family, and being able to dance like I was a normal kid with a normal family. When I came back to my foster home, the stark reality of what I was about to lose sent me to my room to drain out my despair to another song from *The Used*.

When I had to go back to my real home, nothing but poverty and boredom and restriction would be waiting for me. The responsibility for a family that I had no skills or strength to support would fall to me again, and my dreams of dancing, writing for the newspaper, or going to the movies on Friday night would be laughed away by my selfish family as they sat in front of the television. Everyone in charge of my foster care case belittled my emotions, chalking them up to my being fifteen. In the rare moment where it was admitted that my concerns were valid, the narrative changed: I was simply inconsiderate of everyone else's suffering or of the changes they had made to accommodate

me. I isolated myself in grief, or distracted myself in feigned elation with friends. I learned that I was better off not saying anything at all. Once again, I became small.

But I had rage building within my grief. My prayers were filled with anger and bitterness.

How could You do this to me? How could You send me to a perfect family, the one I had dreamed about all my life, the one my mother promised me with every boyfriend and every move, just to take it away from me so quickly? I am so happy here! I have friends, people who accept me even when they know who I am! I sleep at night, I don't have panic attacks, I eat well, I have people to talk to. Why send me to another school, another home, back to despair and loneliness? I am finally true to myself here! It's easy for me to obey and learn about You and follow You here! Do You want me to fail? Do You want to break my heart? If You allow this, You'll break me. I can't recover. Not another move, another heartbreak, not a taste of how good life could be just to be thrown back into prison. Why do You want to destroy me? Why don't You hear my prayers? Why don't You answer my pleas? I will never ask for another thing again, I swear. Just please don't take this from me.

I don't think I ever heard His answer, but it was clear that I was going home; there would be no grand miracle. I had never heard of such an unloving and inattentive God in all my life. I stopped talking to Him for a while. He obviously knew what I was going to say if I had to speak to Him, but He didn't seem to care enough to change it. So *what more do we have to say to each other?*

For most of my life, I was an infant screaming alone in a dark room. The message was clear: shut up and sleep. I secretly loved foster care, I had been nursed back to health, and begun to trust my world again. The milk of kindness finally flowed, and just as I was about to gain weight and strength, God put me back in the crib. Just like an infant,

I didn't understand why the world had to be so cruel and cold. Just like an infant, grief racked my soul, and my gaping need was so overwhelming, I simply cried until my body shut down. In my anger, I left my painfully built trust in God, and became subject to *the void*.

··¿●•∴•

I couldn't see Lady Timpanogos from our apartment window in Spanish Fork. I couldn't draw from the mountain's strength as I'd done from Jane's home, and my confidence began to wane.

I moved the weekend of Thanksgiving break, and it had highs I didn't expect and lows I wasn't prepared for. Within the first argument, my siblings had found words for their feelings of betrayal: "Why don't you go back to your perfect family?" I tried my best to act more mature than my surroundings, but if I was honest, I felt the same way. I didn't know how to respond because they had discovered my secret—I would give anything to get out.

There were a lot of rules in my family that were negotiable—you could be unemployed or overweight; you could get drunk at Christmas and ruin everyone's holidays; you could attempt suicide in front of children, deal and use illegal drugs; you were welcome to blow up and swear like a sailor until someone beat you back down—but you never, ever walked out for good. That's what lame, child-support-ridden-ex-fathers did, and those losers weren't "real" family anyway. Once they were "out," the shunning could begin in earnest—you start talking about them like they were never "in" to begin with, and you alter memories just to confirm that they never were fully brought into the fold. When you abandon the family, you break the contract. Forever.

Whether or not my mother had coached them in my absence was irrelevant. For them, the truth was this: I had

abandoned them, and the younger they were, the more abandoned they had been. I had cowered with them in the hallway when another step-father rattled the bedroom door with screams and force. I told them to laugh their fears away. I'd tried to use my sixth-grade height to scare their bullies at school. I'd stood on the sidewalk late at night with four heavy souls, and wondering if it was safe to go home. Wondering where I could take them if it wasn't. Wondering if there was ever going to be a place of peace in the world for us.

Wondering why stories like "Annie" or "Heidi" didn't seem work in the real world.

The truth is this: Everyone in my family got too heavy. The world was unresponsive. I'd wanted to be the hero who pulled through, but in facing a cold world, I got cold too. If there was no solution, then I would just get myself out and do the best I could to help them once I was on the other side.

So I left, and then I became the same as the backside of every would-be father we'd ever seen. How could I abandon the needy, the poor, the unfortunate, and the lonely like my family? Apparently, too easily. Getting a good night's rest, fun weekends, meaningful relationships, the chance to express oneself, and being able to face the future with hope is all so addicting.

It seems you can go a lot of places as long as you're on your own, and even better, if you've got enough money to have the basics covered. That's why our deadbeat fathers seemed to thrive.

My family was tolerating me, and I was enduring them. We weren't knit anymore, but Jane certainly didn't need me back, either.

I was nameless and wandering again. I didn't belong to this tribe. My last name wouldn't be Nelsen, but it may as

well have been. My family had labeled me an outsider and I inhabited the emotional quarantine.

I tried for a while to be the mature picture that Jane painted of me, handling my mother like a chess player where every word was a move and every move mattered. If I played it right, maybe Sierra would continue to work and she would stay away from bad friends and worse habits, and then we could pull ourselves out of the mire.

When my mother took Dan back in her bedroom not days after I got home, I had hope that they were pulling through it together. We talked one night in my bedroom, and she opened up to me for the first time and spoke to me as an equal. She expressed how lonely she was and how difficult it was to keep her head above water. How Dan was her soulmate and she couldn't bear life without him. It was the first time she had slowed down, even stopped, just to talk, to express, and be honest. I was effervescent with the hope that I could finally understand her . . and that, perhaps, she wanted to understand and trust me.

Song lyrics appeared in my mind as I thought about the care she had loved me with in the early years:

> When you cried, I wiped away all your tears
> When you screamed, I'd fight away all of your fears
> And I held your hand through all of these years
> You still have all of me.

I felt I was discovering the pain she felt by loving every person she had and losing every single one of them—her worst fear was that she would end up afraid and alone.

As often happens in a household of seven people, we were interrupted, but I hoped that we would connect again and that she would always treat me like a peer. Instead, the conversation got Dan back into the family. As it turned out, she avoided any further intimacy with me not only during that time, but for the remainder of my teenage years. That

one moment was so grand, so heady, I lived on it for a very long time. But even she couldn't bear to be compared to Jane, to have her decisions criticized and measured by religious standards—especially by a teenager.

Friendless at my new school, I spent my afternoons and evenings cleaning, cooking, and finishing my homework on time again. Without hope of ballroom competitions, Friday night games, and newspaper stories to edit, I turned back to the television just like everyone else around me. The ball was over, and my stagecoach had turned back into a pumpkin so I could inhabit my lowly station once again. I called my Orem friends and rode the public bus to go to activities they were having.

Predictably, my mother fell behind on bills, and I couldn't figure out how we spent our food stamps so quickly. My family pressured me to ask my Mormon bishop for food. I attended church infrequently and alone, relegated to the metal chairs on the back row in less-than-ideal Sunday dress. We were given flour, sugar, rolled oats, salt, and canned meat. I really had no idea how to cook any of these things other than the canned meat. Like everybody else in my family, I lacked the skills to utilize the gift. The Church didn't check on us after that, and I didn't ask for help. The flour went into the garbage.

I felt terribly confused at the message. I would attend church and hear of lectures about giving ten percent of my income to the church, using scriptures about offering help to the needy as part of the justification. It seemed to me that most regular Mormons were doing just that. There were large and expensive temples and grandiose Christmas dinners, but I was given second-hand clothes and flour with no instruction on how to use it. Some members criticized giving people (like my mother) actual cash, and they felt that only food and clothes should be given; rent assistance was a stretch, and only a limited offer.

I often heard people in Church talking about how food stamps just "gave a man a fish" without "teaching a man to fish," and I suppose that had something to do with the types of food assistance they offered. I might have agreed with the sentiment, but nobody ever taught us how to fish. Or, in this case, to make bread. Or oatmeal from rolled oats. Who was checking on the children? They were quick to help one of their own for a job, and seemed burdened or bothered that my mother was in need of one. I was thankful later for both experiences—being in the heart of the religion and being cast out to the margins—to see where the organizations (especially those I gave money to) could improve.

As a sort of consolation, my mother conceded to keeping me attending Orem High School when I moved back with her to her new place in Spanish Fork.

I think it was a lie to ease my heartache about a fourth high school. She broke that promise overnight when she received custody. Lies. Anything to get me back, I suppose, not that I had much choice in the matter. I knew the commute would be long, so I don't know why I let myself hope that I would be able to stay at Orem High. I was pretty gullible, I concluded, like I had been about everything.

The next Monday after I was released from foster care, I was taken out of school, and I didn't even get to say goodbye to any of my friends. I walked down the lonely halls, emptied my locker, and left without a word. We couldn't even afford to get me a yearbook for that year, prepaid and sent when they came out. Orem high would be just another memory like everything else for me. They wouldn't remember me at all by Springtime.

You Were the Same as Me, but on Your Knees

We moved again, and though the news was unwelcome, I breathed a sigh of relief—I would stay another year at the same high school. I was no longer far enough away to ride the bus, by about four blocks. Mavis, the hot-pink-lipstick-wearing, country-music-lovin', hide-of-an-elephant bus driver let me walk a few blocks to a road on her way and picked me up there. I was blessed yet again by someone willing to fudge the rules a bit to help the helpless. I wanted so badly to stay at my high school another year that my eyes welled with tears at her slight, knowing nod when I gingerly stepped toward the bus. She was, it would seem, the Jean Valjean of the public-school bus line, not the Javert.

Why couldn't my mother drive me to school if she was going to move us? Anger boiled within me as I passed her closed door every morning. Once again, she had stopped going to work and was "sick" often.

I was at war with myself. The worst of me wanted to call her lazy and foolish. The even-minded part wondered if it was another tragic bout of depression. I tried my best to listen to one or the other rather than engage with the third,

and most terrible option posited in a whisper by my anxiety: "Was it drugs again?"

Dan-the-drug-dealer (still getting used to that title) and my mother fought, split up, and returned to each other often. She found boyfriends fresh out of prison to fill in the gaps when he was away. They brought in drugs (that she "found" when she was angry, holding them up for all the children to see or smell as evidence of betrayal) and loads of pornography. Ashley and I made it a habit to walk to the public library and use the internet and search the Sex Offender registry and police records for the names of anyone who stayed with us. Like me, Ashley became distrustful and observant for self-preservation's sake—she took note of where the shoe pinched on everybody. Alex and Brandon practically lived on their bikes, finding anywhere else to be until the weather grew cold. As winter approached, they neglected homework in favor of our second-hand PlayStation.

I stayed away often, with homework, dates, jobs, and practices, so I was no longer sure if Sierra was sleeping with the scary guys she invited in. It was completely silent behind the locked door—either she was sleeping or she was stoned. I had no idea which, and I would rather not know, so I left whenever possible.

My siblings were excellent despite neglect from all sides. They were old enough to fix themselves instant ramen noodles on the scant days, boxed macaroni and cheese on the good days, and cereal at any time. They were even able to use the food stamp card and walk a few blocks to the grocery store when we ran out of milk. Becca was often gone, earning money by begging and doing chores for others, then using it to buy better food. My brothers rode their bikes to our grandfather's home, working on the lawn or doing small chores to get some extra cash.

·•ͼ ●•ͼ•

Once, with their earnings, Alex and Brandon stopped in to eat at One Man Band diner on Main Street. The owner, Stan, liked these scrappy boys so much that he let them wash dishes in the back to earn all the fries and sodas they wanted. My brothers worked every weekend that summer, gorging themselves and getting chummy with Stan. They started to open up to him about their home life, and they were always thankful for the food.

Alex told me later that Stan swore after hearing their story. As Alex related the story to me in hushed tones, both our chests filled with pride. It was extremely validating to hear that a grown man felt it was so bad he would use the BIG BAD F-WORD.

Whenever we approached our mother about how our family lived, she dismissed all our fears and feelings. Alex laughed, "He said if we ever write a book about our life, we have to mention him in it, to give him payment for all the fries!" Alex shrugged it off and I said no more. *A book about our stupid life?*

At the end of the summer, he let the boys go, just in time for school during the winter months. By then, I was working, and I could buy my own fries. I never met him, but his suggestion to write a book stuck with me.

Two-Horse Town

Ashley had taken over as the responsible "second mother" after I left. It was awkward for us. Not as bad as it could've been, though, since I had no desire to be a second mother again. I felt the obligation on my shoulders, but I would often ignore it. Being at Jane's had shown me that it wasn't healthy or helpful for a child to run a home—and how much fun it could be to just be a carefree kid. I didn't have much power over my siblings, so why stress over it? Why should I yell all the time?

I had no control over anything that happened in my home, but knew that things my mother had done were wrong. Once, after riding home from my new high school, I decided to grab the mail before my mom got home from work. I was disappointed to find only a few bills in the stack of mail, and I closed the box and headed back.

But something strange caught my eye.

Each and every bill—from water to electricity and everything in between—were in my sibling's names. How is that possible? How does my nine-year-old brother get a phone bill?

Before I could finish my thought, I knew exactly what had happened. I remembered my mother complaining that she couldn't get qualified for a phone line because she had

run up too many phone bills with long-distance calls and dating hotlines, which had led to cancellation of service many times. She never could pay them but I'd just discovered how she got around it.

I was mad, but I had no idea what I could do. Was this something bad enough to call the police over? And if it was, was it like a speeding ticket where she would just receive a slap on the wrist? That wouldn't help me at all. What I wanted was to go back to Jane, but if all this accomplished was making Sierra pay money we didn't have, then I would just have to sit on it.

Not knowing what might come of reporting this, I shrugged it off and brought the mail to the house. It wasn't until distant relatives looked into our credit scores and history that I remembered this incident. As we suspected, we had to do plenty of disputing to clear our credit, but thankfully it wasn't difficult. Credit companies can understand that nine-year-olds don't get their own phone lines.

Dan moved back in with us, which made Christmas awkward, at least for me. Dan, ever my confidant and the closest dad I'd had, had turned cold since my "betrayal." He had gained weight, which I concluded meant that he had given up taking Meth too. It hurt to not have a relationship with him when he was finally sober.

I hated Spanish Fork. I was never pleased with whatever it tried to do—sometimes, it seemed like it was *trying* to be a hick-town, full of large belt-buckles and paisley decor. Other times it seemed to be trying to be modern, with a strip of fast-food places and a fancy coffee shop on Main street. I preferred Orem, a bigger city with more modern sensibilities and amenities, but that still possessed the small-town feel that ensured every neighbor was a friend.

To a teen who was already angry about being moved and had already decided to hate it, Spanish Fork felt more like an every-man-for-himself, edge-of-civilization hayride that wouldn't end. Everyone was as poor as they were unfriendly.

I hated facing high school alone, but preemptively hating it made me feel a little better about my situation. I hated Jane for not fighting for (or even sharing!) my desire to stay with her in Orem. I hated my mom for making promises to let me stay near my friends, even say goodbye, before I was ripped from that heaven and brought to Satan's Fanny.

I hated myself for thinking that it was possible to stay in one place. Had I already forgotten that my mother didn't let me stay at Provo High, instead of transferring to Timpview High, when they were in the *same town*? If my mother wasn't going to let me attend a school in the same city, why did Jane enroll me at Orem High, and not have me attend in Spanish Fork, then? If the plan all along was to get me to go home, why not have me attend in Spanish Fork, then? Why was no one reaching out to me? Why couldn't I make friends? Why did every single part of my existence have to be made more difficult?

Few people seemed to notice that I existed, but at least one girl in my gym class was bubbly and friendly enough to ask my name.

I whipped out *The Formula*. The one that got me through a lifetime of moves, new boyfriends, new stepfathers, new family members, and new neighbors.

In May, I was released from my sophomore year of school and from the play I was in. I felt the urgent need to get a job. It was always an itch, but I convinced myself that the play was the last time I would be able to be a "dependent minor" and enjoy school and one extracurricular activity. I was right.

I pounded the pavement like my mother had before me (but wasn't currently doing, as she had imperative appointments with her pillow), and dressed my best. As it had many times before, the Sierra formula would get me the things I needed. I wasn't qualified for many of the jobs, and was nervous to boot, but I leveraged the formula to immediately ingratiate myself with every interviewer and potential manager. Smiles, high heels, relaxed posture, unique words. This technique is versatile.

I got the job as a courtesy clerk (euphemism for bagger) at Macey's grocery store. I wasn't sure I could afford their work uniform, and I wasn't on the same level of religious purity that most of the other baggers were on, but I was still so excited. Macey's was the golden employer for high school Christian teens, since it was closed Sundays. Macey's knew this, of course, which is why I made $5.15 an hour the entire time I was there—minimum wage. It was worth it, for Sundays.

"Paper or plastic?" Pushing carts in the rain. Restocking. Gossip between the produce boys and the cashiers. I loved it. I couldn't afford a good dinner while I was there and often only had time to pack a snack—a small plastic sack of chips, a piece of bologna or a hot dog, often without dressing or bread, or a can of fruit were my favorites. I was always weak and hungry. Often I could barely stand with my eyes open because of either blood loss during my period or late nights doing homework. I loved my co-workers, feared my bosses, and was always exhausted, so I always looked forward to getting off early, even if it meant a cut in pay.

Money!

After two weeks I got my first paycheck. I realized quickly that I was simultaneously elated and anxious about money. The first time I saw my name on a check, I nearly jumped at the vision.

My earnings: $86.13. Pretty good for a shortened pay period. Between the $20 charge for my uniform and a few assorted taxes, I was left with $59. 54! Pretty nice!

My mom insisted on driving me to get that paycheck, a suspect move from a woman who normally couldn't muster up the energy to get me to school. From the moment I had that check in my hand, she watched me like a hawk and noted everything I did. She mentioned at that moment, without a hint of shame in her voice, that I owed her for two items of clothing. Oh, and my work shoes. And the gas to get there, too. She gleefully calculated every penny: $23. I separated out religious offerings for my congregation (as I had been taught by my foster family), $5.95, and I owed a friend $5. I was left with $25 for the next two weeks. School was starting. I wanted to earn the money for my driver's preparation course. I started to despair.

I'd hoped to open a credit union savings account, since I discovered that any place you try to cash your check will charge you, but this required a $25 balance at all times. I

fell into greater frustration. I simply decided to cash it at the Macey's service desk, my family following behind. They smelled money, and I noticed how annoying my mother's purse with all her plastic keychains dangling and jangling off of it could be.

I tried to breathe as I approached the desk with my family in tow, telling myself that my first paycheck was going to be disappointing for a number of reasons—I knew that. I would have bigger checks to look forward to.

I endorsed my soon-to-be $25, as my mother peered over my shoulder hungrily. I realized what I must look like to everyone around me, including that nice lady at the counter. My overweight, sloppily dressed mother, with greasy hair, chomping her gum, suddenly had a sign above her that said, "UNEMPLOYED. MISERLY. POOR. DESPERATE. BAD-MANNERED." My hungry, skinny, equally sloppy and greasy siblings had a sign that said, "POOR. DESPERATE. AVARICIOUS. PITIFUL." And I felt very acutely every member of my family lean toward me, ever so slightly, as I signed the check. It was painful and uncomfortable that THEY knew every penny I had as if it were already theirs, spent, and forgotten.

"You owe me money." My mother bluntly reminded me in front of my co-worker, who was retrieving the bills. She continued to smack her gum noisily.

"I know." I said quietly, without looking.

"She owes me money." She told the completely uninterested, and probably embarrassed cashier.

"Yes, I know. I'll pay you."

My boss approached to discuss my schedule, pulling me away from my embarrassing family for a moment as she did. As if taking it as a challenge, my mother spoke louder and interrupted our conversation to say, "How much was that shirt?" She turned to my boss and added, "She owes me for a T-shirt." My pale face flushed, lighting up like a

Christmas tree. "I think it was $7, right? Oh, I thought it was—okay. $7 for that . . ."

Because of my unrefined upbringing and under the influence of bad media, the words *retarded teenager* were the best description my mind could come up with for my mother's behavior. It's not like I had a lot of virtuous literature lying around my house for better synonyms.

My stomach was doing cartwheels. I was certain the cashier knew. We were poor! We were unemployed! Someone will find out—we are slovenly and uneducated! No one would want me working for their upstanding company! They have discovered who I really am. They know my whole family depends on my $25.

The cashier handed me the bills, and I quickly pulled out the amount that had been so painstakingly calculated. As I paid her, I looked her squarely in the face, and emphatically stated, "I'm free of debt to you!" My mother rolled her eyes and murmured her mantra about me being a drama queen.

Jane taught me about budgeting with an allowance and did a great job. I also learned not to get into debt, which is why I was relieved to tell my mother that I no longer owed her anything. Jane was smart for teaching me this principle just before it was time for me to get a job. I wish my mom had learned it, for our family's sake.

I got home later, showered, and fixed some ramen. I sat down on the couch, noticed I had no spoon, then asked Ashley to grab me one before she came into the living room. She did, without attitude, which was shocking, and I happily began eating in front of the television.

"Give me some money." Ashley said, and I realized she had been standing in anticipatory silence for thirty seconds.

Confused, I slowly turned to look at her. "What?"

"You got paid. I want some money," she simply stated.

I scoffed. "No! Why would I do that? I don't even have much."

"Because I got you a spoon."

"Yeah so?" I trailed off, waiting for an explanation.

"And I did your laundry last week. And I made you ramen last night for dinner." She had a list prepared.

"So?" I replied, searching to make sense of what all of this meant. "I thought you just did those things. Because I do stuff to help out, too, like dishes."

"You owe me." She threatened.

"No, I don't!" I left and went down to my room, feeling a little betrayed. I thought my family had been getting along great because things were getting better. Maybe my prayers were working—but no. Time crept closer to my first paycheck, they calculated, and adjusted accordingly.

We were all eating Ramen noodles because my mother wouldn't budget the food stamps. She bought toaster strudels and Pepsi on the day the food stamp card was loaded. I had no lunch I could pack, and as I got ready for work the next morning, I looked at the five dollar bill on my desk.

I really shouldn't buy myself a lunch with it. I could pack a hot dog in a sandwich bag.

But what could I buy with just one *dollar*! I could buy a can of Bean with Bacon soup—my favorite! Or a couple bananas! Or a whole chocolate milk!

I slipped the five dollar bill into my pocket, happier than I had been in years. *My own money! Freedom and control! Scarcity, scarcity, scarcity, SPLURGE!*

Just before I left, I saw my perfect twenty dollar bill lying on my desk. I thought about how many of my Orem friends just left their money lying out, so trusting of their environment. I wanted to be like them. Surely my family didn't walk through my room everyday. When I arrived home, my door was always shut like I had left it before. They wouldn't walk

in, and they certainly wouldn't take that twenty, I assured myself. I felt agitated because I wasn't actually sure.

On my break at Macey's, I spent nearly the entire time debating about what $1 item I would buy for my lunch. I slowly made my way around the store, picking up 99 cent-or-less items—a banana, a can of soup, my chocolate milk. I couldn't decide, and it made me excited to think about how full I would feel if I had all three items. How varied my flavors would be. How I would have a little left over to nibble on after closing time.

I bought all three, and blissfully enjoyed the remainder of my break savoring all of the banana, nearly half the can of soup (when you add water, it's like two meals!), and half my chocolate milk. I felt guilty enjoying this warm meal and all the flavors while my siblings were almost certainly having Ramen in front of the television again. After I finished work and walked home, I sipped my chocolate milk while on cloud nine. I casually disposed of the bottle, as if one dollar wasn't really so much to spend.

When I got home, my precious twenty dollar bill was missing. I had spent almost four dollars on one dinner at work, assured that my twenty was home safe in my room, with many more meals to come.

I was full of rage. I knew I shouldn't have left it there! Now it was confirmed—I couldn't trust my own family!

By the time my mom got home, I was seething, but scared. I wanted to scream and cry at the same time. When she came home, I didn't have the guts to face her. I did try to show her how angry I was non-verbally, but we all knew I just looked like Granny—an angry coward. While skulking, Alex tried to hit me up for money. I bitterly replied I didn't have any. I don't think he believed me, but I said it so forcefully that he thought he'd better not push it.

A few days later, my mom handed me a ten and a five casually and mentioned, "I get paid tomorrow." I don't

know where she got the spare cash if she didn't have her paycheck yet. We were digging into the granola from the Mormon church food stores now. Three days until our card was reloaded. I didn't say anything. I was angry that she didn't pay me the full amount, that she didn't apologize, but was relieved that she didn't intend to leave me without money forever.

She left right after to go "visit" and "work" for a boyfriend, or "doing favors for a crippled guy with money to spare" again, and as she got into the car she ordered Ashley to go into the house and tell me to buy milk and bread with that. I was stunned at what Ashley was saying. I paused and then asked, "Did she say she'd pay me back?" Ashley shrugged.

It was at that moment I realized that she had planned this all out—even telling me through my hungry sister as she left to wine and dine with some wheelchair-bound client. I'm the bad guy. I had been framed. She was testing me. Now that I had money, she wanted to see how far I was willing to bend. How deep my guilt could go. How easily I would break. How much power she wielded over her child's money. I tried to remain calm. I knew that showing emotion would be an admission of her power over me.

Keira the compliant.

I called her without saying hello. "Are you going to pay me back?"

She didn't miss a beat. "You eat here, too."

So much for temperance and self-discipline. I blew up. "You come in my room and steal my money? Who taught us that, 'Taking without asking is stealing?' And you wouldn't HAVE to STEAL if you would just BUDGET our money, instead of buying useless crap like PEPSI and Twinkies!" It felt so good to be right, I was on a high. I knew I was right— because that's what Ben and Jane had done and said. That's

why they had what they had—budgeting couldn't be so hard. I had done it, until she stole from me!

But I had made a fatal assumption: being right didn't stop my mother from being brutal. She was never wrong, and she was far more experienced in battles of wit, sarcasm, and cruelty. She had YEARS on me. I shrank in fear after her first sentence.

"All right, Little Miss Perfect," She addressed me. "Sixteen going on Twenty-five. If you're such a perfect mother, you have to help our family out. Since you know how to be the perfect mother, be one. Starting with your money. Now."

I had hope my logic would win out, since emotion wasn't working. "I'm just suggesting a way to change since your way isn't working. We're not happy."

"NO, it's just how YOU are—*never happy with anything I do!*" I moved the phone from the one good ear I had left.

I shot back, convinced of my righteousness, in total anger and total truth ringing in my voice, "NO. That's how YOU are." I held back from saying, "And you run away from your problems, hoping everyone will solve them for you, instead of making a change yourself."

"It seems you have it all figured out, so just go ahead and be mom, and YOU can feed the family. And if you don't like that, then storm into your room and commune with your God on THAT."

She hung up on me, which felt like the final slap in the face, probably off to find her own pleasure and to pleasure someone else and forget us, hungry and unattended again. But I was learning from her, too. *I won't spend my life running away and using everyone.*

I started to cry. When I was sure I was logical, or right, she would build another wall constructed of obligation and guilt, and I wasn't right anymore—in fact, I was the bad guy. This was all a game, an illusion. I couldn't figure

out the rules, and I didn't even want to play anymore—I lived in torture all the time. I wanted Jane back. At least her rules made sense, and I knew what was right, even if I didn't always live up to it.

I called Jane; she was like a lever I could pull when my back was to the wall.

Jane answered, as always, and listened to my story. I waited for her to help me make sense of this. She would know how to save me from this. "Sometimes moms are selfish and make us feel guilty to get what they want" she explained, which wasn't comforting at all, but it was re-assuring she didn't think I was crazy. "You should go to church tomorrow, pray, feel the spirit, and decide then if you should help. Decide this in the right state."

Although I knew she was right, I wasn't happy about it. Under that direction, I'm sure that Jesus would say to give ALL my money to ALL the poor people in the world. I would never have ANYTHING. In a spiritual mindset, I knew what the answer would be, so I didn't even want to ask. *God's just going to tell me to be kind until it kills me. I'll never have anything of my own ever again. Jesus was always poor, and gave to the poor, and hung out with the poor, and talked about everyone helping the poor. I'm never going to have anything I want.*

"If you give her the money," Jane continued, as my heart sank further, realizing there was no way to win or get out of this, "you should say, 'I'll help out this time, but not any-more, unless I feel it's right. Christ would probably do the same thing, right?"

Her voice faded as I pondered the Impossible Christ. *How in the world could He do it? All the people who hurt and sucked from Him, yet He always helped the selfish and desperate. I don't think I can do this at all. I know this is only the beginning—there will be more times exactly like this. Every time Ashley or Becca came home with babysitting*

money, it would be the same thing. We started learning to hide and horde, to distrust and strike with anger. Granny and grandpa were regular marks for Sierra to take advantage of. She does this to everyone, that's why she can't keep a boyfriend or husband. She's a black hole of a person—sucking everyone dry in the name of guilt and duty. I won't escape until after high school, or even when I'm dead. I just don't see an end to it.

I will stand up to her. I will stop her.

"Well, I'd better go . . ." I trailed off, confused at my path, but angry enough to change it into something else.

"Is there anything we can do?" She asked, and I nearly cried because I knew that she meant it. The goodness in the tone was true.

YES! Take me back! Let me be with YOU again! Tell me what I'm supposed to do; I don't have a plan! Or give me money to solve all these problems! You can afford it!

Then I felt bad for thinking about treating them the same way that my family treated me. I guess I was greedy and selfish too, seeing everyone in dollar signs.

"No." I mustered up the syllable. I was kneeling, and I sank back onto my legs, realizing that the entire time I was on the phone, I had held onto the phone like a life-line. I let my life line go with that one word. Hope had kept me afloat, but now I let myself sink back into the darkness that was working so hard to sink me anyway. My body crumpled, and I ceased crying.

Jane said, with the luxury of hope and freedom and power over her life in her voice, "You're doing a good job."

I pulled the phone away from my face to sob silently. I didn't know I needed that, but I did, really badly. *I just need someone to tell me that what I'm trying and failing to do matters.*

I wish Heavenly Father would say He was proud of me.

Does being a follower of Jesus mean being a whipping boy?

My lifeline hadn't turned out to be the saving grace I had hoped. I hung up quickly, ashamed at being a black hole to Jane just as Sierra was to me.

Instead of a pillar of light descending in my room to boost my self-confidence, I sank into my bed and fell asleep after a good cry.

Hit And Run

I had finally been able to pay for driver's education with my hard-earned grocery-bagger money. But getting the license meant more fees, someone else driving me to get it, and time. My mother agreed to take me to get it when I could pay for it myself—including paying her gas money to get there. I couldn't argue with the logic of it except that it angered me, as she literally lay in her bed jobless, day in and day out.

My mother eventually did get a job, in the deli section of the same grocery store I worked at. I didn't mind walking to my job all summer, but I started to worry about walking such a long distance once it got colder, especially at night. If we worked at the same place I could ride with her most of the time, and maybe she could pay rent, which would also be good for me. Things seemed to be going well, although I secretly didn't want her to use me as a reference when she applied. I was a good worker, I thought, and I knew she frequently got "sick" and wouldn't show up. I didn't want people to think I was like her.

One time, a few weeks into the job, she said I could take the car after I finished my shift and just come back to pick her up later. I felt like a million dollars! All those years

of being a steady, hardworking, obedient daughter were paying off in dividends!

My drive home was blissful and uneventful.

When I returned to the store at the appointed time, I was overconfident. As I pulled into the parking lot, I miscalculated the distance of the nose of the car and the beautiful white truck next to me. My car made a small blue scrape along the bottom of its perfectly smooth surface. I'd made tight turns into tight parking spots before, wondering, "Did I hit it? Am I too close?" but this this time the sound was unmistakable. My heart sank into my gut. I was a dead woman. *Forbidden to drive before she even got her license?!*

I backed up and parked correctly in a panic, then entered the store ashen, making my way toward the deli. Surely, I was so guilty, and cameras all over that place captured my anxiety perfectly.

My mother was friendly and tiredly jovial with her co-workers as they closed and cleaned the meat slicer. I approached her from the other side of the counter and the happy mood slid off her face. "What?" she asked apprehensively.

"Ummm . . ." I began, not knowing what to say. Her look showed signs of souring as she awaited more detail. "I hit a car in the parking lot while I was trying to park." I stated bluntly, but quietly, seeing her nervous reaction with her other coworkers listening. I thought about trying to explain myself, but no amount of good intentions could change this one. I would never drive. I was a goner.

"You what?" she said, looking more dismayed than angry. That surprised me. Had she moved quickly, I would've flinched. Maybe age was tempering her. "I better go and see. I'll be right back!" she called to the deli ladies.

We went outside, with me definitely doing the most I could under the circumstances—I felt like burying myself in Mexico—so instead I trailed behind her.

She marched to the car with purpose, but she seemed so short, stout—more like a workhorse than a show-horse. The strength in her thighs could have pulled the small blue car out of that stall all on their own, dragging through another hard shift. All of a sudden, I became very worried about her. At that moment, I realized that with this mistake I could lose her, which could be costly in such a precarious financial situation.

"Where's the damage?" she demanded, hands resting heavily on the spot where her hips should be. I pointed to the large, shiny white truck to the left, on the lower half of the door.

Her face softened, but concern was still mapped on her brow. She got closer, and closer still. She stood up suddenly, glancing left and right before meeting my gaze. "Did anyone see you pull in?"

"No, I don't think so," I replied. She looked around, arms crossed and foot tapping, then made a decision. Sierra always kept her own counsel.

"Wait in the car," she instructed. "I'm going to go in, get my purse, talk to everyone, and we'll go home."

I was so worried that it was a relief to be instructed, even by her. I followed her words to a T, spending the few moments I waited looking around the lot for security cameras. I was sure police cars would pull up any minute.

But they didn't. My mother walked back out of the store, looked at the truck one last time, then calmly got in the car and pulled away, talking the whole time. "I told the ladies that you had dinged the door with some color, and that I left a note on the windshield so we could work it out. They let me come home for the night, such nice women. No big deal, no problem."

I was easing out of my foggy anxiety. "I don't remember you leaving a note." I murmured. I was almost certain that I had seen her the whole time.

"Oh, it's fine. They're probably not going to call anyway, because they wouldn't even notice it. That's how it happens, you don't notice a shopping cart or something, and it's not hurting the engine. You can hardly see it and they certainly don't need the money." She ended that sentence with a mirthful laugh. Something about her logic didn't seem quite right, but what could I do? I didn't know the people, and in my youthful foolishness, and our family's dire financial situation, I feared getting in trouble more than anything else.

When I took my final written test for my learner's permit, I had to define "hit and run," and answer that it was a felony. My stomach churned with the hypocrisy.

My last two years of high school in Spanish Fork did not vary much. The only thing that truly changed was my address—one last time. I fought through the cycle of waking early with no energy, pulling myself through school, racing home to change into my uniform, and dragging myself through work with whatever strength remained in my bones before falling into bed again to start the cycle again. I occasionally found myself infused with an eager teenage spirit, usually when I attended a dance or had one weekend night free to play. I relished those moments, mostly by copying every detail into my journals (which my mother would then read while I was at school).

My conflicts with her grew though her mantras stayed the same. Homecoming dances were met with, "You may be pretty on the outside, but it has to match the inside." Another semester of good grades that brought me joy was diffused with, "You may be book-smart, but it's another thing to be street-smart. You can't get common sense from a book."

Since I had gotten a job, the fighting was mostly money-related. If I ate too much, accidentally broke something, or requested something I needed, my income was brought up. When we did our taxes in January, our combined income

for the year did not break ten thousand dollars. I had twenty five dollars in a secret college fund, but somewhere in my gut, I knew that twenty five dollars wouldn't pay for a gulp of air on campus.

Everything that was precious to me was eventually used up and destroyed in the ever-hungry, greedy machine that was my family.

My money was stolen. Flowers from school dances were destroyed before my face just to make me cry. Our safety was compromised with wanted criminals and illegal substances in our house, and mold grew in the basement making all of us ill. I begged for rent money from my church. Our clothes washer broke, and with my mother unemployed, we started to do the laundry by hand. We all began to stink.

I found more and more reasons to stay away from home. Every time my mother got a new boyfriend, Ashley and I would perform the familiar ritual of looking him up on the Utah Sex Offender Registry using the computers at the public library or my high school. Sometimes, my mother wouldn't come back for a few days. We were self-sufficient children now, with me leading the pack at sixteen, Ashley and Alex at twelve, and Becca and Brandon at ten years old. We never got enough to eat, and the scarcity in our house made us nip at each other like a pack of wolves. I physically fought off each one of my siblings for infractions. One moment we were a clan, and I would be their defender to the death. The next moment, we were all participants in an impoverished Battle Royale.

My mother would rage at the slightest noise above her room downstairs. She made fun of me for refusing to watch grisly R-rated horror movies with the family, and she began unleashing her physical abuse strictly on Becca, the smallest, thinnest, and most broken of us all. Becca's weakness and unpredictable mood swings had made her the family scapegoat for many things, including my mother's rage.

With no consequences, and my mother's unpredictable state becoming even worse, the abuse quickly escalated until one day I arrived home from school to a harrowing scene in the hallway of our home. My mother stood over Becca's cowering, prostrate form with a mask of rage on her face. As I watched, Sierra began viciously kicking her—shoes on—in the ribs. Becca, the new standard of "compliance" in our home, simply yelped and wheezed as each blow connected, as if even the strength to cry had been beaten from her lungs. My mother took a step back, and I dashed forward to intervene. When I examined Becca, I was horrified to see that she was so thin that her ribs shone through skin that would have been translucent had it not been so heavily bruised and battered.

I turned on my mother, screaming and raging at our supposed caretaker for doing this to my baby sister. I saw yet another of the dozens of apathetic looks she had given me in my lifetime. I knew I was right, yet somehow I still felt powerless. I figured that if she didn't care all that much, the police wouldn't either.

Because I never stumbled onto a smoking pipe, makeshift or otherwise, I let myself believe she hadn't gone back to meth and that it was simply depression that informed her wild swings between inactivity and mania. Our lives were conflicted, and wallowing in scarcity, and felt likely to stay that way.

My mother lost her grocery store job and every other job she had from then on. I didn't know where she went to earn money anymore. Phone calls to her simply went unanswered.

She was once again performing "favors" for "the crippled guy" late into the night. She told us that she had taken up an "upholstery" job at a factory, but refused to say where. I knew for a fact that I had never seen her so much as sew a button, so things didn't add up. She would stay up in Salt Lake City, and not contact us until the next morning, or

possibly days later. When she finally returned our calls she seemed far away, uninterested, and angered by our needs. She spent almost all of her time with her steady stream of clients—men whose homes had wheels underneath them.

I started escaping wherever I could, too. I left my brothers and sisters to rot in front of the television, and I found my relief in "normal" homes. I found boyfriends and loved kissing. My mother found my first and only hickey, which she relished publishing to all I loved, starting with a call to my Granny and Jane.

I cried to hear that Jane had heard the gossip and feared that she would see it as a failure to meet God's standards.

I was inflamed in embarrassment and consumed in my sin. I never thought to examine why my mother celebrated my shame or why she thought it was shameful, considering her colorful past (of which I knew too many details).

I knew that she paid our rent by doing what she did. . . . I was simply being silly and having fun, not earning money with my dates. I guess that truly did make me stupid. I couldn't quite piece together why I felt that what she did was wrong. And why God punished me, but did not seem bothered by my mother's descent.

Like my mother and grandmother before me, I fell for every boy who noticed me. I just knew I would be happy if I could ensure that my hands weren't empty, that my heart never got cold. I was sure I never would make the mistakes my mother did in relationships; I was sure these boys loved me. I drank up every look, got drunk on the attention. I binged on every kind word without a thought for the future crash.

It seems like I spent all of my time either falling for a boy or aching because I had broken up with one, and I tried to fit my studies, work, and family in any spare moments I had. This ensured that my high school years were a merry-go-round.

With each successive steady boyfriend, I matured in commitment and understanding of relationship rhythms, culminating in my longest relationship in high school: Matt. We ran in different groups, but knew each other. I started spending more time with him and his friends, and our shy eyes would watch each other while making small talk with the group. *God bless the innocent "Peter Parkers" of the world.*

He finally got the courage to ask me on a date, and though I didn't much care for *Star Wars*, or for movie theaters, the date felt magical nonetheless. We had the whole theater to ourselves on a random Tuesday night in the summer. I invited him to dance to the prelude music in the theater, totally alone together.

I won him over like a long winter's freeze being cracked by the sun's warmth. Matt was willing to do anything for me—he read books I loved, gave up playing video games, talked into the wee hours of the night about my troubles, protected me from my family, drove me away from painful places, and read the entire *Book of Mormon*, putting away his chains and Slipknot CDs. He was helpful to his brothers and sisters, loving to his mother, and his family thanked me for it.

He had a way of making me feel new and innocent again. I spent nearly all my time at his parents' house getting to know the family. We played board games and watched silly movies. We wrote his older brother who was off preaching the gospel far away, scrapbooked, and laughed over the dinner table on Sundays.

I cared deeply for them, especially his mother. She had made a simple, lovely home and remained cheerful and kind in a determined, easy, leading-lady manner. His father was reserved and hilarious, slipping his jokes into the conversation like a well-trained sniper's shot before settling back to watch the effects with a satisfied chuckle. I

loved his sisters deeply and learned to trust that people said what they meant when they were being nice—not just when they were being rude, like my family.

I honestly believed I would marry Matt and marry his family, too. I had written my future with him, I would wait as he served a two-year church mission like his brother. I would bond with the family through the absence, and then he would return triumphantly to my arms.

·•¿ ●•∴•

Back at home, things kept getting worse. My mother was certainly not getting a full-time job, so when I couldn't beg any more money from the LDS church and the government teat ran dry, we once again lost our apartment.

I raged and worried often. It was my senior year of high school and I was *not* going to move again. I had just started gathering friends. In the year since I'd arrived, my opinion of Spanish Fork had softened. I went to dances, had a job, and made a life here.

I desperately searched for any way I could to keep myself at Spanish Fork High School. My mother had decided that we would join her latest boyfriend, who lived in same neighborhood where I'd ran away from home before entering foster care. It was the meth neighborhood with the food stamp grocery store, and the broken, old homes. My family was a runaway train headed for a cliff. My stomach turned to lead at the guilt—but of all my siblings, I was the only one with an escape hatch.

Most disappointing of all, I realized that I was going to take it. Just like the moment I fought off a tsunami of guilt to enter foster care, I once again took the course of self-preservation. I made the choice to do what I truly wanted instead of putting my family's desires first.

I negotiated a deal: I would stay in Spanish Fork with Sierra's Dad—my felonious bastard of a grandfather—for my last year of high school. They filled their house with tobacco smoke and with raunchy, filthy talk that left me sick, but I already knew how to stay away from home.

I wore heavy perfume and showered everyday, embarrassed to smell like a chimney. I started waking up with headaches and a hacking cough that wouldn't leave.

My Granny implored me to live anywhere but Grandpa's. The horrors of her life with him were well known to me, but the part of Sierra inside my DNA stayed determined and fiery. I was willing to live near a beast to get what I needed—no, what I wanted: the true luxuries in life like a house without mold and the use of a car.

I was relieved to find that rather than hounding me as she had for so many years, my mother just simply faded from my life. She almost never called, and she visited only once. My life became comparatively peaceful. I started to forget that I even had a mother, or siblings. I got up in the morning, made my bed, showered quickly (a bathroom to myself!), and ran to school. I worked most nights, and whether I did or not, I made sure I had a friend's house to visit or a date with Matt planned. I made everything else my world so that I wouldn't have to be home with my felonious grandfather and his live-in girlfriend.

Every once in a while I would pause and think about my siblings, and I visited them once or twice a month. I made sure to look through the house—always dirty dishes, always overflowing trash, always a sleeping or absent mother, always the television glowing with color, and there was never a clean corner, never a book that anyone was reading, never a full cupboard, and never a smiling face. I heard that my brothers were starting to get into some legal trouble mimicking *Grand Theft Auto*, which they played even during school hours. Ashley, the brilliant, witty sister, was

missing so much class that they were considering holding her back. Becca was absent from the house nearly every time I visited, with the other children waving a hand towards the vastness of the surrounding neighborhood to show where she had gone. Money was her prime motivator. She was babysitting now but was getting into trouble for the way she "had been acting with the children."

I tried to read between the lines to determine whether it was her physical or sexual abuse rising to the surface as she cared for the children. I never knew.

I hated to admit it, but it was a burden to visit. I had no way of helping them aside from using the money from my job to keep my phone turned on and and fill my car with gas in case they were in need. Both of those things allowed me to stay in contact, but I had put a wall around my heart to get me through the final days before graduation.

Years later they recounted a million little horrible things that crept in when I wasn't around to protect them anymore, and I couldn't forgive myself.

I was the first to graduate from high school in my family, and my mother and one sibling showed up. My mother came for the free lunch.

But I Still Haven't Found What I'm Looking For

I had asked Jane if I could stay with her and attend college in her city after graduation. Hope erupted inside of me when she said yes. The day after graduation, I was packed and moving. My grandpa, surprised and possibly hurt somewhere underneath all that leathery skin said, "Well you don' waste no time, do ya?" I felt a pang of guilt. I'd avoided the house at all costs, but I tried occasionally to show love to him, and in return, he tried to show that he appreciated it. He may have been gruff, but he was kind, in his own way. Afterward, I visited him often to assure him of my gratitude, but I was nonetheless pleased when my hacking cough left me.

Three days after my graduation, as I settled into my same old spare room at Jane's, I received a phone call that brought my joy to a screeching halt—my mother was in jail. The children were home alone, and we didn't know when she could get out, or make bail. I drove to gather them, to help them pack. They stayed overnight with Granny, who flitted around, fretting and nervous. All our worst nightmares were right—Sierra was doing drugs and her use had accelerated at a terrible pace. The children could not be in that home.

They had been kicked out of their own home and brought to a youth shelter by our crazed, drug-addled mother before she had been arrested later that day. Something had gone awry, and in one of her horrible rages, she had demanded all the children *out* before going on a bender that started with meth and ended in a jail cell. Sprawled across every sleepable surface of Granny's tiny, government-subsidized apartment, the children slept fitfully for two nights. These children needed lives, and after discussing it at length, Granny and I knew what we had to do.

I knew I might not see my siblings again for a very long time. I knew it was possible that they would hate me and our side of the family forever. But they would be fed. They would be clothed. They would be sure to attend school and do their homework. They wouldn't end up in juvenile detention centers, or youth shelters, or get their Thanksgiving meal from a food bank.

We called their father, David, and asked him to get them out of this state while my mother was behind bars. I hadn't heard his voice in a decade, yet the thought of calling him still brought me the same fear and apprehension as it did the day I turned eight.

David and his parents—my siblings' grandparents—agreed to take the children and raise them. It meant I wouldn't see them again for a long time, but I was so relieved. Their father might have been gruff, scary, and disinterested, but he always went to work. As far as I have ever known, he did not attempt suicide in front of tiny children. He did not move every year. He did not get arrested for anything. He didn't look like he was starving. That would have to do. I had already calculated a thousand times over how much I earned and how much rent, utilities, and gas cost. Whether I wanted to or not, I knew I couldn't raise four children myself.

I had the dubious task of retrieving my mother from jail the day my siblings left. A massive ocean of feeling raged within me. It moved me to tears in private, as if the water had found a small corner from which to leak.

My mother prattled on about how the water in jail tasted awful, and the food was even worse. She chatted about flirting with the guards for privileges and which of the other women in the facility were nasty. As she always did, she pretended she was oblivious to my indignation, and I made very few comments, but the ones I did make were biting. My pride swelled and my hatred ripened. Nothing I could do would help her understand how stupid she had been, and how much it had cost everyone. We parked in front of the house to enter and help the children pack up their belongings. Instead of sorrowing with us about our great loss, she acted as if we had just stopped off at the bank.

I hugged each of my siblings one last time as we loaded what little they owned into their grandparents' car. They all looked like they had rolled out of a hole in the ground. They looked so tired and angry and beaten. And hungry.

Our movements were silent as we worked alongside each other. I brought my camera to take one last photograph of us together. We all smiled as we were supposed to do. I printed the photo later, and absolutely no happiness was developed from the negatives.

·•¸ ●•∴•

My siblings clambered into the back of the SUV, and each formed the "I love you" sign for me one last time through the window of the closed door.

I watched them drive away, relieved of the burden, to the point of being completely emptied. It was like birth—I

had pushed with anguish and hard work and tired bones all that I could to make a better life for *my* children.

I was so sorry I had actually fought with them with the same hands that now embraced them for the last time.

I felt enormous guilt for the wall I built around my heart when I deployed my emergency parachute and stayed behind in Spanish Fork.

I grieved at not being there in the future for my sisters' first prom, or to stroke their hair as they confessed their first kiss. I had a cherished prom dress I could have passed on to them. I could have celebrated the day they first bled. I could assure them that the end would come, and that life would move on.

My sister wouldn't watch my reflection ever again as I applied mascara with half-open lips like I watched our mother do. I would never watch them curve their arms like ballerinas as they styled their hair in front of the mirror. Ashley would never borrow my favorite black shirt again. Becca would never curl up on my bed with her stuffed animals as we giggled into the night air.

My brother Brandon's delicious, unique way of cooking Ramen noodles was lost, never to be learned. The jokes that Alex and I shared would be lost in the cloud of exhaust we stood in now. When I saw him again, he would tower over me. They all would.

I wanted to take them back. Empty wallet and all. Freedom had just cost me my entire family. They would grow together as Millers in their new environment, but I was untangled from the tribe. Keira Sullivan. Keira Solo. There would come a day where I wondered if we ever really grew in the same forest.

I didn't cry. My whole soul was parched. Crying meant I had something to give, something to use up, and I was completely hollow. My body was hunched and hollow as I

turned away from the rapidly disappearing car that held my treasures.

My mother was a ways off.

I got in my car and left, and I never looked back at her, not even in the rearview mirror.

If You Do Not Want to See Me Again, I Would Understand

I spent the summer before college working as often as physically possible, yet somehow I was unable to save any money. My car would break down at the most impossible moments; my strength sapped, making me susceptible to every germ in the air.

Every week I called Granny to feed the flames of my hatred with a new update. My mother was homeless. She was living with a new name-with-a-beard every week. Sometimes she was with a trucker traveling the country or going to Moab for a camping weekend.

It was the fun-sounding updates that irritated me the most. I wanted my mother to hurt for what she had done to our family. I was young, yet I was not traveling around the country like I had dreamed. Anxiety about the future I wanted for myself, coupled with jealousy at my mother's freedom, made me physically ill. I couldn't see it, of course. The stress of working and still being left hungry for more was eating me up. How dare she enjoy a single moment!

To satisfy my dear Granny, I suffered through various "family" gatherings over the next few years. She was determined to never give up on her daughter even if Sierra's

own children already had. I would meet my mother at Granny's apartment for birthday celebrations (what was to celebrate?) and around Christmas time, then leave as quickly as possible to avoid socializing with my mother and, often, whatever man she was dating at the time. My wrath was the only gift I brought for holidays together. The pitiful sight of the three of us—my Granny, mother, and me—in the clutter of Granny's one-bedroom apartment summed up all that was left in our tiny family. I often wished I could move, like my siblings had, to fade away from their lives and find my own. I already had one foot out the door—I found myself not wanting to answer Granny's calls anymore. Her neediness and passive-aggressive attitude sent me into fits of rage or panic attacks.

Sierra started to go weeks, then months without calling anybody, and eventually we only saw her on her birthday when she would appear on Granny's doorstep for her free meal. She would resurface from time to time in the form of a collect call from the nearest jail. She would always ask for money or for luxuries to be purchased from the jail's store to make her life on the cell block more "comfortable." How I raged!

I couldn't run away from my animosity, even in my dreams. It took me many years to realize that my fury, whether conscious or unconscious, became an obsession. The more I avoided her, the more her face appeared in my dreams. The more I recited to myself how much I didn't care what happened to her, the deeper the fermentation of my resentment went.

Sierra was my great enemy, and I saw her everywhere. I saw her in every aggressive or fiery character I encountered, and avoided them like the plague. I would catch a glimpse of frizzy, curly hair in a crowd and not be able to control the fear and anger that threatened to consume me. When any inconvenience arose—car problems, cancelled

appointments, requests to work longer hours—the tide crested as if it waited for its moment to strike.

Sierra caused me so much turmoil that I prayed almost every day that she would die. In my anger, it never occurred to me that it wasn't something I should ask of a merciful God. If she would just die, maybe the fire inside me would subside too.

And I checked. With each passing week, she seemed to be more alive than ever. She was living the life she had always dreamed of before children got in the way: partying harder, living larger, escaping cross-country. I wept as my heart ached at this great injustice.

I called my siblings infrequently, and to my dismay, I felt we had little to say to each other. Our roots were slowly being untwisted. It seemed that all we had in common was Sierra, and that was the last thing that the kids wanted to talk about. Nonetheless, I felt some responsibility to report on her doings, if only to let the facts prove that she was living happily in the fractured mess she had created for everyone else.

Ashley, ever sharp, and also raging with me, replied simply and wisely, "No. I think she is suffering very much right now. I think she's getting what she deserves."

Her statement gave me pause and stuck in my mind for future evaluation, perhaps when my anger had finally subsided. Perhaps I was simply jealous because running away was exactly what I wanted to do.

I toyed with the idea of changing my name. A name is just a label, after all. And all the world is just a place to rest your head.

Her Confidence Is Tragic; Her Intuition Magic

I'm not sure how things soured with my high school boy-friend so quickly, but when they did, the way I reacted showed me that Sierra's blood pulsed through my veins. I called him to "talk" and ended up in screaming at him, crying, begging, and yelling at him to take me back. I had my arguments, my reasons, but when my pleas fell on deaf ears, it made no difference. After watering, planting, digging, and hoping, my planned harvest and garden died. My future went up in flames. I lost my love and my hope for a family in the process.

When that relationship died, it shook me. I used dating as a way to cope with pain. By being young, pretty, and available, I could have all the dates I wanted, crowding out the loss with the sheer number of dates and activities I participated in. To do that, I dated anyone who would ask, Mormon boys or not, and I didn't care for any of them in the least. I was left emptier than I was found.

I spent a lot of time, after we burned each other up, in the nearby canyon. I would drive up there early in the morning and rage at the mountains. I had thought them protective

before. They stood so still, refusing to change to mirror the loss in my life. So I climbed on them to conquer them.

I wished, sometimes, that I would get in a car crash so that my life would be forced to pause. I didn't know who I was or what I was doing in this city. I was grasping at the ghosts of what used to be—living with my foster family like it was old times, searching for Matt's face in first dates.

Like many others do, I started college in the fall feeling all alone. I made a few quick friends, got dates quicker, and the rush and rumble distracted me from the gaping hole my mother had left in my heart.

I kept the thought at arm's length, wanting to name it and define it, but mostly pushing it away. It didn't make sense. I detested her afresh when I examined myself and found her in the mirror. I stopped peering, and a storm raged silently. Some days, I hated myself, too.

I worked the *Formula* that I always had in my back pocket to secure instant friends, neighbors, jobs, grants, scholarships, and dates. My map for navigating new territory: Smiles, high heels, relaxed posture, unique words. So many guys came and went in my life. Some days I would pull into the driveway with one date in the car only to find the next waiting for me.

It was completely odd to date a person and present yourself as a great candidate for commitment but think you were too precious for their love. I was constantly terrified that they would see me for exactly what I was—a young woman who had seen and even done awful things, unworthy of commitment, and running from everything that looked too much like her past. I was an inferiority complex with a superiority complex.

I counseled with Jane many late nights about my anger. My fury was unbearable, and as I peeled layers off of it late at night I found that underneath my anger was great

anxiety. I closed my textbooks and I worried for all my family . . even my mother, to my great surprise.

I didn't understand why I worried so much for her when I also prayed for her demise systematically like a Catholic caresses their rosary beads. One night, in agony, tears, and prayers, I found my next step.

I was attending church. I was praying. I was even spending a tiny amount of time on self-reflection and reading about anger, forgiveness, and freedom. I admired dramatic stories like Nelson Mandela's. The answer I found felt right in my heart, but like most real solutions, the execution of it would be a heavy burden:

Pray for your mother. Pray that she will be kept safe and that God's grace will save her.

Why pray for her to be safe? Forget wanting to employ God as a hitman. How about simply wanting the consequences of her actions to hurry up and seize her? Why on Earth would I want her to continue being a rock in my shoe, a thorn in my side?

Her actions had turned all I held dear to dust and my whole soul to stone.

If I forgave her as God has commanded, who would remember? Who would count all that I lost? Before you hear this sinful woman's case, I want mine heard first.

Her legacy of wounds was still inhibiting my progression and marring my new life. How could I ever desire for her to be free and safe when she did no favor like that for me, and I continued to live in a prison of hate?

Pray for your enemies. Love them that hate you. Bless them that curse you. . . .

I spit out the words in prayer night after night, like a dose of horrible medicine from a patient Parent. I scrawled a quick poem in my journal one day in between my English and Introductory Psychology classes:

You're like a dose of horrible medicine,
sliding down my burnin' throat.
You're like a dose of horrible medicine,
a dozen burning layers; coat after coat.

You're like a dose of horrible medicine;
a seizure capturing my brain.
You're like a dose of horrible medicine
with absolutely no way to ease my pain.

And the dose of horrible medicine
all soaked up, so full of greed
was the dose of horrible medicine
that just maybe, was the thing I most need.

Part Three

Starlight

I met my future husband during my first year of college. Our eyes locked across a dance-class floor, and my first thought as I saw him speak up in the class was, "He *fits* me."

I supposed Eve thought the same of Adam when she first saw him.

His warm smile was a welcome gesture as his lips formed the name, "Nicholas." We briefly laughed in the afternoon sun as we quickly built a friendship.

As we sat at a table in a restaurant on our first date, I realized that what I was offering was inadequate. What man who remembered to lay his napkin on his lap and thank the waiter needed me in his life?

I sat there a complete lie. I was smiling, wearing mall-store clothes and jewelry. I looked nice, fresh, and young. I was polite and kind to everyone I came in contact with. But I was also the product of my life up to that that time—homeless, hungry, frequently weak and ill, a fighter, a hater, a lonely teenage girl, the poor girl, boy-obsessed, impulsive, the freckled, white and sullen child, the fast-food worker, always poor, always begging for attention, nail-biting, anxiety-ridden, depressed, used and useless human being. I had nothing to offer but a heart in critical condition.

After picking me up for a date one day, he asked me to explain who I was living with. I took a deep breath. I decided at that moment that I should rip it like a band-aid. If he reacted poorly, I wouldn't have to hope that this kind person would ever want to be around me. No more *Formula*.

The truth shall set you free.

"That was my former foster mother. She took me in when I was fifteen, because my mother is a meth addict and a prostitute—she's homeless now. My family has been split up, and my siblings live in Arizona with their family. I was converted to the LDS church as a teen, and although my family isn't interested, I still love them. With all of that said, I promise I'm not as crazy as that." I managed a smile and half-hearted laugh.

When the words, "prostitute" and "addict" came tumbling out of my mouth for the first time, they were foreign. Maybe the prayers I spit out for months were getting rid of the poison. But I realized that any labels that stuck to my mother would also stick to me. I wished for the first time that wherever she was then, that maybe God would erase those labels—and erase mine.

My face searched his for surprise. I had just, for the first time, voluntarily said a prayer for my awful, wretched mother. The lines disappeared from my brow. Did Nick see the light in my soul?

I meant every word I said to him. I loved my hopeless family.

He listened intently.

He didn't walk away.

Everything that has been the most precious to me in my life has been an illogical choice. I consider myself a smart

person, but the big decisions—the ones that have made my life the happiest—have always come from my gut. When it really matters, I find myself shooting from the hip—and nailing a bullseye. Maybe I'm following my intuition. Maybe I'm riding off into the sunset on a prayer. Maybe that's just the moment when God or fate or the universe finally seizes the opportunity to take the wheel and teach me that it's all going to be all right. I had no idea what foster care was, yet it lead me to a year of hope and repose. Who knew that in the erratic and terrifyingly emotional moments of being a young, runaway teen there was great purpose?

I let myself believe that I was going to marry boys I liked in high school, and I certainly did not marry them. Then I let myself believe that marriage wasn't for me, or at least not now, so I treated my dates like that. I had been brokenhearted and used, and I treated every person I encountered in college like that. I shouldn't have.

I wondered if there were any good people out there willing to love someone who hadn't lived up to the promise of her own soft heart. Who had allowed the cold world to affect her.

I was too young to know after a year of dating that I needed to marry Nicholas—but I wanted to. I was too stupid to start such a serious marital contract with him and with our two families. I was far too poor to be married in any decent, respectable way. I was far too broken for any therapist to recommend marriage to me in the next *decade*. I hope you understand that I truly know that. I knew it then, I still know it now.

And yet, on September 6, 2007, during my sophomore year of college, dressed in a simple white dress my foster mother purchased for me, I joined hands with Nicholas Scholz, and we were married.

What can I say to explain myself? Everyone knew I was shooting from the hip.

All I can really say is that I was ready to be a wife.

To love and to be loved. In a family.

I was ready long before I met him. My heart was soft, even if it was shattered. I was ready to create a family for myself—to build a foundation under my feet. That's not ideal, but it's what I had to work with. I had been ready for quite a while to belong somewhere, to commit to something. I did that in all the wrong ways sometimes; this time I got it right. He was right, and the timing was right. It was just right. Not logical. Not practical. I don't recommend it to others. I'm embarrassed to say I was married at nineteen.

I was simply ready to be his wife, because . . . well, I had seen all thirty-one flavors in my short life, and when I found the right one, I was done.

All these years later, I still don't linger over any other flavors. I don't wonder. But I knew as I agreed in front of witnesses to have my eternal soul sealed to him, that I would wonder every day of my life whatever happened to him if I let him go. Therefore, I couldn't let him go.

My now-retired military biological father thought I was insane for marrying young, but he was only barely getting to know me as an adult after re-entering my life following my high school graduation. My foster mother was a little more tactful about her concerns with such a young marriage. I stuttered over an explanation, but I should have held my peace to avoid looking like a fool. The truth is, there is no reason. My foster mother stepped up to take on the mantle of wedding planner to show her support.

My mother resurfaced at the news and she wholeheartedly approved of Nick, and the marriage, with great joy. That should've worried me, perhaps. She simply said, "When he came to meet me, I heard, 'You are about to meet your son-in-law.' I was stunned but totally fine." My prophetess mother stamped her approval by showing up in her

best dress, eating, and laughing. She was gone with the wind again two days later.

·•˙●•˙.•

I never truly believed that Nicholas loved me until the day he proved it. He had kissed me, he held my hand, he repaired my guitar and surprised me at Christmas. I wanted to believe. Everything pointed to that conclusion, even if I didn't trust it.

That day, the day, the big wedding day, is when my hope sprouted to belief. Without a trace of regret, without a hint of cold feet, he promised to take care of me, even when I was old, when I was sick, to love me through poverty, wrinkles, sleepless nights, and endless days.

I was flippant and oblivious; he was careful and detail-oriented. I had the ability to attain the state of the hopeful as quickly as a state of great despair; he believed in making his own luck. As the officiator at our wedding said that day, my love for him at this moment was not enough for eternity, but he assured us it would grow. It did. It grew through the cracks in the slabs of cement I had erected for protection; like a tenacious wildflower.

At the ring ceremony that night, before we sat down to celebratory dinner, my diabetic Granny's sugar dipped too low. He was there to help. We settled her issues and got her to the table. Finally married, I asked him to help me out of my dress, then I could eat. It wasn't traditional to have things done this way in some forgotten bathroom in the basement, but I had no other help.

He assisted. He did not touch me. As is true to his character, this wasn't the right time or place for either of us. This wasn't what he had planned, or how he'd envisioned it. So, with the self-control of Joseph in Egypt, he assisted, told me I looked lovely, and left.

I stood alone in shock. I actually laughed out loud in surprise, all alone; my single laugh, more like a cough, echoed in the corridors. I was dazzled to be living my own version of some Jane Austen novel. The long-suffering, the thoughtfulness, the kindness, the honor!

It was in that moment that I learned what made Nick different. The wedding ceremony was not a purchase contract; I was not a piece of land to be plowed and harvested. I was a person; and I was a person worth committing to.

The dinner, arranged and paid for by my new in-laws and my foster family, was a whirl, with people making knowing comments about the reason for my late appearance. I blushed—nothing could be further from the *truth*! Then I blushed about blushing, because people would think I was guilty of what they had hinted at.

We ate, we were filled, we were praised, our joy was full. After the dessert and some goodbyes, I took his hand and left the crowd.

It was as if Nick took the time to light a candle and sweep the far corners of my heart.

He opened the hotel door to the exact room I'd told him in jest that I wanted, the most expensive room they had, with a thousand rose petals lining the curving staircase all the way to the room.

How many times in my life had I tried to be this thoughtful for my mother and foster mother! Someone had done it for *me*! There was sparkling cider and dessert at a table below. I trembled with anxiety and an inability to contain so much joy and love in one day. Every person in my life had extended a portion of kindness to me. People showed up. People gave gifts. Family worked hard. Every wish had been fulfilled simply because I asked. And then Nick answered

questions in my heart that I didn't know were left unan-swered. My hands grew cold while my heart swelled. I excused myself to go to the powder room.

I stood looking at myself in front of the mirror, caked in makeup, coated in hairspray, fresh flowers wilting in my hair, and the first real pearls I'd ever touched in my life strung around my neck. I carefully removed it all—shocked that this wretched person I'd watched in the mirror all my life was experiencing this much happiness and love. Was this the same pale, freckled, dark-circled little girl with a cowlick? Who would pay willingly for a diamond to grace the finger of the forgotten bastard child?

If someone had told me as a child or a teenager of the love and luxuries this day would contain, I would have never believed you. It was a fairytale beyond any imagination—money to have pearls! Releasing butterflies into the crowd! Chocolate fountains! My foster family loving me enough to pay for my part of the wedding! A lovely gown! Affording a camera to prove it all! So many guests! No longer lost and wandering, but sealed and settled! Inconceivable.

I stepped out gingerly, hesitantly, worried, excited, and happy. I became Eve; full of life, potential, innocence, wor-thiness, empowered by my choice, and ready and open, without shame, in front of pure love, and possessing pure love.

And with experimentation, gentle humor, kindness, and an extra measure of joy, I became his wife for good. And it was then, after the passing of *that day* and the true consummation of marriage, that I *knew* that Nicholas Scholz loved me entirely. Unlike the sexual abuse of my childhood, unlike the acts I watched and heard my mother perform, this union was one of truth and beauty because it was loving and consensual. While I had not reconciled my past with my conscious mind yet, I could still be fully present in that moment without understanding it entirely.

It healed me because both of us brought only a child-like trust with no shame into the relationship.

It was through Nicholas that my heart developed a tiny crack, where God could pour His love into me. My mother was absent (like I felt she was most of my life). From her I had the idea, "If your own mother can't love you, how can you believe anyone else can?"

Nicholas answered that question by loving me in repeating tides on the shores of my subconscious for years. He was unfailing.

He complimented me on my character, and I pushed him away with laughter. He brought up my accomplishments and I shrugged them away. He grew entranced by my face and admitted his love of it, and I looked away in disbelief. The demons and their war on my soul made more sense to me. I memorized and believed a verbal stab at me better than any soft words.

As is true to his character, he did not change because of my actions. I began to hope that I could believe him. I began to find his words delicious to me. I was hungry, but I still did not receive them. But I at least looked at the offering with desire.

I Dreamed a Dream

In many ways, Nicholas and I are opposites. For example, he's very responsible with money. He's also careful, cautious, and research-oriented. He was raised by two lovely, well-mannered and educated people in one of the best homes built on the side of the mountain. When I brought my Granny up the front steps and into the Scholz home, she scanned the entryway, which was the same size as her entire apartment, and whispered *"Do they have servants?"* I looked at her and could only shrug.

I wandered through my new in-laws' home to find out just what the opposite of my childhood looked like: I ran my finger along massive encyclopedias on bookshelves that reached to the ceiling. I went to the powder room knowing that there were enough other bathrooms for every person in the house and enough bedrooms for each child in their family. Beautiful family photos with smiling, unbruised faces stared back at me in every hallway. They had a big backyard and regaled me with tales of family dogs. The smells of home-cooked food wafted through the house. So this was what my mother had been searching for. It really *was* heaven.

When I sat down at a large dining room table I tried my best to look like I was in my element as they asked me

about myself. I watched them daintily eating with their forks backwards—not like a shovel—in what I later learned was the "international style of dining". I sat closest to my father-in-law, who spoke cheerfully and projected his voice well. Once he ceased asking me about myself, he divulged that he came from a background similar to mine. This comforted me, even if it felt unbelievable. I looked at his face. I did not see lust, deceit, hatred, or greed. He looked composed, positive and confident. Knowing this gave me great hope.

The influence of Nicholas's family transformed me. I found myself slowly changing with each exposure—I shopped at different places, my taste in music expanded, I felt freer to experiment with new recipes and learn about other cultures. Before, any mistake I made was costly. Now, it felt like mistakes were "budgeted" into my time and income. I felt more in control, and found myself opening and expanding my mind and personality.

I was able to care for myself as well. This meant visiting the dentist, seeking mental health professionals on campus, and getting verifiable evidence of my past, such as copies of legal documents with the police department, or getting test results documenting the right-side nerve deafness that had been my lifelong companion. It was validating to spend time (for the first time outside of foster care) discovering my own interests or making sense of my abusive past.

One of the greatest gifts afforded me in this Cinderella-change in my life was seeing the story of *Les Miserables*. Every cultured person I had ever met in my life referenced it, but I had lived the first eighteen years of my life in the time before Google, and my family certainly didn't have enough money for a computer or internet. Even if I could search for it on the internet, it was such a strange name. I had no idea that the signs I would see for high school performances of

"Less Miserables," as I called it, was the exact same story that intelligent neighbors called "Le Miz."

Nick informed me beforehand of the expected dress standard of the performance. He had to teach me the basics of theater etiquette for the Abravanel Hall in Salt Lake City—a city I had rarely visited since seeing the Christus statue in the LDS Temple Visitor Center at fourteen.

A live orchestra played the timeless music, and even with my limited hearing capabilities, I was impressed. Being used to television and movies my entire life, stage acting took some getting used to, but by virtue of its beauty, my tastes adjusted quickly. I did my best to sit up straight (that's what rich folks did, right?), but by the time Fantine entered, I was enveloped in the story, hunched over in piqued interest. I watched her tell a story that made me examine my mother's choices differently for the first time in my life. The lyrics taught an ugly truth that even I had not considered about a prostitute's life:

> "There was a time when men were kind
> When their voices were soft
> And their words inviting
> There was a time when love was blind
> And the world was a song
> And the song was exciting
> There was a time
> Then it all went wrong . . .
> . . . He slept a summer by my side
> He filled my days with endless wonder
> He took my childhood in his stride
> But he was gone when autumn came
> And still I dream he'll come to me
> And we will live the years together
> But there are dreams that cannot be
> And there are storms we cannot weather

I had a dream my life would be
So very different than this hell I'm living
So different now than what it seemed
Now life has killed the dream I dreamed."

My head was in my hands, and my eyes hadn't blinked. Tears ran past my knuckles, beyond the palms of my hands. The tears reached my elbows and fell to the floor. My lovely outfit was completely ruined by the cathartic experience.

Had my mother had dreams that never were? How strange to me that she had the "script" for every new boyfriend and subsequent move-in about how this time was different, how we were going to get the dream house, the dream life . . . and she was somewhere homeless while I wept in a million-dollar theater.

My salt-stained pearls irritated my neck as I contemplated that perhaps—no. Well, just maybe—no, it couldn't be! That it was possible . . . very possible . . . that she was desperate for love or money. That my mother, the monster, the addict, the homeless, endless partier, the prostitute, might not have dreamed the life she had now. That maybe those bedroom sounds were an act, when I thought they were the truth (and maybe her "clients" thought so, too). Maybe, after a long day mopping the deli floor, less than $10,000 a year combined income with your teenage daughter, you had to make up the difference of cost of living in a "job" that could only be done in non-working hour gaps of time. Just maybe.

Just maybe . . .

Maybe she's not a monster, but very human.

Soon after Fantine's life ended, her destitute daughter Cosette appeared on stage. I was stunned to complete silence at the accurate portrayal by Victor Hugo, Alain Boublil and Herbert Kretzmer of a child's greatest pain and hope. I wanted to run away from the words as they reverberated

off the ornate walls. I wanted to privately grieve every loss brought up with her words:

> "There is a lady all in white,
> Holds me and sings a lullaby,
> She's nice to see and she's soft to touch,
> She says "Cosette, I love you very much."
> I know a place where no one's lost,
> I know a place where no one cries,
> Crying at all is not allowed,
> Not in my castle on a cloud."

How did the lyricist know that I self-soothed as a child with hopes of a kind angel? A Ms. Honey to my Matilda? That all I wanted, all any child ever wanted, was to be told they were loved and cherished beyond measure?

I stared at the scene. I peered into the weeping faces of my fellow patrons. The "rich people up on the hill" that my mother had scoffed at now sat crying alongside me. The company I kept now told a different story than I was given as a child. As I travelled, dined, and worked alongside them, my mother's narratives started to fail.

While there were a few interactions with selfish people that my mother spoke of, the majority of these people were generous. Some were generous in the extreme. I slowly realized that my day-to-day interactions were with the same people who had handed my family a free Thanksgiving turkey not so many years ago. They were part of the PTA that made my school the safe and cheerful environment I never wanted to leave. They were the ones who paid their electricity bill and said "Yes!" when prompted to pay more for my family's heating bill in winter. They were the families that marched through my living room with Christmas presents—total strangers giving to total strangers. I could reach out my hand and touch the very people who donated to my college scholarships, or whose taxes paid for

my medical care. This crowd was not my enemy. Without ever knowing it, these people were the best friends a child could have had.

They were my Castle on the Cloud.

You Electrify My Life

It was a crisp Spring day in our first year of marriage. The sun was warm, but the air was not. Fruit trees were blossoming along our empty street in Springville, Utah. My sweet, dear husband of merely a few months let go of my hand and ran ahead of me. He surveyed a pear tree with a smile and beckoned me over.

I walked toward him at my own pace, and he grasped my hands and started to direct me, looking back and forth repeatedly from the tree to the ground as he did so. "Stand here."

I stood on an ordinary patch of grass, north of a flowering white pear tree on his parent's property. The tree was about twenty years old, almost like me. It was lovely and taller than the house already.

Nicholas left me to stand there. I expected something now, and waited patiently.

His young body deftly climbed the lowest branch and he started to rock back and forth. He turned to me in anticipation.

Petals glided down in thick sheets from the pear blossoms, filling the air with their sweet scent. I hadn't expected something so lovely—it was snowing all around me!

The tiny petals kissed every single inch of me, like gentle butterflies.

That simple action was the most thoughtful gift anyone has ever given me, and it cost nothing.

He grinned at my joy.

They say that true love is not real. They say that there is no goodness left. They speak of grays and broken hearts . . . and I get that.

But I have felt petal-soft white snow on a spring day. And if the ravages of age come to claim what's dear to me, this will be the last memory they take. The proof that love is in every blade of grass and every eyelash; every petal and particle hum the same song.

You Are My Sunshine

I wanted to give this joy to others.

This was the environment that created my children, born into a shelter of great love. I may not have been conceived in such coveted circumstances, but my three sons were. They were nourished, body and soul, in the purest, greatest love we two souls could muster.

Being a mother with so little family support on my side—and without as sound a mind as I would hope—made me Humpty-Dumpty. I broke open and had to be put back together again with each birth.

Motherhood is a giant mirror. I faced all my shadows when their brilliant lights came into my life. The timid Keira was a tender and thoughtful mother, but she was a victim.

I mourned that I became a mother with no mother to be with me. The day I delivered, I wondered if my mother was strung out somewhere with no idea of my great change. There is something about motherhood that creates a yearning inside you to reach out to the women in your life, to connect. While I felt love from other friends and my foster family, nothing could fill the chasm I felt at missing a mother or sisters, an aunt or even a cousin. I often felt I was attempting to create water for myself in a desert.

More accurately, I gave everything I had to try to be the kind of mother to a child I had wished for myself. I researched endlessly. My guilt was heavy to bear. I stayed up late, I awoke early. I rocked my new baby endlessly, I bought everything I could to make him happy. I was desperate in my attempt to be the ultimate mother.

Postpartum depression was the result of starving while planting a garden. The path I chose showed me the demons from my past. I saw that I still played the victim, that I willingly sacrificed my happiness, health or sanity to be "good"—this time, the good mother. I gave up any and all of my pleasures or dreams to be a child's whole world. It was not healthy for any of us.

When I broke down, Nick encouraged me to take at least one night a week to be Keira—not wife, not mother, but myself.

I was twenty-three, yet I had very little idea of who I was. I had spent my life pleasing others; I did not know how to be authentic to myself. Being authentic was dangerous, too, because people might be bothered or hurt by your choices. They could abandon you. The idea of my husband abandoning me if I became something selfish was more than I could bear.

At first, my nights out were miserable. I spent most of the time shopping, yet found no lasting fulfillment in being a consumer. I had no idea what else to do, though. All told, I had moved twenty-eight times in childhood which left me with no roots or lasting friends. I had lived a long time silencing my own voice, my own needs and desires: at first, there was no inner voice to listen to. This meant that I looked to others to see my preferences, needs, and desires, and I also looked to them as some sort of conduit of God. I still did not think God really wanted to speak to me, or if He did, that I was deaf spiritually and not just physically. Luckily, I leaned on Nicholas to varying degrees for

the first decade of our marriage, as I learned to listen and then trust myself.

I decided that I desired to finish the bachelor's degree which I had started before my marriage. I already had my associate's degree and enjoyed the connection and the exposure of ideas. I felt proud of the fact that I was the first in my family to go to college, and hoped for the same achievement high that I experienced before. But if I went back to school, I would need care for my first son. My childhood left me walled and jaded, and I trusted few people with my child. Luckily, my foster mother cared for him to help see the dream through.

By seeking what made me happy and making the difficult choice to pursue it, I became a fantastic mother. I went from bored, disconnected, and overwhelmed to passionate, engaged, and joyful.

As always, making these hard, seemingly selfish choices to self-preserve was a renaissance of my soul.

For one of my courses, we were assigned a gratitude letter. I thought back to the night I realized that my fellow audience members at Les Miserables were my village that kept me alive. My frosty heart was thawed, layer by layer, as I scribbled a list of every possible resource that had been given to me in my childhood.

Tears freely flowed from my eyes as I wrote the letter. *My* letter, with *my* list, and *my* computer.

While I grieved not having a mother when I became a mother, I felt my heart soften and warm with my gratitude. I published it on a personal blog, sharing it with relatives. It quickly spread across social media platforms and nationwide news outlets. I loved seeing my hope multiply in others like it did within me.

Immersing myself in structure was often miserable work, but familiar, and I pushed through, fed by the light and truth I was exposed to in literature and with my professors.

My biological father, my Granny, my foster parents, my in-laws, my first son and my husband were in the crowd when I carried the banner as Outstanding Student of my college at the graduation ceremony.

Walked into the Angry Sea;
It Felt Just like Falling in Love Again

After graduation, I sunk into a structureless existence as a stay-at-home mother. I wasn't sure I was going to be good at it or like it, because expectations were vague and that made it difficult to please. I miscarried twice. I floundered.

I felt like the butt of a joke. All that promise at graduation, everyone asking me what I was going to do with my life! It was now six months down the drain, no closer to career, graduate degree, or networking. I confidently waved off pursuing those options because, surely, I'd be pregnant soon with a second child and a sure future, and would have to delay those plans anyway. Some promising future. I couldn't even do what those who couldn't tie shoelaces could do—bring human life into the world.

The days and weeks seemed to take me by the wrist and drag me through them. I had lost my free will, and my compulsions started to creep in.

I could only think about what I couldn't do, what things took too much money or effort, and how nothing mattered. Like a bird in a cage. I wanted to run away to a beach. Nothing held any promise here. Living in Provo, Utah meant being bombarded by images of large families,

women with swelling bellies, and strings of children be-
hind them.

I was lost. I had no plan. I had no hope, no direction,
no desire. No burning bones, no fire in the belly, no pas-
sion. Even my family got tired of me. I was tired of me, too.
I wanted a break from my brain. Depression, my Granny's
old friend and my mother's longest lover, took up residence
in the space between Nick and me at night in our queen
bed. Depression fed off my tears and summoned old de-
mons. It stole my identity and confiscated my confidence.
It had a way of conjuring a cloud that brought interference
and turbulence with my prayers. It crippled me efficiently
every night it showed up to influence me.

After hours of crying in prayer, rehashing the same
conversations with an exasperated, but loving Nick, I
grabbed at one small idea. I decided to write out my mem-
ories, so they wouldn't have power over me. Maybe I could
help someone. Thank someone. Find a clear path out of the
overgrowth inside of me. Maybe I would find out exactly
what I was by seeing where I came from.

I decided to start with the thing I wanted the least.

I wrote my most devastating memory: the sexual
assault.

When finished, I stumbled into the room, asked Nick
to read and edit, and collapsed on the bed in heaving sobs.
I bore the weight of decades of shame, and I felt like vom-
iting for hours. The panic attack I felt had me googling
symptoms of asthma or heart attacks.

"I can't do this. I can't. I can't read that ever again."

Nick read it calmly, and didn't try to convince me oth-
erwise for weeks.

When I felt able to, I wrote my earliest, and most pow-
erful memories. While writing, they consumed me. Every
feeling took over my body—sweating, arousal, tears, an-
ger, lightheadedness, shame, guilt, fear, and physical pain.

Afterward, I didn't share with Nick immediately—my head was a lead balloon and my body felt it would run a marathon with ease.

It's unbelievable—I'm sure—but I returned to my computer. What I wrote the night before no longer haunted my days or dreams.

I started writing every bad thought and memory, and didn't return to read them. When I got bored writing a dirty laundry list of my mother's wrongs, I started weaving people's influence on me into stories and putting faces to paper.

Finally, after taking a walk with Nick, saying I was unsure I could do my family justice, I wrote the best of my heart. I was afraid that this would just be a long compilation of my mother's faults, and that no one would see anything in her worthy of love. How she convinced men to marry her—more than seven times. Why she made friends, why she was admired by many, including her own family. So many of my memories of her were negative. If I couldn't find a way to see her as a human being rather than a monster, how could anyone else?

On a cold November night, with *Les Miserables* music ringing in my ears, I did. The storm had passed, the clouds broke at my command. I was exhilarated—I won! Those creatures let me go.

I laid in bed, the clock glowing 2:17 AM next to me, but I could have written all night. I prayed for the first time in a while and told God directly that I was *going* to write this book. He could do what He wanted with it—sit it on my shelf next to the family history, or publish it broadly—it really didn't matter to me. It was my medicine, my direction, and hopefully, one day, a way to help another soul. Either way, the poison had permission to leave me.

I had returned to the beginning and found my path.

A Kiss to Build a Dream On

Sierra disappeared from my life after I set boundaries and limits around her visitations. Having a child to protect gave me an excuse to care for myself in many ways. I flourished as her shadow left my life and the poison of my past drained from me when I wrote every wrong made against me. Some called it betrayal. Some called it cruel. Some called it justified. I chose freedom, and like the other self-preserving choices I had made, the distance and silence created much peace and facilitated plenty of healing.

I'm certain *Tess of the D'Urbervilles* would support my decision.

Strangely, as the memories flowed, I felt empowered, no longer in my mother's domain to be gaslighted. I found qualities in her that I admired. Positive stories percolated in the distance and safety. Swimming lessons, butterfly kisses, and dance class memories washed up on the shore of my consciousness as I parented. I determined that I wanted to preserve kindness in my heart from my grandmother, and the confidence and perseverance of my mother.

I heard from Granny that my mother had landed in jail again. While she was certainly doing illegal things, most of Sierra's warrants were the direct result of unmet court

dates and unpaid fines. Granny and I learned to find relief in her incarceration—it was the only time we saw her. One such episode was the first time we saw her sober in over a decade.

I started writing Sierra friendly letters of encouragement and sending my son's colorful drawings her way. She responded positively and I was reminded that there were things I liked about her after all. It was hard to remember Sierra sober; those bad memories clouded anything worth remembering. It was like getting to know her again. I decided that if I wanted a visit, the jail was the safest place to have it.

As I peered at Sierra through the safety glass, I finally saw her clearly. There were evidences of the meth addiction and the monster it created. At some angles, there were traces of my mother, too. I savored the laughs we had and the look of joy on her face. She was effervescent in that cement box, humbled to the dust and thankful for any visit. Her cracks let the light in.

After many failed attempts, she was able to stay sober and find a job.

··•· ●•∴•

As Nick and I drove peacefully through the canyons of Utah for a date, we came upon a tunnel through the side of a mountain. I laughed and remembered that Dan had told us to hold your breath and make a wish out the other side. I hurriedly recited the instructions to Nick, and we both gasped for air at the other end while holding hands.

"What did you wish for?" He laughed.

I was wearing a stunned smile, which piqued his curiosity.

As a little girl I had played, "What would you get if you won the lottery?" The list of things I'd wanted could have filled this book.

Now, with tears forming in my eyes, I replied, "Nothing."

••••••

A short time later, I joyfully announced to my husband that we were expecting our second child.

This birth was physically traumatizing to a great degree. I was able to look at myself with deep amazement and reverence for being able to endure an unmedicated birth. It was healing spiritually. I experienced an emotional high that never crashed into postpartum depression. Actually, it was quite the opposite. I learned to access a part of me that I never had before—a sort of divinity in me.

But still, the birth had been violent and it had severe and lasting impact. I was so close to death and I was bedridden for nearly six months after his arrival.

Using the training for unmedicated birth techniques, I took up a practice of meditation that helped me conquer my severe panic attacks. I overcame body shame, distorted eating patterns, and was extremely healthy. I examined my life and learned of minimalism and veganism. I took horseback riding lessons to become braver. I wrote 90,000 words for this very book. I started my own non-profit, The Provo Promise. My second son's birth was me, rising from ashes and becoming a master of my fate. I learned how to choose happiness.

Believer

My last child unravelled me, and the disintegration helped me empathize with my mother more than I ever had. The hope of a baby was my only joy and bright spot during a terribly difficult pregnancy, delivery, birth and postpartum. Our third son was ten pounds, and I felt it. The scar tissue from the previous birth, along with its bad patch job, made every day I carried him heavy and painful. I was shocked at what over a year of pain and unrest did to my face. Something hardened in me. My personal prayers begging for relief not only seemed to go unheeded, but instead the challenges only increased. The more I ritually and superstitiously attempted to please an All-Powerful God with the ability to save me, the more I suffered. I tried to find comfort in the Biblical story of Job.

More so than any other pregnancy or birth, carrying him brought me to my knees. To my very limits. My mental state wavered, no matter my coping mechanisms. The exhaustion was so profound, the pain so constant, and the postpartum so drastically weakening, that I grew angry at God. I screamed at him in my meditations. I disobeyed him, hoping for a change because I was convinced my actions had some influence on my circumstances. I read Atheist literature in pursuit of "real truth" that complimented my

mind, even if it did not comfort my heart. I catapulted myself into the exact opposite of my usual surety. I researched what qualifies me to get some space from the LDS church, since I was only taught how to join it when I was too young and too abused to understand boundaries. My faith was broken. All it had promised me if I was the well-behaved, timid Keira was not happening. I slowly realized that those promises couldn't be made by anyone in the first place. We all suffer.

God, or god as I knew Him, was completely, totally silent.

Everything about me broke.

My pain was a megaphone.

> "Pain! *You made me a believer* . . .
> "Pain! *You break me down, you built me up,*
> *believer* . . .
> "*My luck, my love, my God, they came from* . . .
> "Pain! *You made me a believer* . . ."

I raged; silence. I repented; silence. I left; silence. I bowed; silence. I swore; silence. I thanked; silence.

It was the ultimate victim moment in a long life of victim stories.

There was no worse time to be silent than at this moment of physical breaking, yet there was silence. I sat dejected in my closet, "mother of three" written in stretchmarks, bags, dark shadows, and bowed neck. The last and most desperate prayer I uttered was met with more silence. Across from where I sat on the floor, I looked at myself in the mirror. I looked like Death; *somehow* I was still alive.

"Fine." I said to the Silence. "*I'm God now.*"

I tried to earn God. Please God. Find God, as if lost. I sang hymns about God as if it wasn't what I was experiencing currently. I went to a church or synagogue or the temple as if God was a location to arrive at.

Unlike many of my past spiritual experiences (even meditation) where I disassociated from my body and longed for escape in my unpleasant times, I was fully present for the pleasant and the unpleasant of my postpartum life. I did not miss a moment. I was fully cognizant, powerful, and decisive. Unlike with other births and recoveries, there were no angels and taking sips of heaven. I growled at death to stay in his corner. I forcefully brought my last baby to life. I was fully present for the repair. I was the fierce love I wished for myself as a defenseless child. It was healing to be a part of the process of becoming so fierce. I felt as if I had been uncaged.

Being a mother is my greatest, loudest lesson: I cannot ignore myself. I cannot neglect myself. My desires, needs, and wants are my *divine voice*; my body is not a petulant child to discipline. My children will die if I am not (what I used to call) "selfish." Being a mother was my way of getting all my needs met that I had ignored in myself all my life. Every crying child, every tug of my clothing is a reminder that we all have needs, and that's okay. Our needs connect us, which is one of the reasons they recycle themselves. That annoyed me in the early days of motherhood. I responded to neediness—my own, and others'—with annoyance.

Up until this point, I learned the wrong sort of motherhood and womanhood from my mother and raising my siblings. I had learned that I come last, if I am on the list at all. I worked or cared for children in the home because my mother needing me to help her superseded my childhood, my needs, or my desires. I did not get to be in all the performances, or join a sport, or even leave the house. I happily obeyed and made a prison for myself out of home. Then, I wondered why I was depressed.

My mother may have taught me this horrible lesson, but it was the only one she knew. She also ended up exploding with "selfishness" and abandoning us for long periods of

time or, later, attempting suicide or indulging in risky be-
haviors in order to escape the prison her life had become.
I learned that children were a burden and acted out the
prison sentence when I was an older sister, babysitter, and
when I became a mother.

I learned very quickly that religion was another form
of self-harm for me. I self-flagellated over forgiving my
mother and being angry, over not getting everything
perfect, over not receiving my own witness or my own an-
swers—always requiring a prophet, leader, my husband,
friends, or family—not being my own master. I found it all
abhorrent when I saw what it really was to me: a helpless
version of me looking outwardly for control and answers.

It was only this final birth that made me truly see that
I was wrong and idolatrous and superstitious in my rela-
tionship with "God." I don't search far away for God; I am
God. God exists in the eyes of everyone I meet. God is in
the air I breathe, the water I drink. The entire universe is
permeated with love, and I am included in that love. I am
equal in divinity to everything I encounter. What I want
matters, too.

I withdrew, and immediately my inner voice started
talking.

What you need or want to be happy is DIVINE, not sin.
I am speaking! Hear me!

I spent so much time praying to outward god, my
"Wizard of Oz" god. He was male; he was cruel, foreign, de-
manding and fickle. I had to travel far to get to him; people
hadn't seen him but said he was awesome. I had to speak
to him through others; when I finally got to him, he was
green, loud, scary and required strange and hurtful tasks.
When I complied, I still didn't get what I wanted. I still suf-
fered whether or not I obeyed.

In the end, he was a fraud behind a curtain.

I was very interested in getting to know the real source of goodness, and like the story, I was instructed to examine my own Ruby Slippers, my own powerful travel companions, my own desire for home.

I felt that I was being trusted on a new level. A level in which I did not need to endlessly be a self-flagellating, child-like servant who needed to earn her worth and get her answers outside herself through structure.

I didn't understand much of what I experienced, but luckily my children begged me to sit with them through movies, music, and simple art that spoke to me like a child when higher thought processes weren't possible. My children voted for *The Lion King*. I was on bedrest from the birth and agreed. I was stunned silent as words of truth came from a cartoon. The movie sums it up nicely:

> "You have forgotten who you are,
> so you have forgotten me."

I was surprised at getting such a profound revelation of the divinity within ourselves from a *children's movie*.

It was confirmed again in a meeting with my LDS bishop. I was angry and sobbing, and he was emotional alongside me. "Why is there no help for me when I'm so broken? Where's God's restitution for all I've lost? Where are the miracles promised?" I cried out.

His careworn face and concerned eyes looked up at me: "Have you ever thought that your payment could be your beautiful family life and all the love you have now?"

He waited. "Have you ever thought that you're the miracle?"

I had not looked in the mirror for that.

There Is a Crack in Everything

In the *Book of Mormon* (for LDS folk this book is further scripture, similar to the Bible), there are often two groups referenced (one 'good', the other opposing): Nephites and Lamanites. These names come from the leader they choose, and adding the ending "-ite" to the name. At one pivotal moment in the narrative, the two groups live in harmony after a visit from Jesus, and the author describes the situation thusly: there were "no manner of '-ites,' but they were one . . . "

That became what I strove for.

I was not religious enough for my religious friends, but I wasn't anti-establishment enough for my ex-religious friends. I was not entirely atheist or secular because I admit that I *have* had experiences with the Mysterious and Unknown.

All my life, I have experienced many levels of abuse and violence, but I had found at this time that there was one last unforgivable violence. It was the violence I had done to myself. I was too afraid to be *me*—loving others had been so costly, speaking up had been so dangerous, striving for what I wanted felt like I was taking from those I loved most.

I *had* been in a cage, and I had all the signs of a sort of psychological shackle. I counseled with my former college

professor and now friend, Matthew, about my life-long imprisonment.

"Keira, there are answers for you, but only *you* can find them."

"I don't know anything anymore." I replied dejectedly.

Matthew thought for a moment. "There are two types of freedom: freedom *from* and freedom *to*. You can be free from an actual prison, or culture, or laws . . ." He paused. ". . . or a *church or belief.* That's freedom *from* outside influences. But now . . . " he looked at me like I imagined Jesus might. "Now is your chance to explore your freedom *to*."

I thought long and hard about that concept. It was not always a positive experience. I looked at my future and the landscape had disappeared. Plans vanished that had been made for me by outside influences. I did not know myself well enough to be sure what kind of future I wanted. I became quiet as I pondered.

Eventually I chose for myself, and I declared Radical Love as my religion . . . and I was terrified and free in the process of being more honest and authentic.

Over my lifetime, I watched my dreams at night progress over the years, and they gave me an indication of my mental and emotional healing. As a child and teenager, I dreamed of being persecuted and screaming, but having no voice. Then I had dreams of being rescued from what was chasing me, usually by Jane or Nick. Then I had dreams of being pursued and narrowly escaping by myself. Next came visions of being able to fight off opponents.

I had many dreams of screaming at my mother or changing my past and being braver when she chose wrongly. Eventually, I came to rescue and love her, or forgive her. After my faith crisis, I dreamed of stressful or horrible situations where I called out to Nick or Jane, but they would not or could not help. I learned to solve my own problems

and fight my own battles. Lastly, I had self-exploratory dreams of love and bliss.

I've written them in journals over the years, looking for meaning in these fragments of my unconscious. I like to think that it showed my progression: through a mental state of victimhood to survivor, and then empowered veteran who had made the choice to do battle—as if I were born for it all along.

Pilgrim

Hello.

i am.

I am a divine pilgrim.

I am a tired wayfarer.

I kept my back to the sun for many years, afraid of the burning power of light.

The wind whistled and the atmosphere closed in around me, and it was then that I realized that the Sun and Light was all I knew anymore. It was the only thing left with a shape, a purpose, and a name.

So, I turned toward the Sun and found that it was atop an impossible mountain.

I could at least die trying to reach something with a Name.

In his infinite chicanery, God pulled a bait-and-switch; just as I thought I had made it to the peak in my religiosity, I circled back to the same lessons with new eyes. I discovered that we are living seasons, not exponential lines on graphs.

I choose to think I can no longer see God's face because we are in an embrace. Maybe we are dance partners. In the silence, I stopped searching for the woman or man in God and started looking for the God in woman or man.

The God in nature. The divinity of my own body as my only home and my only temple.

If you can't see God in all, you can't see God at all.

My will and anger and hate have melted in the refining fire of a long journey. I have often thought it wouldn't get much worse, but it has. I have often thought it couldn't get much better, but it has. Love has taken root in me, it has grounded me, sustained my every breath, quenched and cooled my scorched heart and soul. Love is in my movements and in my hope; it is the stuff of all my dreams and my only religion.

Now, I am at peace. Not because I have arrived. Not because I am named.

I am at peace because my past and my future have less bearing on where my feet go now. I walk as far as I can today. I appreciate my company on the journey today. I am only alive because of a village of miraculous people that lifted where they could. I'm in awe of the depth and breadth of a stranger's generosity.

I have hope for the future, but my faith doesn't lie there. I appreciate my past for what I can, but I don't desire to dwell there.

I have miles to go before I sleep.

When I stripped myself of labels, titles, names, and obligations, when the heavens grew dark, I found only one thing written in my heart: LOVE THY NEIGHBOR AS THYSELF.

I wrote this poem as an attempt to center myself in the early days of "practicing" my newfound "religion":

> *I saw Jesus once*
> *outside my house*
> *on a hot summer day of sales*
> *drinking from my hose bib oh-so-quietly.*
> *I was afraid*

and I didn't offer him a cup
and closed my door.
I saw Jesus once
talking to himself
on the corner of the Parkway
and State Street
and I was afraid
and I didn't offer Him an ear.
I was too late for church.
Jesus stopped talking.
The Book stopped singing.
The clouds came
and I grew a desperate darkness
inside of me.
So I bought the hungry, pregnant Jesus
an All-you-can-eat buffet
on Sunday.
And I laughed under a tree with Toothless Jesus
as He sat on His only home with me.
I put a ring on my left hand
and climbed into bed with Jesus.
I told him I was sorry for my harsh words
after a very long Tuesday.
And in the middle of the night
Jesus cried out to me,
hungry and alone.
I got him all cleaned up
and I offered him some milk,
singing tenderly,
and I thanked Him for
coming to me again.
I promised I wouldn't ever
shut my eyes to Him again.

In gazing up at stars that didn't seem to give a damn, I learned that I cannot take away God's agency (or anyone's) to interact with *me*. I *do* have a choice on how to act and react. I fell in love with the idea that, in the words of Auden, I could "let the more loving one be *me*."

Symphony of Sorrowful Songs

For years, I had fantasized about revenge. I clung to the thought of justice. I had waited for this very day. My mother sat in my living room. It was one of her rare visits, but carefully planned by me, with plenty of boundaries. Today was the day.

I didn't know it was going to be *that* day; there was no stage, no Oprah.

She sat across from me on the couch in tears, not making much sense in her words or her hurried tone. My deaf ear made hearing her a struggle, anyway. I tried to read her lips, but her face was buried in her hands often and her features were twisted with emotion. We talked about losing Granny, but right before she died, I arranged for her to speak with her other estranged daughter and grandchildren. We talked about my hard-working siblings—both brothers married, generally healthy, but still emotionally silent. We talked about my sisters struggling, juggling motherhood and work, and fighting to keep the relationships that created their children. I mentioned it was a miracle they had graduated high school. We discussed the ways I tried to keep lines of communication open with all of them. It wasn't easy; a chasm of distance and disconnect had grown between all of us.

"All I have undone, all I have unraveled, you are putting together. All the bad I caused is being restored through you."

She sobbed. I hadn't seen my weaving until she put the pieces together.

I reached for her hand. It honestly never crossed my mind that this was the hand that smacked me, that flipped me off, that greedily took my money, and that sometimes refrained from holding me.

I held her hand as she said, "I didn't know. . . . I did the best I could. . . ." I knew those words immediately. They were so familiar to me.

I had often used the same words myself—in personal chastisement and personal prayer over my angry words, and in trying to come to terms with my own mistakes of motherhood and marriage.

I also didn't see that those hands were weathered by laundry and dishes, typing, soothing chicken pox, writing notes in lunch boxes, and, sometimes, holding me as I cried.

I just offered to hold her hand because that's what you do when someone is in anguish.

The whole moment was touching, quiet, and underwhelming. It wasn't something grandiose. It was a spring weekend while my sons played in the backyard. Peace and forgiveness settled gently on our shoulders. In my childhood, I would have said that this is not what she deserves.

Do any of us get what we deserve? We are all broken to some degree and deserving of pain and offense. But that is what grace is for. None of us should really get the punishments we 'deserve.' Grace lifts us out of our misery and gives us more beauty and love than we deserve.

She started speaking through tears again.

"You know, I was always my mother's favorite. She loved me in such a special, attentive way. She adored every

inch of me. And she told me, when you were about a year old, after her scary stroke and everything, 'I never thought I could love anything more than I loved you, Sierra. But then you gave me Keira. Thank you.'"

And that was when I cried. My head fell and my throat choked.

I was needed. I was wanted. I was loved. I had forgotten.

I had forgotten because I remembered the back of every father I knew, instead of marveling at my biological father wanting to be a part of my life now. He often told me his biggest regret was not being there for me.

I had forgotten. I had forgotten that I had a beautiful body to call my own. I had forgotten because, in my pain and loneliness, I stopped visiting the lonely. I had forgotten because I looked elsewhere for what I had in me all along, and when I searched outside of me, I was always a stranger, a guest, a burden, a charity case.

My mother's words forced my mind to return to this moment.

"You are the unifier. You are bringing everyone back together. You are healing it back together." My depression-riddled mother was not wrong. What she was saying was very sane. That was the problem. Life is so . . . painful and devastating, and it is always moving through your guts with heaviness and without mercy. Your mind bends and blisters. We both knew that.

She continued, "I'm so sorry about my depression. I'm sorry I'm not better enough now to help you. I'm so sorry I wasn't there for you when you suffered with depression too, with your babies. When I heard you were suffering, I wanted to help, but I couldn't. . . ."

I sat in silence with my mother—not the monster—the human being. The eighteen-year-old girl who gave me life. The unimaginable horrors she had seen and done. The broken heart. The lost dreams. The guilt took up residence

in her bowed neck. I saw pain everywhere, and I felt relief with the realization that I would rather be *me* than her.

That day finally came.

I uttered the words to my mother that I hoped to hear one day from my children. "You were a good mom. You did your best. I love you." Light in all her crevices.

That was one of the last times I ever saw her.

There was light in every crack I had. I took it all in. It was a gift. It wasn't one that I needed, or even obsessed with wanting anymore. But it was still a treasure. It made so many things clear to me.

My journey was not to escape—a victim. My journey was not to triumph, to scale, or to conquer—a bully. My journey was the middle way: to mend, to value each treasure, and place it where it would do the most good for everyone, including myself. My journey was to infuse all our broken bones.

My journey was light and love.

I wish *you* light and love, my neighbor.

Selah.

Dear American Taxpayers

November 28, 2011

Dear American Taxpayers,

My name is Keira Scholz, and I am twenty-three years old. I am the daughter of an uneducated, meth-addicted prostitute who was the single mother of six children. Since 1987, you have supported me as you paid your taxes. You are the sole reason I am alive today. I am writing to thank you for it. I hope this message gets to you.

From the moment my mother found out she was pregnant with me, to the time I graduated from college, the taxes you have paid have been my bread and butter, my warmth and shelter, my health and happiness. I was born in a clean, safe hospital staffed with competent doctors because of Medicaid. I was vaccinated, diagnosed, treated, medicated, and consistently checked because of your tax-paid public assistance. I received better dental care than my husband, whose parents never spent a government dime. I was an overall healthy child.

I was fed nutritious food and vitamin-fortified cereals to keep malnourishment at bay thanks to the Women, Infants, and Children (WIC) program and my mother learned how to provide varied meals for my growing body because of

the resources and education offered by that program. Later in life, I entirely subsisted on the meals provided by Food Stamps as my source of food at home. At school I was offered a free breakfast and lunch, and sometimes that was my only food for the day. I would have starved without this charity. At times even that wasn't enough, so I want to thank you for donating to places like your local food bank, which always helped us get through the holidays.

Sometimes we could not afford to heat our home, and state-funded programs paid for our warmth in the winter. Sometimes we could not afford personal hygiene items such as diapers, toilet paper, shampoo, or toothpaste, but various churches and volunteer programs such as Bikers Against Child Abuse (BACA) or The Children's Justice Center were always willing to step in and help a family in need. At times we could not afford new clothes, but thanks to places like the Salvation Army and Deseret Industries, we never went without a pair of shoes.

When we could not afford rent, we lived in government-subsidized housing. These houses were sparse, but they were always clean, always safe, and always in good repair. I lived in comparatively safe neighborhoods as well, and was always sad when we had to move. I felt that the houses or apartments the government offered were better than the more expensive, run-down rent alternatives we lived in.

Christmastime was always very hard, but we had wonderful Christmases thanks to Sub-for-Santa. Every year was a joy as we opened the gifts piled under our Christmas tree—Santa really *did* exist.

I was educated by the public school system staffed with many caring people. I learned to read, and I devoured books. I was successful in my school work simply because I could read well. Even though we were poor, I could rely on public transportation and because there was a library in every city in which I lived, my grandmother and I would ride the bus

to the library each Saturday and I would choose good literature to read from an extensive selection of books. I was empowered by the ideas I consumed, and I was exposed to the idea of higher education—college—because of the characters in those books and because of the librarians I befriended. I also had school counselors and teachers who guided me along the way, encouraging college and lifetime learning, so that by the time I graduated high school, I knew that was my goal. I knew it would better my life.

When I was taken into foster care at fifteen years old, I lived in safe foster homes owned by volunteer foster parents. Your taxes paid reimbursements for my housing, food, and clothing there, as well as the medical and mental health services I needed while living in foster care. My foster parents were good, kind people, and they taught me how to work hard. With the help of a licensed professional, I was able to work through some of the issues that landed me in foster care. I was seen by a caseworker a few times a month so that I always had someone to report to if anything was awry. I was defended in court by a Guardian-ad-Litem free of charge, so I had someone to state my case. I was very lucky.

I went to a state-funded university, and was able to attend by the grace of scholarships and federal Pell grants. Thank you for giving me the gift of higher education. Without your financial support, I would have known nothing about college, or at least I would have never dreamed of earning a degree.

Although these programs are the only reason I am alive, well, and educated today, I am happy to report that my little family, currently consisting of my husband, myself, and my son, has never applied for a single welfare program. Although currently we qualify for WIC, food stamps, and Medicaid, we will not take them because *we do not need them.* Nonetheless I am grateful that they were there for

me when I needed them. My mother may not have always used the government's assistance well, but I am alive today in spite of that, thanks to your kindness.

You may or may not approve of these programs; you may be Republican or Democrat or Green party or whatever else. We do not have to agree all the time. But you paid your taxes. You probably dropped spare change into the Salvation Army Santa's bucket at Christmastime. You probably donated old clothes every once in a while. You may have volunteered to be a Sub-for-Santa one year. You may have dropped a can or two into the Food Bank bin at the grocery store. You probably did it, never thinking you would get a thank you, and you were not expecting one. That's just what good people do.

But I'm here to say thank you. Thank you, from the bottom of my heart. Without this vital assistance, I would not have lived to be twenty-three. I would have died for lack of a vaccination. I would have died without oxygen at birth. I would have frozen in winter. I could have grown up malnourished or died in a filthy neighborhood. I could have been just another illiterate girl. But I'm not, because I was fortunate enough to be born now, to be born in the United States of America. I am a free, college-educated, vaccinated, perfectly healthy American woman.

Oftentimes, those who receive these types of assistance do so without giving thanks, receiving money from a faceless establishment, and seem to only demand more. Those who pay into the system feel it is an insatiable beast with no gratitude for the gift. I am starting now with a thank you that is twenty-three years in the making. Thank you for the gift of life. I hope to give back, starting today, with a heart full of gratitude, by saying: Thank you for paying your taxes.

A Note

With a compilation of journals, interviews, police reports, court documents, and the limits of mind and memory, I have written the honest truth as I recall it.

Names, specific identifying features, timelines for abuse, and locations have been changed to protect all those involved.

While characters in this book are of differing religious affiliations, the characters and their actions are not necessarily a reflection of their preferred churches.

References

Title This book's title comes from the line, "There is a Crack in Everything—that's how the light gets in." It is from the song, "Anthem" by Leonard Cohen on the album, *The Essential Leonard Cohen.*

Chapter 2 "My Daddy Gave Me A Name, Then He Walked Away" is a line from "Father of Mine" by Everclear on their album, *So Much For The Afterglow.*

Chapter 3 "Sweet Disposition" is a song on the *Conditions* album by The Temper Trap.

Chapter 4 "Hear You Me" is a song by Jimmy Eat World, on the *Bleed American* album.

Chapter 5 "Sweet Child of Mine" is by Guns N' Roses, on their album, *Appetite for Destruction.*

Chapter 6 "Vagabond" is a song by Wolfmother from their self-titled album.

Chapter 7 "Blessed Are the Penny Rookers, Cheap Hookers, Groovy Lookers" is a line from Simon and Garfunkel's song, "Blessed" on their album, *Old Friends.*

Chapter 9 "Heavenly Father, are you really there?" is a line from the song, "A Child's Prayer", an LDS children's song.

Chapter 11 "The Glass and the Ghost Children" is the title of a song from the Smashing Pumpkins' album, *Machina*.

Chapter 12 "With The Birds I Share This Lonely View" is a line from The Red Hot Chili Peppers' song, "Scar Tissue" featured on their album, *Californication*.

Chapter 13 "We Don't Belong to No One; That's a Shame" is a line from a song called, "Name" from the Goo Goo Dolls' album, *A Boy Named Goo*.

Chapter 14 "I Won't Tell 'Em Your Name" is a line from Goo Goo Dolls' song, "Name" from their album, *A Boy Named Goo*.

Chapter 15 "God Help The Outcasts" is a magnificent song featured in Disney's *The Hunchback of Notre Dame* by Menken and Schwartz.

Chapter 16 "Confluence" is an arrangement by John Williams from the soundtrack to *Memoirs of a Geisha*.

Chapter 19 "I Gotta Take It On The Other Side" is a line from "Otherside" by the Red Hot Chili Peppers' album, *Californication*.

Chapter 20 "Fire and Rain" is James Taylor's song from *Sweet Baby James*.

Chapter 21 "Semi-Charmed Life" is a song from Third Eye Blind's self-titled album.

Chapter 22 "Rest in Pieces" is a song from Saliva's album, *Back Into Your System*.

Chapter 23 "The Mystery of the Universe is Feminine" is a misheard lyric from the song, "I Want You" on Third Eye Blind's self-titled album.

Chapter 24 "Send Me All of Your Vampires" is a lyric from the song, "I Want You", on Third Eye Blind's first album, *Third Eye Blind*.

Chapter 25 "Your Love is Gonna Drown" is a lyric from the song, "Marching Bands of Manhattan" on Death Cab For Cutie's album *Plans*.

Chapter 26 "Blue and Yellow" is by The Used on their first and self-titled album.

Chapter 27 *Welcome, Happy Morning*, Lutheran Hymn by Venantius Fortunatus, c. 530–609, Translated by John Ellerton, 1826–1893.

Chapter 28 "Safe 'Til St. Patrick's Day" by John Mayer on the album, *Room For Squares*.

Chapter 29 "I Almost Fell Into That Hole in Your Life" is a line from the song, "Black Balloon" by Goo Goo Dolls, from *Dizzy Up the Girl*.

Chapter 30 "Stand Inside Your Love" is a Smashing Pumpkins' song from *Machina*.

Chapter 31 "It's a Hard Knock Life" is a song from the musical *Annie*, written by Strouse and Charnin.

Chapter 32 "Every New Beginning Comes From Some Other Beginning's End" is a line in the song, "Closing Time" by Semisonic on their album, *Feeling Strangely Fine*.

Chapter 33 "You Were the Same as Me, But On Your Knees" is a line from "Black Balloon" by Goo Goo Dolls, *Dizzy Up the Girl*.

Chapter 35 "Money!" is a song by Pink Floyd, featured on their album, *The Dark Side of the Moon*.

Chapter 37 "I Still Haven't Found What I'm Looking For" is a U2 song on their album, *The Joshua Tree*.

Chapter 38 "If You Do Not Want To See Me Again, I Would Understand" is a line from "Jumper" on Third Eye Blind's self-titled album.

Chapter 39 "Her Confidence is Tragic; Her Intuition Magic" is a line from the song, "Meet Virginia" by Train on their self-titled album.

Chapter 40 "Starlight" is a song by Muse on their album, *Black Holes and Revelations*.

Chapter 41 "I Dreamed A Dream" is an incredible song featured in the stage adaptation of *Les Miserables*.

Chapter 42 "You Electrify My Life" is a line in "Starlight," a song by Muse on their album, *Black Holes and Revelations*.

Chapter 43 "You Are My Sunshine" is a folk song attributed to Davis and Mitchell.

Chapter 44 "Walked Into the Angry Sea; It Felt Just Like Falling in Love Again" is a line from "Death of an Interior Decorator" by Death Cab for Cutie on their album, *Plans*.

Chapter 45 "A Kiss To Build A Dream On" is a song by Louis Armstrong on his album, *Ella and Louis*.

Chapter 46 "Believer" is a the title of a song by Imagine Dragons on the album, *Evolve*.

Chapter 47 "There is a Crack in Everything" is a line from the song, "Anthem " by Leonard Cohen on the album, *The Essential Leonard Cohen*.

Chapter 48 "Pilgrim" is a song by Enya, featured on her album, *A Day Without Rain*.

Chapter 49 "Symphony of Sorrowful Songs" is also known as "Symphony No. 3, Op. 36" and was composed by Henryk Górecki.

KEIRA SHAE Keira Shae was born in 1988. Keira grew up in a poor, non-Mormon (also known as the Church of Jesus Christ of Latter-day Saints/LDS church) family in Provo, Utah and encountered abuse, drugs, prostitution, family separation, and profound poverty in the shadow of the Temple and the LDS Church's flagship university. She experienced kindness from an LDS foster family as a teen, which changed the trajectory of her life.

She attended the following Provo Elementary schools: Joaquin, Westridge, Provost, and Sunset View. As a teenager, she became a runaway and entered foster care. Because of this, she attended Provo, Timpview, and Orem High schools, and graduated in 2006 from Spanish Fork High School in Utah, USA. As Outstanding Student of her college, Keira graduated with honors with a Bachelor's degree in Behavioral Science: Psychology from Utah Valley University in 2013. She was the first in her family to graduate from High School and University. She is currently earning her graduate degree.

Keira is married to Nicholas Scholz, and together they have three sons. She founded The Provo Promise scholarship in 2016 for Pell-ineligible children who are residents of Provo, her hometown. With the introduction of a similar program from within Utah Valley University, the Provo Promise Scholarship was phased out in 2019.

How The Light Gets In is Keira's first book.

Made in the USA
Lexington, KY
05 April 2019